P9-AFQ-705

GUILLERMO DEL TORO'S
PAN'S LABYRINTH

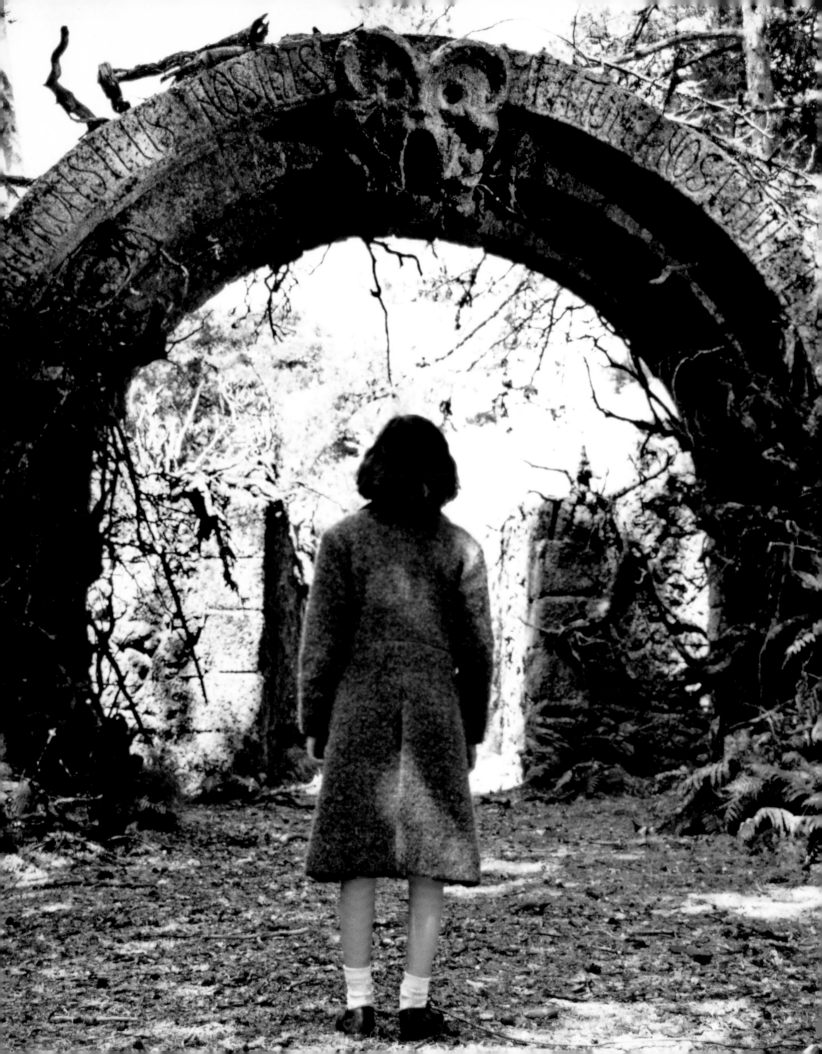

Guillermo del Toro's
Pan's Labyrinth

Inside the Creation of a Modern Fairy Tale

by Mark Cotta Vaz
and Nick Nunziata

foreword by Guillermo del Toro

HARPER DESIGN
An Imprint of HarperCollins Publishers

An Insight Editions Book

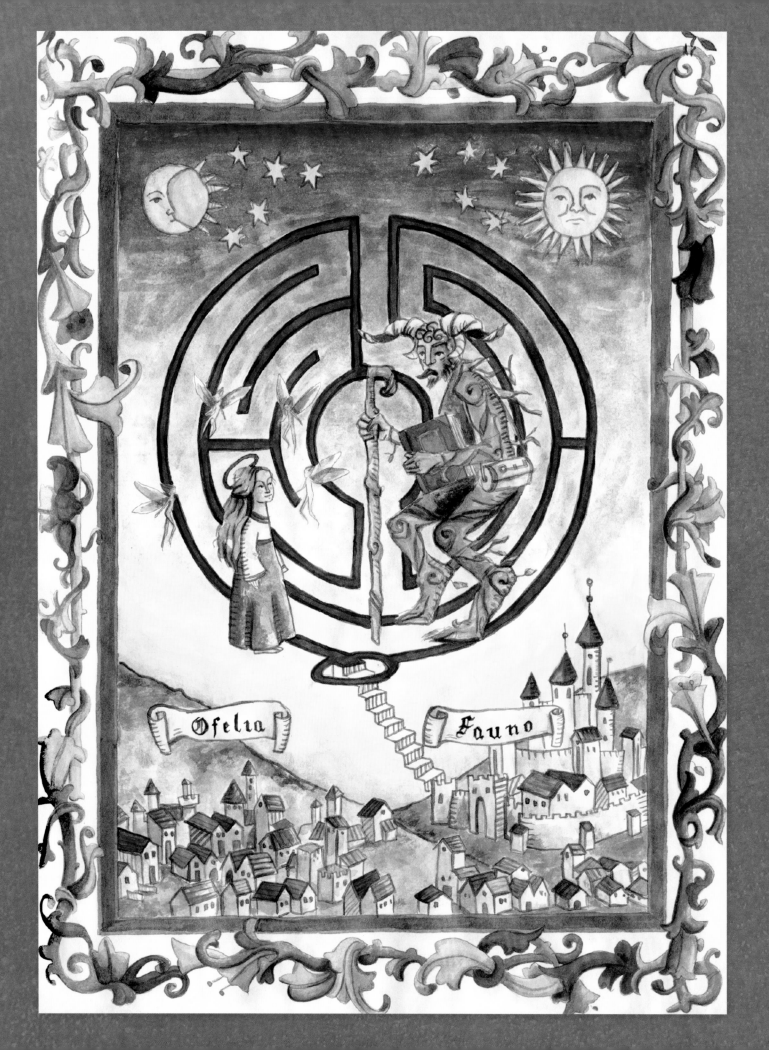

The labyrinth is a primordial symbol. It can mean so many things, culturally, depending on where you find it. But the main thing for me is that, unlike a maze, a labyrinth is actually a constant transit. . . . It's about finding, not losing, your way. —Guillermo del Toro

PAGE 1 Labyrinth conceptual art by Carlos Giménez. PAGE 2 Young Ofelia stands on the threshold of the ancient labyrinth. ABOVE Faun head art by Raúl Monge. OPPOSITE Illustration from the *Book of Crossroads* by Esther Gili, calligraphy by Maria Luisa Gili. PAGE 6 Conceptual design by Sergio Sandoval of the kingdom of the underworld.

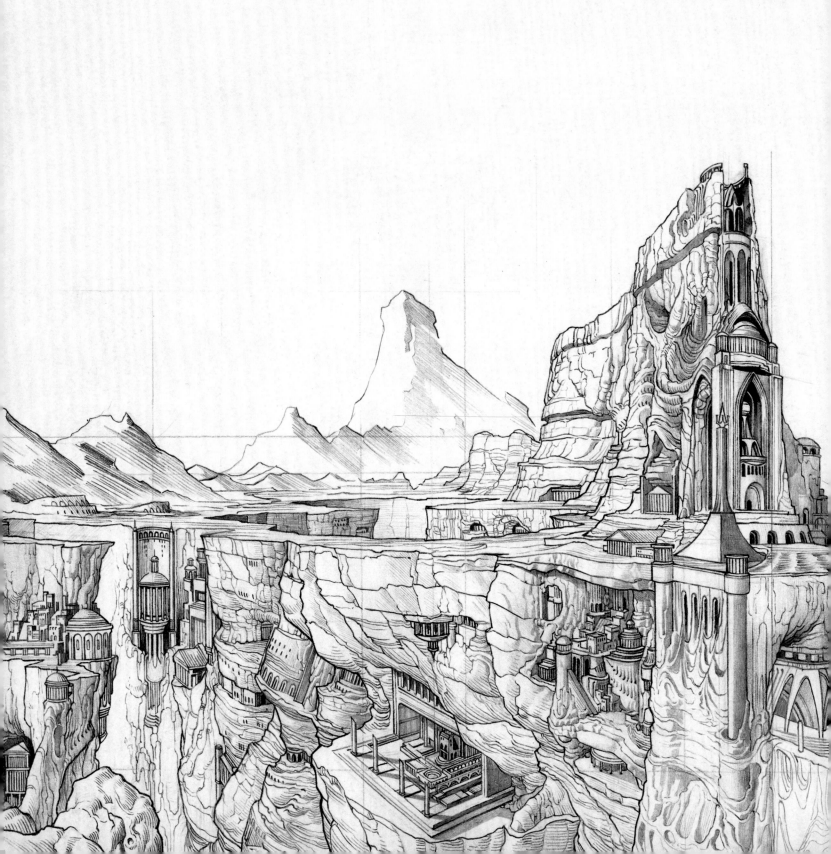

CONTENTS

SO, HERE WE ARE—ten years after its release—still talking about this movie.

And I am incredibly thankful for that.

In my estimation, *Pan's Labyrinth* was the second most painful movie to make (the first was *Mimic*). But it is also one of the three I love the most—the others are *The Devil's Backbone* and *Crimson Peak*.

FOREWORD BY
GUILLERMO DEL TORO

Obvious to everyone but me, we were overreaching and underbudgeted. It was, no doubt, the wrong Mexico/Spain co-production to attempt at that particular time. Catalonian horror was fruitful, yes, but always viewed as a sensibly budgeted exercise. And a big-budget movie like *The Others* always demanded an international cast and had to be shot in English. Mexico offered a limited amount of money for co-production, and we had to fill key positions and achieve a postproduction process that (in Mexico, at the time) was uncharted territory. Why do it, then?

All of it goes back to one nice dinner with Alfonso Cuarón in his London home. We were both in a sort of exile and trying to find our way into films that pushed us forth. During the course of the evening, I told him the story of *Pan's* (start to finish) with exacting attention to detail. We felt confident and charged, but there was really no reason to. Alfonso had embarked on *Children of Men* and made it clear that he would be on that journey at the same time I was shooting. Our producing partner, Bertha Navarro, and I would have to do the heavy lifting.

But it is a fact: Lost causes are the only ones worth fighting for.

I've gone on record in other books and audio commentaries about how much adversity we faced (crew mutiny, backbreaking giant frog puppets, forest fires, loss of entire sets, a fiendish plot by rival producers bent on sabotage, and much more).

I was mercilessly pushing everyone to the limit, but I carried the weight of the world—this fantastic world—on my shoulders. I was sleeping less than three hours a night and was losing three pounds a week (I have regained them all, thank you) due to the enormous stress. At a very early point in the production, I forfeited my salary and my points and just closed my eyes and worked harder than I have ever worked.

But amidst the pain, this was also a time of prodigious love, emotional rewards, and changes. Without my realizing it, this movie changed me and my life forever.

I had already made a movie I was immensely proud of—*The Devil's Backbone*—which prompted me to embark on this "companion piece" as I called it. A "sister" movie for the boys' adventure I had shot. They are both movies about innocence and war and about infinite melancholy and loss. But *Pan's* was more intricate and ambitious from a technical and visual standpoint. You see, before taking on *Pan's*, I had the chance to experiment with a fine degree of visual construction in *Hellboy* and had learned to fuse digital effects and makeup in *Blade II*. Now this project allowed me to attempt a new kind of tale—one that was ambitious but still delivered within a restrictive European budget. The budget was 14 million Euros (around 19 million US dollars at the time) and hardly sufficient for my ambitions: I wanted to build every single set, fabricate most of the props and furniture, and design and fabricate most of the wardrobe. On top of that, I wanted to deliver a myriad of creatures that were entirely uncommon in Mexican or Spanish cinema.

In summation: a movie that should not be attempted. If you listen to reason, that is . . .

A budget is a state of mind. So, the route we took was fraught with danger. Bertha Navarro suggested a young, unproven production designer: Eugenio Caballero. I agreed to go with Eugenio mostly because I saw great promise, yes, but even greater commitment. In his eyes burned the death wish of the novice—the limitless hunger you have when you don't know boundaries or budget.

I supported Eugenio: first, by placing my office amidst the art department so I could torture him daily, and second, by hiring the very best—and the most loyal—set construction company in Spain, Moya Construcciones.

I insisted on having DDT Efectos Especiales deliver the makeup effects, because I had watched them grow from

BELOW A panoramic view of the *Pan's Labyrinth* preproduction office in Madrid, Spain.

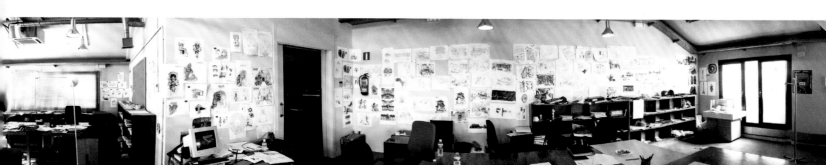

infancy. Little did I know that this was to be their adolescence, and we would go through their growing pains together.

The wardrobe was to be designed by Lala Huete, whom I deem an absolute genius and one of the most brilliant and unconditionally dedicated collaborators I have ever had. She was going through the most dramatic period of her life and she never surrendered. In my opinion, the wardrobe becomes the "set" for the actors face and body; it tells you their story before they open their mouth, and Lala instinctively understood this.

In cinematography, I had my compadre Guillermo Navarro, with whom I had a preternatural shorthand communication and whose sense of light I adore. Guillermo brought with him two of his key collaborators: David Lee, the most prodigious gaffer, and Rick Stribling, his 4x4, all-terrain grip man. We would face adversity together.

I storyboarded, designed, and planned everything to a T and then marched straight into hell.

One vital bit of information needed before undertaking this journey was that a labyrinth is a pilgrimage, not a maze. Not a place where you get lost but a place where, after many twists and turns and moments of despair, you are found.

This particular fairy tale contains another moral: the idea that, sometimes, out of great but secret sacrifices, changes flow that ripple through the world.

The military skirmishes chronicled in the film are insignificant (most military activity of that time is lost to history). Repression was waged in Spain under the radar. Men were shot, rebellion suffocated, and buildings burned all during a time of official "peace." The "peace" of the winners. So, no— the guerilla army didn't win the war. But, as in the film, it did win a few battles. And, most importantly, it never gave up.

All those anonymous men, shot by the side of the road, paved the way for change and freedom. And, in the same way, Ofelia gave it all for small changes in the world: A baby lives, free of the shadow of his father; a small flower blooms in a dry tree. But these minute changes are not insignificant. They are a part of the chain of good. Because—if I may quote myself—in the absence of light, darkness prevails.

Because the fight you must fight is the one no one else is fighting. The tale you must tell is the one no one will tell if you stay silent. You don't do the movie you need, you do the one that needs you.

I studied and read all the Celtic lore that I could find. I read anthropological, psychological, and sociological studies of fairy tales and continued reading myths and folk stories from around the world—a vice I have indulged since childhood—and kept careful notes and observations.

I wanted the tale to feel ancient and traditional, like a story told before—passed from generation to generation. But I wanted to restore a sense of violence and majesty to its darker elements. I wanted the fantasy to be as brutal as the reality surrounding it: not an escape but a conduit.

I marveled at the fact that fairy tales and fantasy are considered "childish" endeavors, while war is viewed as a noble and adult quest.

I constantly experimented with new ideas for the creatures—I wanted them to feel fresh and beautiful. I devised a new, unproven "leg system" for the Faun and toyed with a series of Protean transformations for the Pale Man. But, in the end, it was budget constraints that depurated all these things: We only did what we could afford and we only afforded what was vital.

Zen through limitations, you might call it.

But it is the duty of the filmmaker to remain unreasonable. To stay ambitious past the printed budget or schedule. It makes no difference if the budget is 190 million or 19 million, your vision must hunger for much, much more and deliver value and artistic worth well above the numbers.

So, here we are: ten years later, yes. And this small flower is still in bloom. *Pan's Labyrinth* is a movie that seems to have affected people as deeply as it affected me. To some, it takes root almost at a molecular level. I confess that I still cry (rather loudly) during the last three minutes of the film. And that I am still arrested by its beauty and destroyed and lifted by what it says about our world.

Within these pages, you have a loving consignment of facts, figures, and some unpublished art to memorialize our decade-old creation: a fairy tale for troubled times.

One that almost killed us making it. So, please, enter the labyrinth.

We'll meet you there.

I think my closest relationship as a storyteller is with the fairy tale. Everything I do has a sort of a fairy-tale patina. To me, the horror genre is very closely related to fairy tales. My movies are also very autobiographical. I am able to understand the bad guys and good guys and all the characters. . . . When I was a child I was not very outgoing; I was basically mute. I would not talk to anyone, I would observe a lot. You see that type of child in my movies. —GUILLERMO DEL TORO

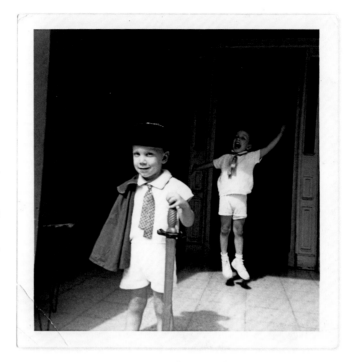

THE LITTLE BOY FEARFULLY AWAITED the church clock tower's tolling of midnight, knowing that at the stroke of that hour he would see the hand of a mythical faun appear from behind its hiding place. The face would follow, then a goat's leg—and he would start screaming.

That little boy was filmmaker Guillermo del Toro, in the grip of what he recalls as his childhood penchant for "lucid dreaming." Did his apparition foreshadow the Faun

INTRODUCTION
THE STORYTELLER

of *Pan's Labyrinth*, the film that has been called his masterpiece? "Well, I don't know," del Toro muses. "It was like a goat man and far more malevolent and demonic than the one in the movie. I would see it and always wake up screaming. There are all those images in Mexican iconography of the devil being sort of an upright goat, a goat man. I suppose it had more to do with that. I think a lot of the iconography in Mexico, of the Catholic religion, is very gory and sinister, with notions of sin and damnation and good and evil and sacrifice and suffering—all of that has stayed with me my whole life!"

Del Toro has retained childhood memories rich in nightmarish visions and wonder. That child within has been a voice in not only *Pan's Labyrinth* but throughout his work—del Toro has said his movies are all really one long autobiographical movie. "As adults, we lose the child we were, you know?" reflects Mexican film producer Bertha Navarro, who has worked with del Toro since his career began. "But Guillermo has that child within himself, and that is what is amazing about him. I think that is a very powerful and unique way of seeing things."

Del Toro is popularly known for his Hollywood blockbusters, including the *Hellboy* movies, but fans, friends, and fellow filmmakers have a special fondness for his three lower-budget Spanish language films—his directorial debut, *Cronos* (1993), *The Devil's Backbone* (2001), and *Pan's Labyrinth* (2006). Navarro, who produced all three, notes they are bound by unifying themes: "Guillermo has his personality in all his films, but these three films are closer to him in a cultural and historical way, and they all [feature] a child or children."

The parallels between del Toro's own childhood and the imaginary worlds of his films are clear. A completely mute girl witnesses her grandfather's transformation

GUILLERMO DEL TORO GOMEZ.— "Toro", "Torito" o simplemente "Memo". Actor innato, cómico natural: el mejor carrillero del IDEC. Cinéfilo de corazón. Impulsó el cine entre los compañeros. Hizo admirablemente sus pininos de maestro en secundaria. Amigo de los maestros, en particular, de Daniel Varela. Será un excelente comunicador porque tiene muchas cualidades. Dicen que el primer cuento que oyó en su vida: fue DRACULA.

into a vampire in *Cronos*, a clear reflection of his younger tongue-tied self. His childhood memories haunt the ghost story at the heart of *The Devil's Backbone*—a corridor where an apparition of a boy is glimpsed is a re-creation of a corridor in his grandmother's house. And in *Pan's Labyrinth*, a young child encounters the monstrous stuff of young del Toro's nightmares.

"We are fascinated by horror—but I find that very healthy," del Toro reflects, adding that embracing the "otherness" is the ultimate act of tolerance. "Being in love with the monstrous is about the desire to understand the Other, as opposed to destroying it. War is the ultimate act of intolerance; there are only live victims and dead victims." That unique blend of heart and horror characterizes his work, from *Blade II* (2002), *Hellboy* (2004), and *Hellboy II: The Golden Army* (2008), to the sci-fi epic *Pacific Rim* (2013) and his Gothic romance, *Crimson Peak* (2015).

But it is *The Devil's Backbone* and *Pan's Labyrinth* that are the most closely linked in theme and spirit—the writer/director himself has likened his reiteration of familiar motifs to an artist returning to paint the same tree again and again but creating each piece anew with fresh eyes. Del Toro's longtime cinematographer, Guillermo Navarro, brother of producer Bertha Navarro, says that the seeds for *Pan's Labyrinth* were indeed planted in the soil of *The Devil's Backbone*. Both explore the monstrous and the supernatural; both are told against the backdrop of the ultimate

10

ABOVE The young Guillermo del Toro (foreground) with his brother, Federico.

LEFT A clipping from del Toro's 1982 school yearbook reads: GUILLERMO DEL TORO— "Toro," "Torito," or simply "Memo." Innate actor and natural comic: the best prankster at IDEC. Cinephile at heart. Impelled his friends to visit the movie theater. Friend of teachers, in particular Daniel Varela. Will be an excellent communicator because he has so many great qualities. They say that the first story he heard in his life was Dracula.

OPPOSITE In *Pan's Labyrinth*, the Faun has an air of menace, as seen in this 2015 image by William Stout.

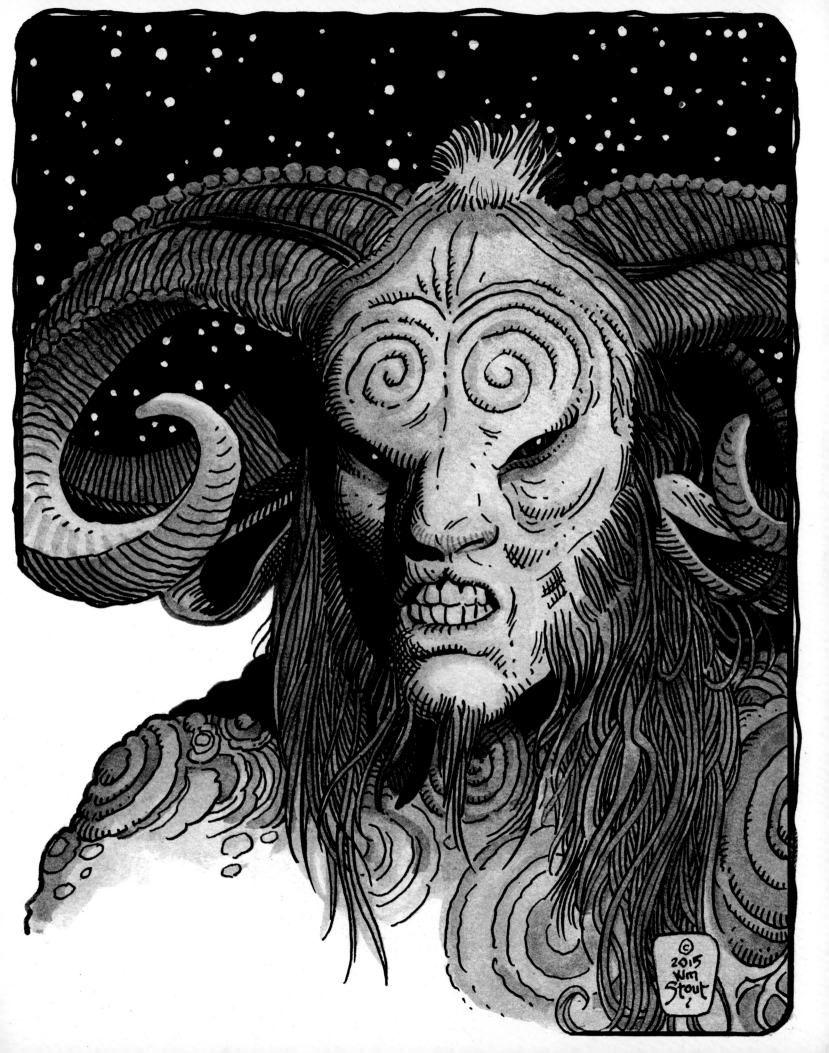

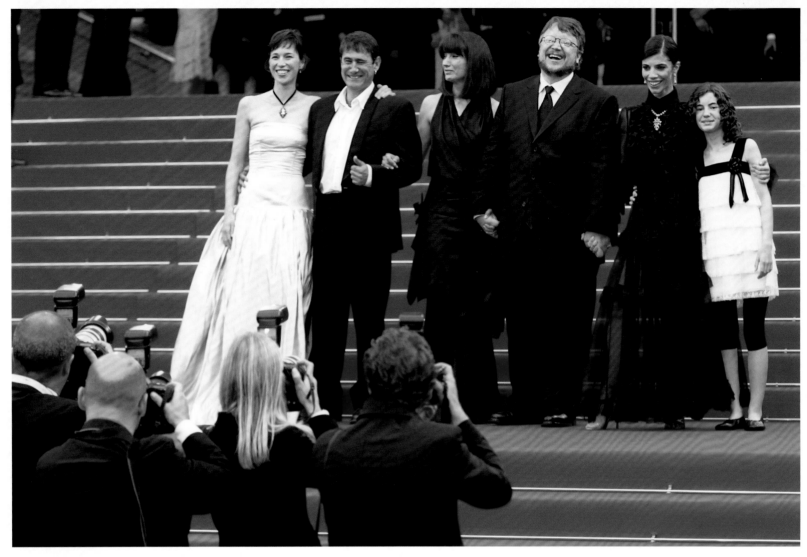

horror of war; both were shot in Spain and co-financed by Spanish investors.

The Devil's Backbone is set in 1939, the final year of the Spanish Civil War, in an orphanage on a sunburned plain far from the fighting. The institution is run by an older couple loyal to the Republican forces fighting the Fascists—and rumor has it they have a cache of gold to help finance the cause. A fixture of the grounds is the bomb that once dropped from the sky but never exploded—it marks the orphanage as a place of secrets. The legend of the gold beguiles the cruel young groundskeeper who has grown up within its walls, while a new orphan is drawn into the mystery of a phantom boy he sees in clear daylight his first day, an apparition holding the most sinister secret of all.

"Originally, my idea was just to do Devil's Backbone," del Toro explains. "But the more I learned about the Civil War, the more I found it was almost like an onion—the more layers you peel, the more you cry. It was tragedy upon tragedy. The Republican side and the Fascist side both committed enormous atrocities and both had enormous losses. It was really hard for me to articulate that only in one movie, but I felt very proud of Devil's Backbone."

When del Toro was working on Cronos, ideas for the film that became Pan's Labyrinth were already gestating and

taking form through drawings and story ideas recorded in the notebooks integral to his creative process (the film's brutal interrogation scene was imagined all the way back in 1993). Prior to its worldwide release in November of 2001, The Devil's Backbone began its theatrical release in Spain on April 20, followed by film festivals screenings that included the Telluride Film Festival on September 2. On September 11—the day that terrorist attacks on US soil led to the destruction of New York's World Trade Center—the film opened at the Toronto International Film Festival. In the immediate aftermath of the tragedy, del Toro felt compelled to continue exploring the themes begun in The Devil's Backbone, imagining the follow-up as the second part of a thematic trilogy. "When 9/11 happened, I felt a lot of emotion about innocence and war," he recalls. "Pan's Labyrinth is not an allegory of 9/11. It's just my response to my emotions."

There was symmetry to the release of Pan's Labyrinth in 2006, five years after The Devil's Backbone—the stories themselves are set five years apart. In the second film in del Toro's imagined trilogy, it is 1944 and General Francisco Franco's Fascist government is in control of neutral Spain. An innocent girl named Ofelia, who always has her nose buried in a book and a mind full

ABOVE The director and his stars command the red carpet at the premiere of Pan's Labyrinth during the 59th International Cannes Film Festival, May 27, 2006.

INSERT Early concept art by Raúl Monge for the monolith at the bottom of the pit.

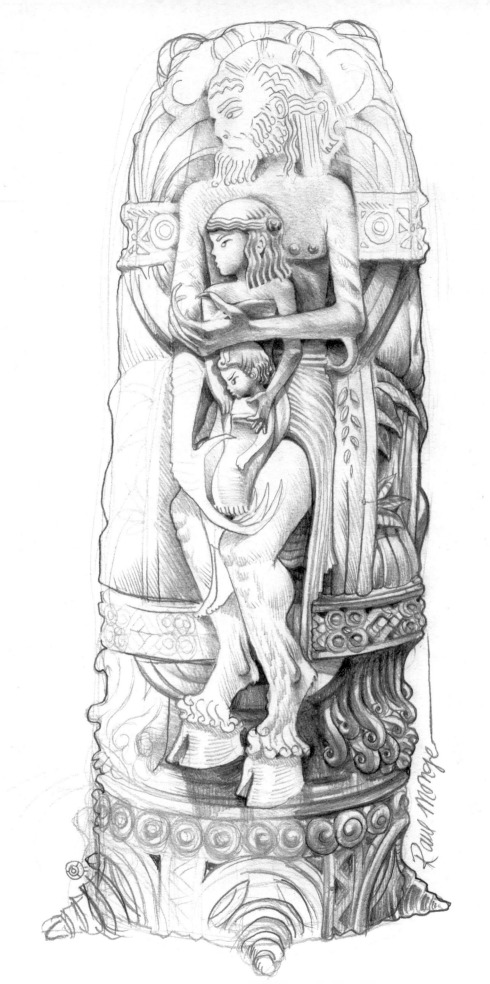

of wonder, is confronted with harsh reality at a mill in a forested region that has been commandeered in the government's ongoing war against Republican holdouts. Ofelia and her pregnant mother, Carmen, are introduced being driven in an elegant Rolls Royce to join Carmen's new husband, Captain Vidal, the officer in charge of exterminating the local guerrillas. During a stop, Ofelia wanders away and finds a curious object on the ground—the right eye of a stone figure partially concealed by forest growth. She pops it back in place and a winged stick bug crawls out of the statue's gaping mouth. On that first day at the old mill, the stick bug reappears and she follows it to an ancient labyrinth nearby. That night, the stick bug again visits Ofelia, transforms into a fairy, and leads her deep into the labyrinth. There she meets an old Faun who welcomes her as the lost Princess Moanna—the daughter of the king of the underworld! But before she can reclaim her place in the kingdom, she must prove herself. The Faun gives her the *Book of Crossroads* that will, in turn, instruct her on three tasks she must successfully complete before the full moon.

El Laberinto del Fauno, the film's original Spanish title, was pure del Toro: an unlikely blend of genres—fairy tale, horror story, and wartime period piece, with an innocent girl at its center. The film—helmed by Mexican filmmakers, co-financed with Spanish investors, and made in Spain—was a low-budget production. In fact, *Pan*'s entire budget—del Toro places it at $19 million dollars—roughly amounted to the visual effects costs alone for his previous studio film, *Hellboy*.

The film's postproduction was a whirlwind rush to make its scheduled premiere at the Cannes Film Festival 2006. What no one expected was the standing ovation at the end of the screening that went on, and on, and on. . . .

"I can tell you, officially, that the director of the Cannes Film Festival said the ovation clocked at twenty-four minutes and is perhaps the longest ovation ever at Cannes," del Toro reports. "It was, and is, the happiest day of my professional life."

"We finished just in time for Cannes; we were stressing to get it there," producer Bertha Navarro recalls. "Cannes is not easy, but the response of the audience was incredible. It was then that I knew the film would work."

Cannes began an astounding ride of international box-office success that included *Pan's Labyrinth* becoming the highest-grossing Spanish language film ever in the United States. Critical acclaim included Film of the Year accolades, and award ceremonies honoring all aspects of the film from the Goya in Spain, to the Ariel in Mexico, and the Academy Awards in Hollywood. The film's unlikely triumph was a testament to del Toro's vision and relentless drive, as well as the filmmaking culture of Mexico that made up in ingenuity and collaborative spirit what it once lacked in technical resources.

As a boy, Guillermo del Toro was always attracted to the macabre, and he found a fount of inspiration in popular culture. One of his earliest discoveries was *Famous Monsters of Filmland* magazine, published by Forrest Ackerman. At age seven, he bought his first book, an Ackerman-edited anthology, *Best Horror Stories*. Del Toro was a voracious and eclectic reader, from medical books to horror comics to literature, particularly the darker realms explored by the likes of Baudelaire, Poe, and Lovecraft. He was fascinated by art and studied painters like Goya, Manet, and Picasso, along with comic book greats such as Kirby, Wrightson, and Toth. He began drawing—special obsessions included the Creature from the Black Lagoon, Frankenstein's monster, and Lon Chaney's ghoulish Phantom of the Opera—as well as sculpting. "My brother and I would do full human figures with clay and Plasticine—liver, intestines, the heart—fill them with ketchup, and throw them from the roof," del Toro recalls. "So I was an artistic, but very morbid kid."[1]

In the 1980s, del Toro began his career with short horror films. Makeup effects are essential to that genre but were lacking in the Mexican films of del Toro's youth. "If you watched a Mexican horror movie from the fifties or sixties, it actually looks like a Universal monster movie in the thirties and forties, so they were very antiquated, most of the time," del Toro says. "But they were a big influence on me in other ways. They were not afraid of mixing genres, such as a cowboy movie with a horror movie. I probably inherited the license to do that stream-of-consciousness approach to genre from Mexican cinema, the freedom where I can mix a Civil War movie with a fairy tale, you know?"

Del Toro began creating makeup for his own movies, and his friends' films, as well. When writing the screenplay for *Cronos*, he realized his vampire protagonist required makeup that no one in Mexico, including himself, was technically sophisticated enough to make. The indomitable spirit and drive that would characterize his emerging career asserted itself—del Toro decided to organize his own makeup company, Necropia, and advance his abilities by studying under the master, Dick Smith, an Oscar-winning makeup artist of legendary proportions whose work includes *The Exorcist*, *Little Big Man*, *The Godfather*, and *Taxi Driver*. Del Toro wrote to Smith, who accepted him as a student.

"Guillermo went to New York and studied under Dick Smith," Bertha Navarro says. She pauses and smiles at the wonderful audacity of it all. "Incredible."

"It was not in a formal classroom; it was more a course of training you had to implement yourself, and that gave me a lot of discipline," del Toro recalls, noting that J. J. Abrams was one of his fellow "classmates." "To me, [Dick Smith] became a fatherly figure. I think that without Dick Smith I wouldn't be a filmmaker because

he was instrumental in making the tools available to me that I needed to create *Cronos*."

As in his films, synchronous and synergistic connections determined the course of del Toro's own story. He knew cinematographer Guillermo Navarro, who was working on *Cabeza de Vaca*—the eventual 1991 release by director Nicolás Echevarría—about the Spanish conquistador who made an epic journey across what is today the American Southwest. Navarro's sister, Bertha, was executive producer, and the cinematographer knew she was looking for a makeup artist to create the look of the indigenous peoples. He introduced her to del Toro, who was hired—his makeup on *Cabeza de Vaca* became part of his thesis work for Dick Smith.

After completing *Cabeza de Vaca*, del Toro asked Bertha Navarro if she would read his *Cronos* screenplay. "I was impressed by the quality of the writing, the story—everything," she says. "I thought, 'Wow! This guy is so young, but so mature.' I didn't expect such quality from a young guy from Guadalajara. I said to him, 'Yes! I would love to do it.'"

Guillermo Navarro also signed on as director of photography for *Cronos*, the beginning of a long collaboration that would include *Pan's Labyrinth*. *Cronos* was an auspicious beginning, a highlight being its screening at the 1993 Cannes Film Festival, where it won the Mercedes-Benz Award.

But making *Cronos* wasn't easy, Bertha Navarro recalls: "In Mexico everybody said, 'We can't do fantasy-horror or genre films.' So we had trouble getting the financing. I was told that I was crazy, this young guy nobody knows [who] wanted Federico Luppi, a great Argentinian actor, [to star] and then he wants Ron Perlman, and here you are bringing all this together—you are mad! It took me maybe a year to get the financing. Also, at this time there was this change of technology, where . . . music and sound [became digital]. We didn't have the structure yet [in Mexico], so we came to Los Angeles to do postproduction, so that was more expensive. But Guillermo did a beautiful job and it was a great film."

The drive and determination it took to finish *Cronos* was an early indicator that del Toro, and the team of collaborators he was drawing into his creative orbit, had the capacity to make the most audacious dreams come true. Del Toro was part of a breakthrough generation of Mexican filmmakers, which includes his friends and fellow directors Alejandro Gonzáles Iñárritu and Alfonso Cuarón. *Pan's Labyrinth* broke the "curse" that had prevented previous Mexican films from winning multiple Oscars by netting three of them. Less than a decade later, Iñárritu's 2014 film *Birdman* won Academy Awards for best picture, director, and original screenplay, with his Mexican director of photography, Emmanuel Lubezki, winning for cinematography. The director's follow-up, *The Revenant*, won three Oscars at the 2016 ceremony (best actor for Leonardo DiCaprio, best director for Iñárritu, and best cinematography for Lubezki) making Iñárritu

only the third director to ever be so honored two years running, while Lubezki was the first to win the cinematography category three years in a row, the first being for Alfonso Cuarón's 2013 release *Gravity*. Cuarón himself won Oscars for *Gravity* for directing and editing, the latter shared with Mark Sanger.

"With Guillermo we discuss everything we work on, absolutely everything," Cuarón explains. "Guillermo and Alejandro are the main [collaborators] at every step of my game, from the first draft of a screenplay. It is not different with any project. And when I received my Oscar I thanked Guillermo and Alejandro."

Del Toro's network of filmdom friends who mutually share works-in-progress includes director James Cameron, whose filmography includes two of the most successful movies ever, *Titanic* and *Avatar*. Cameron observes that del Toro has a personal code of honor and a strong sense of morality that allows him to look "horror and the dark things square in the eye. There's too much shifting sand underneath most people in Hollywood, and I never wanted to comport myself that way. I've always believed my word is my bond, and he and I bonded over that.

"One of the things that struck me, early on, with Guillermo was that he came out of a culture of young filmmakers in Mexico where everybody supported one another," Cameron adds. "He always said that when somebody was finishing a film it was like a baby being born. You're going through labor and everybody gathers to support, from offering advice to getting into the cutting room, and I got infected by that vision. Generally,

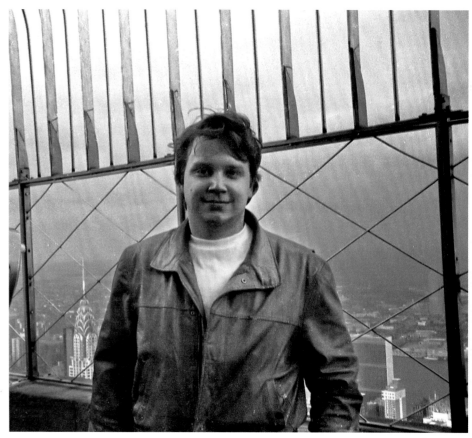

ABOVE The young Guillermo del Toro at the top of the Empire State Building, New York City, where del Toro met Oscar-winning makeup legend Dick Smith, was a pivotal stop on his journey to becoming a filmmaker.

it's like wolves in competition, but Guillermo gave me a very different perspective of this kind of supportive network among filmmakers. I have always made myself available to him when he's requested that I look at cuts and give comments. A couple of times when I've been finishing a film he's taken it as a kind of moral duty to come and camp out with me. It's pretty amazing, such a high-caliber filmmaker freely offering that."

As part of del Toro's collaborative circle, Cameron was among those with a front-row seat as *Pan's Labyrinth* emerged, first as a tale del Toro told, then as a screenplay, and on to early cuts and pre-theatrical-release screenings. "There was something about the filmmaking in *Pan's Labyrinth* that represented a maturity or confidence," Cameron reflects. "That movie just felt different to me from Guillermo's other work—it felt like something he had been building toward."

Producer Thomas Tull, founder and CEO of the production company Legendary, who was inspired to collaborate with del Toro after seeing one of those pre-release screenings of *Pan's Labyrinth*, explains that his privileged position has allowed him to peek behind the curtain at the creative process of many great filmmakers. He has pored over del Toro's famous notebooks and uses the phrase "mad genius" to describe the filmmaker himself.

"I've said to him, 'The line between insanity and genius is often very thin,'" Tull recalls. "When you look at Guillermo's notebooks, you start to connect the dots a little bit on how he thinks. It's not just little drawings or ideas. It's a peek into the logic jumps he makes, the way he plots. You realize that an idea he's developing might be as extraordinary as what he has in his head—sometimes it's even more so."

After *Cronos*, del Toro made his first Hollywood film—a breakthrough, baptism of fire, and crossroads experience rolled into one—embarked on that first filmmaking sojourn to Spain for *The Devil's Backbone*, and returned to the United States in triumph to direct two big Hollywood studio productions. All the while, the elements of *Pan's Labyrinth* were growing, coalescing, and transmuting until coming to full bloom in the summer of 2005 in Spain, when filming began at location sets and soundstage spaces.

Looking back over the ten years since the release of *Pan's Labyrinth*, Bertha Navarro recalls the mix of young talent and time-tested collaborators who somehow accomplished the most audacious filmmaking feat of all—creating a masterpiece. "*Pan's Labyrinth* was a very creative moment," Navarro reflects. "Also, it was beautiful to work again with my brother; I did all three [Spanish-language] films with him. It was like creating a team. You work together and even without talking you understand each other. *Pan's Labyrinth* was very hard to do. But, fortunately, you forget the hard times; you keep only the good part."

Ultimately, del Toro feels that making a movie is about controlling the chaos that always conspires against one's creative dreams. It might be a set that wasn't measured properly and is found to not be ready for filming; environmental conditions that conspire against the best-laid plans; an actor who must leave for a prior commitment with a key scene still to shoot. Whatever the challenge, it is up to the director to adjust and find a way to keep a production moving forward. This is true of any ambitious production, but *Pan's Labyrinth* would particularly test del Toro's ambitions and the mettle of his team.

"I want to tell you that *Pan's Labyrinth* was the worst experience of any movie I have done," says David Martí, the co-partner with Montse Ribé of Barcelona-based DDT Efectos Especiales, the special effects studio that created memorable creatures for the film, including the Faun and the sinister Pale Man. "Very good movie; very bad experience. We went bankrupt. I cried three times. I got into an argument with Guillermo, the only one in my career for the now eleven years that I've known him. If I have to do another *Pan's Labyrinth* I will *die*! I will get a heart attack or something." But DDT retains lessons learned from the creative struggles. Martí adds: "We have a saying: 'We always have the ghost of *Pan's Labyrinth* behind us.'"

The ghost of *Pan's Labyrinth* remains with the Mexican, Spanish, and American members of the production. Del Toro himself has not forgotten the struggles of making *El Laberinto del Fauno*. "I am not able to forget the problems," del Toro admits with a pained laugh. "The two hardest shoots I've had at almost every level were *Mimic* and *Pan's Labyrinth*."

Mimic, del Toro's first Hollywood movie, released in 1997, was a hardball lesson in studio politics and an early turning point. But of the two examples, *Pan's Labyrinth* remains del Toro's toughest production. He not only directed but also wrote the story and screenplay and was "down in the trenches," as he puts it, as a producer. "I was in a state of constant anxiety because almost anything that could go wrong, went wrong," del Toro recalls. "I was sleeping three hours a night and losing three pounds a week. I was dealing with very [mundane] stuff like getting immigration permits and passports for the technicians coming to Spain from Mexico, and dealing with a [tight] budget with the line producer. At the same time, I was dealing with huge creative challenges—I hired a [relatively inexperienced] production designer, I was pushing [DDT], a very small makeup effects company, to the limit, I was dealing with the overages of visual effects and how to make the movie fit the very narrow budget we had for the ambition we had. And most of the crew thought we were making a strange, silly movie. We had huge pressures."

Del Toro also had to face "the enmity" of an outside group of Spanish movie producers who were looking for any pretext for shutting it down, not to mention drought and fire conditions at the main location that resulted in restrictions imposed by the Spanish government agency charged with managing the country's forests. Throughout the adversity, del Toro relentlessly pushed his crew, as he admits: "I remained perpetually unsatisfied and hungry. No matter what we did, I wanted more."

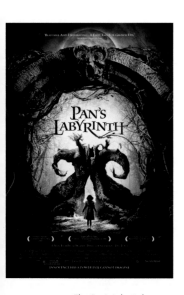

ABOVE The *Pan's Labyrinth* theatrical release poster features the fig tree that is the setting for the first test for the young heroine, Ofelia, who must prove she is the mythical lost princess of the kingdom of the underworld.

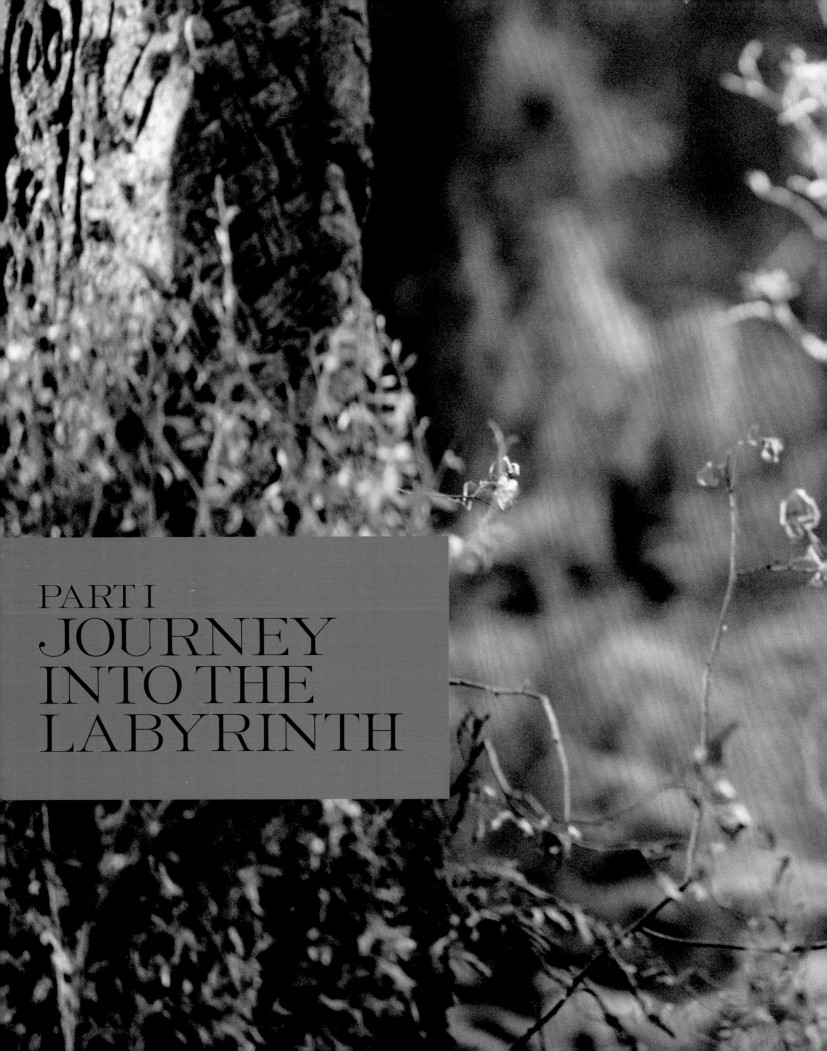

PART I
JOURNEY INTO THE LABYRINTH

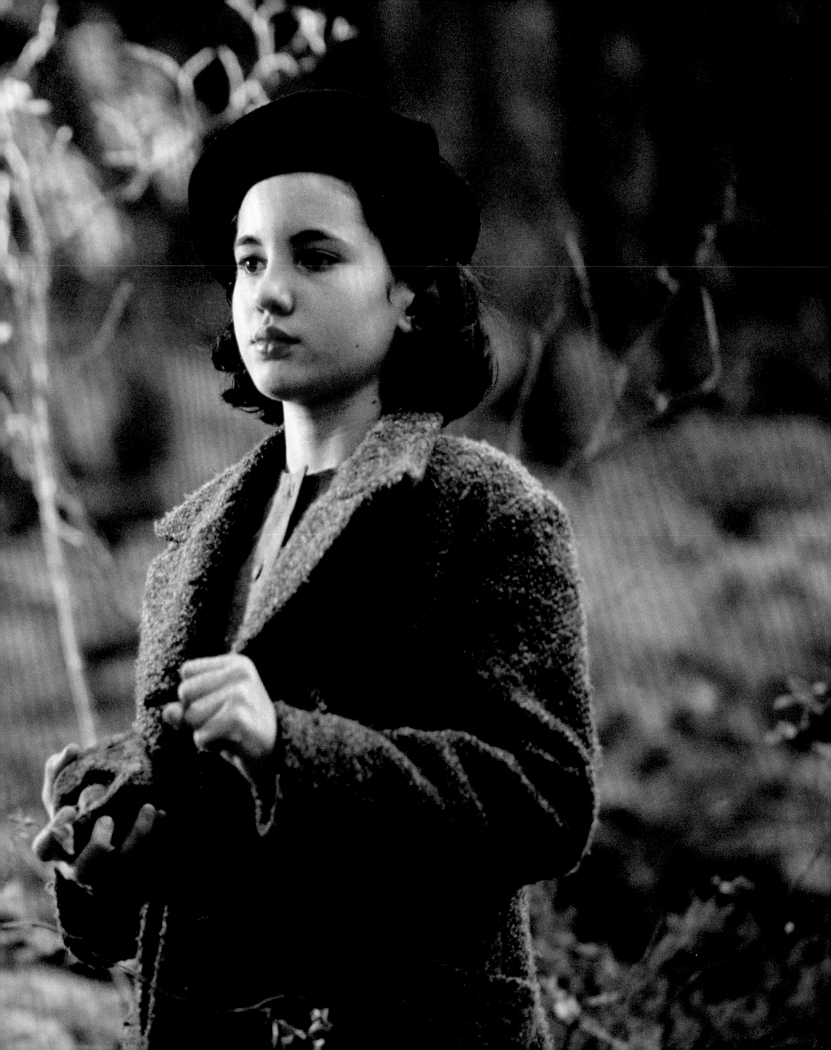

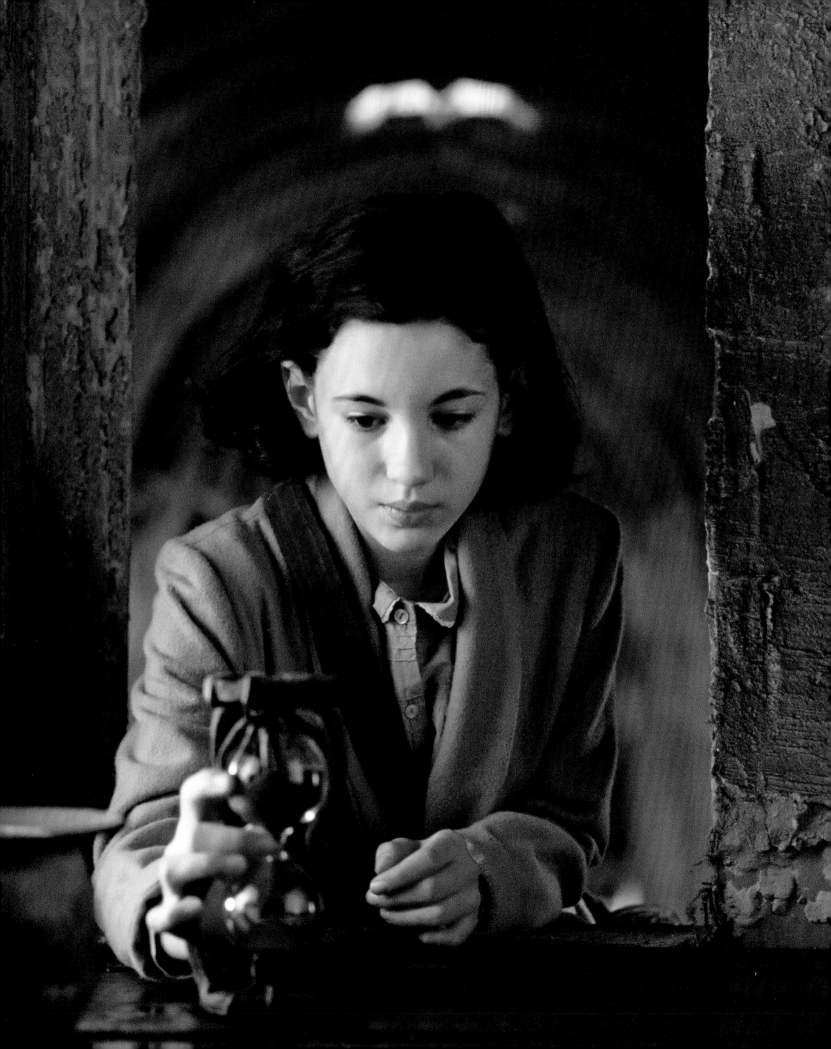

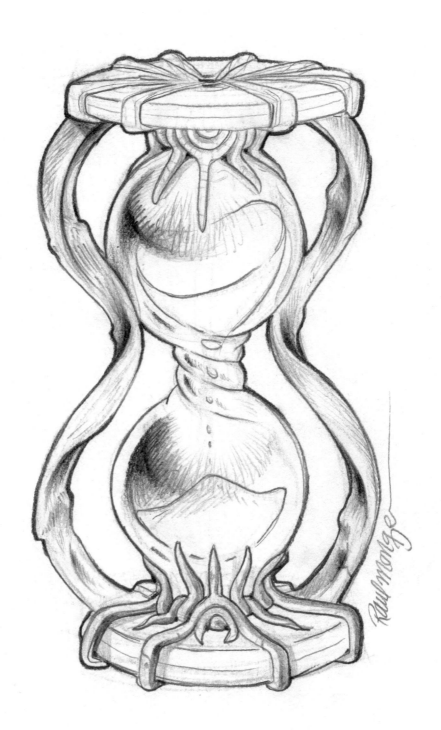

mo del Toro is not a tourist, meaning he can't turn off who he is. There's no way to fake your way through his kind of authenticity, that kind of passion. He ... *study charts that say, "This is the type of movie that will make money," or go, "Here's a niche in the market I can fill." There are plenty of people out there* ... *who are also passionate. Most people are either gifted writers, but they're not visual. Or they're very visual, but they're not storytellers. Guillermo is all of those things rolled into one, which is very, very rare. He is equipped with the skills to be able to bring that passion to life. That's what separates him.* —THOMAS TULL

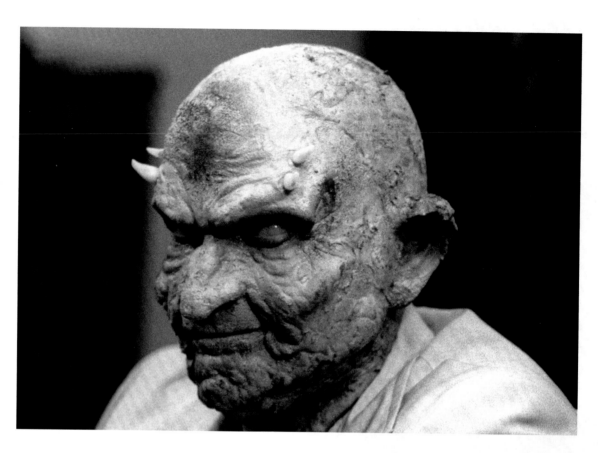

CHAPTER 1
THE PATHWAY

PREVIOUS PAGES Ofelia, played by Ivana Baquero, holds the stone eyepiece of a statue that begins her fateful journey into the labyrinth.

OPPOSITE Ofelia turns the hourglass that will measure out her allotted time in the lair of the terrifying Pale Man.

ABOVE Guillermo del Toro under prosthetic pieces (applied by Lorenza Newton) and contact lenses. He sculpted and molded this makeup in forty-eight hours for the *Hora Marcada* TV episode "De Ogros," co-written and directed by Alfonso Cuarón.

INSERT Hourglass concept art by Raúl Monge.

DIRECTOR ALFONSO CUARÓN recalls that the genesis of *Pan's Labyrinth* went back to the late 1980s and his earliest working relationship with del Toro on a Mexican TV show called *Hora Marcada*—a science fiction/horror anthology series in the vein of *The Twilight Zone*. Del Toro had written a script for an episode, "De Ogros," and brought it to his friend. "He said, 'At this stage you're better at directing than me, so why don't you develop and direct it?'" Cuarón recalls. "So, that is Guillermo's generosity. And ultimately that is what happened. And of all those shows we did back then, that is the one I remember most fondly. I can also tell you that story is the seed for what he ended up doing with *Pan's Labyrinth.*"

"It was the story of a little girl who had an abusive father and she discovers there is an ogre living in the sewers of her city and she ends up escaping into this underworld, leaving her father behind," del Toro explains. "She preferred the monster rather than the monstrosity of her father. So it's very closely related to *The Devil's Backbone* and *Pan's Labyrinth* and probably most of my work."

Del Toro says the films he made prior to *Pan's Labyrinth* prepared him, honed his skills, and gave him the experience to overcome adversity. The director's course as an artist, and his resolve to not compromise his vision for *Pan's Labyrinth*, was determined, ironically, by a production that was both a big break and his least-fulfilling professional experience. The critical success and attention for *Cronos* had won del Toro passage to Hollywood and his first big studio picture, *Mimic*, but he recalls the experience as "a losing proposition from the get-go."

The eventual 1997 release stars Mira Sorvino, fresh off her Oscar for Best Supporting Actress in *Mighty Aphrodite*, as a scientist who accidentally alters the genetic code of cockroaches, causing them to transmute into six-foot creatures that mimic the humans around them. But trouble began on the first day of shooting in Toronto—a hospital set they were shooting in looked too otherworldly for the producers. Where del Toro was going for beauty and emotional resonance, the producers, del Toro recalls, asked "Are you making an art film out of a B-movie bug picture?" It was the first of many battles, with the final film being recut with added scenes shot by another director. (In sweet vindication, del Toro released his "director's cut" of *Mimic* in 2011.)[1]

Del Toro shared his troubles making *Mimic* during a visit to James Cameron's home, giving a blow-by-blow account while they stood in the kitchen. "He told me how they fired him in the middle of shooting and had another director come in," Cameron recalls. "But the cast supported Guillermo and walked off, because who wouldn't support Guillermo? When you've worked with him you know how passionate and singular his vision is. So the cast defied [the producers] and forced them to bring him back."

Cameron adds a coda to del Toro's *Mimic* travails. At a public event, he encountered one of the *Mimic* producers. The man strode up, offered his hand, and told Cameron he should come work at a company where they "honor and support" filmmakers. "He had his hand out and I hadn't shaken it yet," Cameron recounts. "I started to reach out to shake his hand, because that's your reflex, but I held back. And I said, 'Well, if your idea of honoring and supporting the filmmaker is to fire them halfway through their film and only hire them back when the cast protests and walks out, like you did with my good friend Guillermo del Toro, then that's some shit you can keep, my friend.' And he went berserk. His face just went red and his veins bulged and he transformed into this, like, salivating mad dog. He kind of came after me, and two of his guys had to grab him and pull him back. I was ready to [defend myself]. I bare him no malice, other than the fact that he fucked over one of my friends, and that goes back to the honor thing. Ultimately, I would kind of love to see that alternate universe where I'm in jail today for having taken him out. I told Guillermo about it, and he laughed for days."

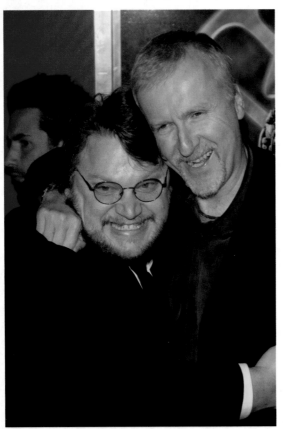

The worst of *Mimic* came when del Toro got news that his father had been kidnapped and was being held for ransom in Mexico. The problems of making a film instantly paled. Del Toro recalled his reaction to the crisis in Christlike terms—after all, he was thirty-three years old: "The perfect age to be crucified!" he told a reporter. "Having gone through that experience, I can attest, in a non-masochistic way, that pain is a great teacher."[2]

Cameron came to the rescue and provided his friend with the fees to pay a negotiator from the UK to handle the first part of the kidnapping. The del Toro family would ultimately pay the actual ransom. After some seventy-two days, the unhurt and healthy Federico del Toro was freed. Although the senior del Toro opted to stay in Mexico, his son decided to move his family—wife, Lorenza Newton, and daughter, Mariana (a second daughter, Marisa, would be born after *The Devil's Backbone* was shot)—out of his native land and to the US, settling in Austin, Texas, first, before moving to Ventura County, near Los Angeles.

A bright spot in that traumatic period was that on *Mimic* del Toro met Doug Jones for the first time. The future Faun of *Pan's Labyrinth* never planned a career playing fantastical creatures requiring elaborate makeup and costumes, but his rare physical talents seemingly made it inevitable. "When you arrive in Hollywood and you're six feet, three inches, weighing 140 pounds, with a background in mime—and my one party trick is I can put my legs behind my head—well, that makes you rather appealing to the people who make creature things," Jones explains. "I'm on the Rolodexes of all the creature shops who need a tall, skinny guy to fit [makeup or costume characters]."

Jones was on *Mimic* for three days' work performing as one of the cockroach-like creatures, but he didn't meet the director until the second day, when they sat across from each other at lunch. Del Toro gave him a contemplative stare and asked, "So, tell me everything you've been in before." Jones listed his credits, and del Toro was familiar with each one and had insightful comments, particular regarding the creature and makeup effects. "I was so taken with this man, how affable and kind he was—and what a squealing fanboy!" Jones says. "It was like the conversations I've had with fans at conventions. That's when I knew this one was different—this one was a keeper."

In 1998, a year after the release of *Mimic*, del Toro and a team of Mexican filmmakers that included Bertha Navarro formed a production company with a two-fisted name, Tequila Gang. In a *Variety* article it was reported that Tequila Gang was already a presence at the Toronto Film Festival, negotiating projects that included del Toro's *The Devil's Backbone*, a projected seven-million-dollar production to be shot in Spain.[3]

Rather than crushing del Toro's spirit, *Mimic* had clearly strengthened his resolve to fight for his creative visions and partner with like-minded artists to make sure his work would not be interfered with in the future. "What it did was convince me that from that moment on the only thing I would defend was the right to do things

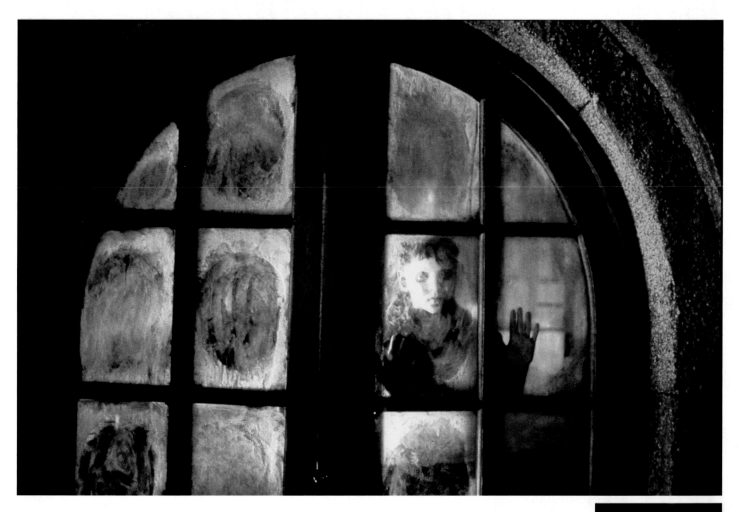

as I see them," he explains. "I have, since *Mimic*, not made a single movie where I felt I was creatively compromised. I may screw up. I am not infallible. But as I've said repeatedly, 'Success is fucking up on your own terms.' And in that regard I think I'm successful!"

It was natural that after the debacle of *Mimic* the writer/director wanted a break from the Hollywood system. James Cameron reflects, "I've gotten to know Cirque du Soleil quite well and how that culture works. They make their money chasing ideas that are so surreal, dreamlike, and whimsical that they sometimes can't be quantified on paper. So they look for the most creative people and trust and support them. That's the culture that Hollywood *should* have but doesn't. You throw a guy like Guillermo del Toro into that culture and he's bashing his head against the walls and sometimes he gets so tired and bloody that he goes off to make what he calls his 'little Spanish-language films.' The second time he did that he came back with *The Devil's Backbone*. All of his films are amazing, but that one is a jewel."

Originally, del Toro envisioned his ghost story set against the backdrop of the Mexican Revolution but later realized it would be clearer if the setting were the Spanish Civil War. "The Mexican Revolution started with an uprising, and then a coup, and was a war between factions, with constant betrayals and changes of power,"

Alfonso Cuarón explains. "There was less ambiguity with the Spanish Civil War. In Spain it was pretty much a very unified right wing fighting a very fragmented left. And both *The Devil's Backbone* and *Pan's Labyrinth* are set in the final part of the war, in which the fortune goes with Franco and the right wing. And you can see the monsters that start to come out of that, all those ghosts that Spain has been unable to hide."

The Devil's Backbone would become a kind of training ground for *Pan's Labyrinth*, providing a number of filmmaking lessons, not least of all those learned from plotting its stunning cinematography. Guillermo Navarro describes his work with del Toro on *Cronos* as "a beginning," but on *The Devil's Backbone* they established a true creative partnership—together they would develop del Toro's philosophy of storytelling without words. Del Toro talks about "visual rhymes," imagery that echoes throughout a story, and even from movie-to-movie; he distinguishes flashy eye candy visuals from what he calls "eye protein," in which visual elements—their color palette, even shapes and textures—help tell the story. With this philosophy in mind, the camerawork that del Toro and Navarro developed on *The Devil's Backbone* formed the visual language they would bring to the labyrinth.

"I think one of the things that makes it hard for actors to work on a movie set with me is that I want them to be

21

OPPOSITE Del Toro with friend and fellow filmmaker James Cameron at the Los Angeles premiere of *Hellboy* in 2004.

TOP AND ABOVE The ghost boy, Santi (Andreas Muñoz), in *The Devil's Backbone*. *Pan's Labyrinth* would be the second in a projected thematic trilogy set during the era of the Spanish Civil War.

dancing with the camera," del Toro says. "They need to move in a certain way, very precise, and the camera is going to always be moving, as I say, 'like a curious child, always looking for a better angle, like trying to look over your shoulder to see what you're doing.' Guillermo Navarro always finds a way to service those moves quickly."

"It's not that *Devil's Backbone* and *Pan's Labyrinth* are specifically connected in terms of things like color, it's not that," Navarro elaborates. "The connection, in all the work I've done with del Toro, is that the film language is a visual narrative. The way the scenes are shot and blocked, they become elaborate ballets of the camera, which is a very technically complicated thing to do."

To achieve that balletic effect, the major cinematographic tools included a Steadicam and a small crane they discovered in Spain that would become part of Navarro's arsenal in *Pan's Labyrinth* and beyond. "On *Devil's Backbone* we had this extraordinary crane operator named Carlos Miguel, a genius, who was part of the design of this crane," Navarro says. "Now they actually manufacture it, but at one point this was built in someone's garage. This little crane allowed us to move the camera in a very solid but elaborate way and only needed one person to operate it, which reduces the problems with the typical crane where more people have to be involved in the motion. Although we were all speaking Spanish on set, we used English for film terms, like 'push in.' The way Carlos pronounced it sounded like 'puchi,' so that's what we called it. The Puchi crane."

Following the September 11 attacks and del Toro's decision to continue the themes of *The Devil's Backbone* in a trilogy of films, it became clear that the next film in the sequence, *Pan's Labyrinth*, would be a mirror image of its predecessor. In both stories, an innocent child is driven to a foreboding new home (the orphanage in *The Devil's Backbone*; the mill in *Pan's Labyrinth*), the supernatural manifests itself the first day in daylight and nighttime, and reality and fantasy intertwine. There is also evolution between the two films' villains as Jacinto (played by Eduardo Noriega), the adult orphan in *Devil's Backbone*, represents a crude "proto-fascist," as del Toro calls him, while Captain Vidal is a full-fledged one.

Del Toro would make his story a conscious melding of fantasy and reality. "I thought of how some people feel that fantasy is an escape from reality, a notion that I find condescending and incredibly irritating," he says. "Fantasy is a language that allows us to explain, interpret, and reappropriate reality. It is *not* an escape and I'm very vehement about that." Although he had strong feelings about the core themes of the film, he recalls his initial writing stage as a freewheeling period in which he simply let his imagination roam: "I go through a bunch of permutations where I write crazy stuff I can't afford and then I go back to my original notes."

With fairy-tale lore as a touchstone, del Toro recalled classics stories of princesses who are frustrated by the constraints imposed upon them by their rigid fathers and each

night escape into a fairy-tale kingdom where they dance until dawn, returning exhausted and with their shoes worn out. That led to the idea of a woman who escapes her Fascist husband by entering a fairy-tale world where she meets a beautiful Faun who, it is revealed, seeks to offer her baby as a sacrifice that will make the dying plants in a labyrinth bloom again. But that idea took another turn as the Dickensian tradition of an orphaned child, an Oliver

TOP Cinematographer Guillermo Navarro. Although Navarro served as DP on del Toro's *Cronos* debut, their creative bond was truly forged on *The Devil's Backbone*.

ABOVE LEFT A *The Devil's Backbone*–themed page from del Toro's personal notebooks imagines the bomb that hits the orphanage grounds but miraculously doesn't detonate.

ABOVE The bomb hit as realized in the final film.

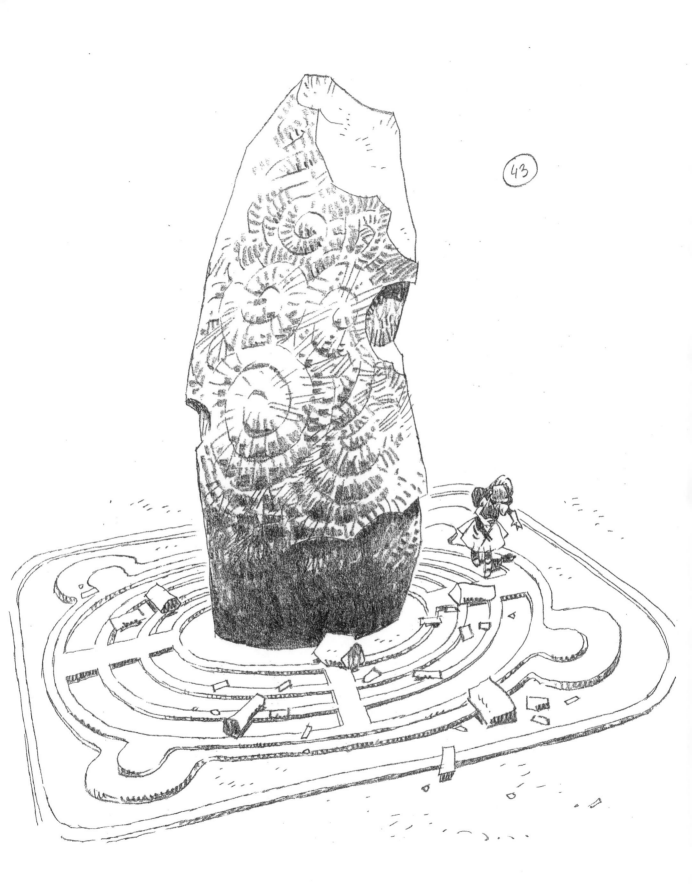

Twist or Nicholas Nickleby, tugged at del Toro's imagination. But the idea of a boy clashing with his father was not the story he wanted to tell.

"I knew from the beginning that I wanted it to be a masculine/feminine conflict, because fascism is masculine, and I very much wanted it to be about the strength of a woman against the brute force of a man," del Toro explains. "I understood, through my daughters, there would be great beauty in making it a story of this quintessential girl in the rite-of-passage moment in which she is told to grow up and behave like a lady, to stop thinking of childish things, to leave the toys and fairy tales behind. I understood the character of my daughters, who are very strong in fighting for who they are in the real world against the silliness that we give them as parents. They have a better idea of where they want to go, in many ways, than the adults around them."

Through this process, del Toro came up with the narrative structure that helped unlock the story: "One of the constant things in fairy-tale lore, no matter where—Japanese, Javanese, Chinese, Indonesian, European, American—is that the rule of threes seems engrained in the storytelling, you know? It's three bears, three brothers, three wishes, three doors, three tasks. So I decided

that I would construct the story in threes. There are the three tasks Ofelia faces, the three women who represent three possible futures [Ofelia, Carmen, and Mercedes, Vidal's housekeeper]. There are three main bad guys, the two lieutenants and the Captain. The movie is full of the rule of threes."

Even before a screenplay was finished, he had the full story in his head. As del Toro laid the groundwork for the production, he consulted with one of his valued peers. "Over lunch he told me the whole story, beginning to end," James Cameron recalls. "It was like a fairy tale, and just by the way he told it, it was clear how magical and wondrous it would be. I eventually read the script and we had a more detailed discussion."

As the second of del Toro's filmmaking forays in Spain, *Pan's Labyrinth* was again to be a communion of two cultures whose relationship was very old and very complex. "Spain has a strong influence in Mexico, definitely, but we mark the difference, you know?" says Bertha Navarro. "We are not Spanish—we are Mexican! And there is this hate/love thing. The conquest of Mexico by Spain was severe. They destroyed everything. And we did incur the racism toward the indigenous people. So that culture is lying underneath, and also within yourself."

BELOW Fairy-tale themed artwork created by Guy Davis for the *Pan's Labyrinth* DVD release.

INSERT Ofelia at the bottom of the pit by Carlos Giménez.

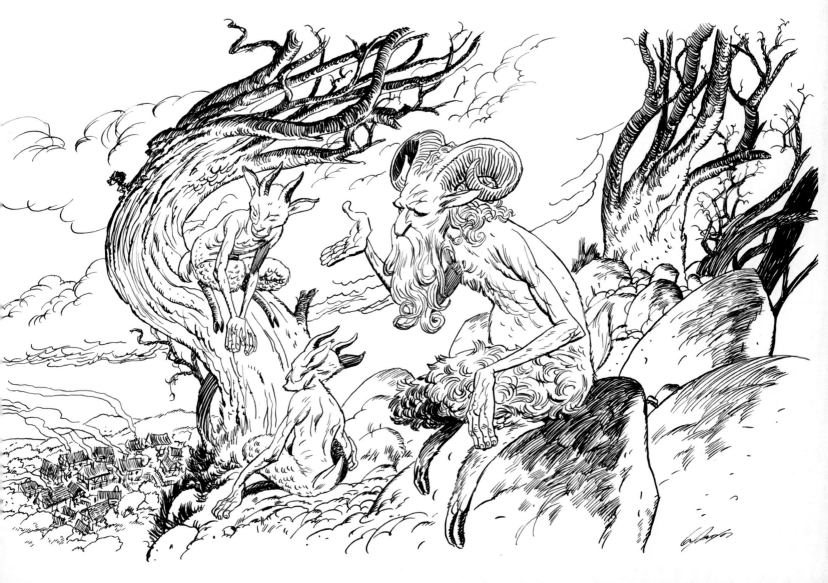

It was very clear to me from the beginning that as a producer I was going to support the ideas, the cast, and what Guillermo needed, because he knew what he needed. So [Tequila Gang] was going to support Guillermo to put together these two films, The Devil's Backbone and Pan's Labyrinth. That's why we did both as co-productions with Spain, because there were not enough financial resources in Mexico to do that level of quality for those films. —BERTHA NAVARRO

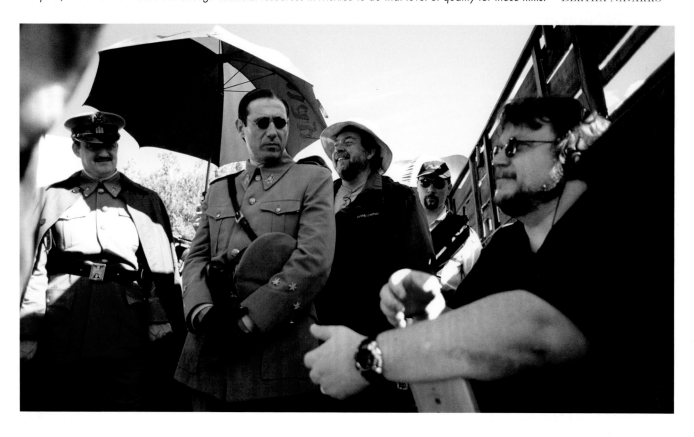

CHAPTER 2
THE SPANISH CONNECTION

TOP Del Toro's first choice for the sadistic fascist Vidal was Spanish actor Sergi López.

OPPOSITE For López, whose native region of Catalonia was persecuted under Franco, the chance to embody the brutality of the era was impossible to turn down.

THE SPANISH CIVIL WAR has been called the opening battle of World War II. It began soon after the Republican government was voted into power in February 1936, a rule that opposed the power of the Catholic Church and was supported by Socialists and Communists. That summer a rebellion against the left-wing government began in Morocco and spread to mainland Spain, with General Francisco Franco as leader of the rebel Nationalists. Nazi Germany and Fascist Italy were on Franco's side, using the conflict as a staging ground for weapons testing and battlefield stratagems, while volunteer brigades from around the world (including the United States), arrived to help the Republicans, or "Loyalists." By 1939, when Franco's forces emerged victorious, an estimated 600,000 had died in the fighting.

Historian Paul Preston notes that Franco made an "investment in terror" that continued long after the Civil War ended. "With all of Spain in [Franco's] hands at the beginning of April 1939, the war against the Republic would continue by other means, not on the battle fronts but in military courts, in the prisons, in the concentration camps, in the labour battalions and even in pursuit of the exiles."[1]

Many Republicans and their sympathizers escaped to Mexico, and many of the Mexican production principals

who worked on *Pan's Labyrinth* grew up under their profound influence. "In the end, the refugees found a good spot in Mexico, and that is also what interested me in *Pan's Labyrinth*," says production designer Eugenio Caballero. "It connected me deeply with a lot of things that I heard of, read about, and knew of since I was a kid. I grew up with the grandsons of the people who came. That generation changed a lot of things in Mexico. For example, education—I grew up and studied at a school founded by the people who came [from Spain]. I heard a lot of the stories of the grandparents and parents of a friend of mine. It was also a war of images, so there were a lot of photographs, films, and documents that we had seen since we were young that connected us with that war. It was really part of our daily life."

"That was a reconciliation with the Spanish, because they were our teachers, they were a different kind of contact with Spain," recalls Bertha Navarro. "So we in Mexico lived with, and knew a lot about, that Civil War. Maybe we knew more than the Spanish themselves, because that history was sort of silenced under Franco. The historical context in *Pan's Labyrinth* [was clear to us]—it was fascism against freedom."

For Guillermo Navarro, filming *The Devil's Backbone* and *Pan's Labyrinth* in Spain was a personal and collective voyage of discovery. "Guillermo del Toro and I had both moved from Mexico for different reasons and circumstances, and *Devil's Backbone* became an important

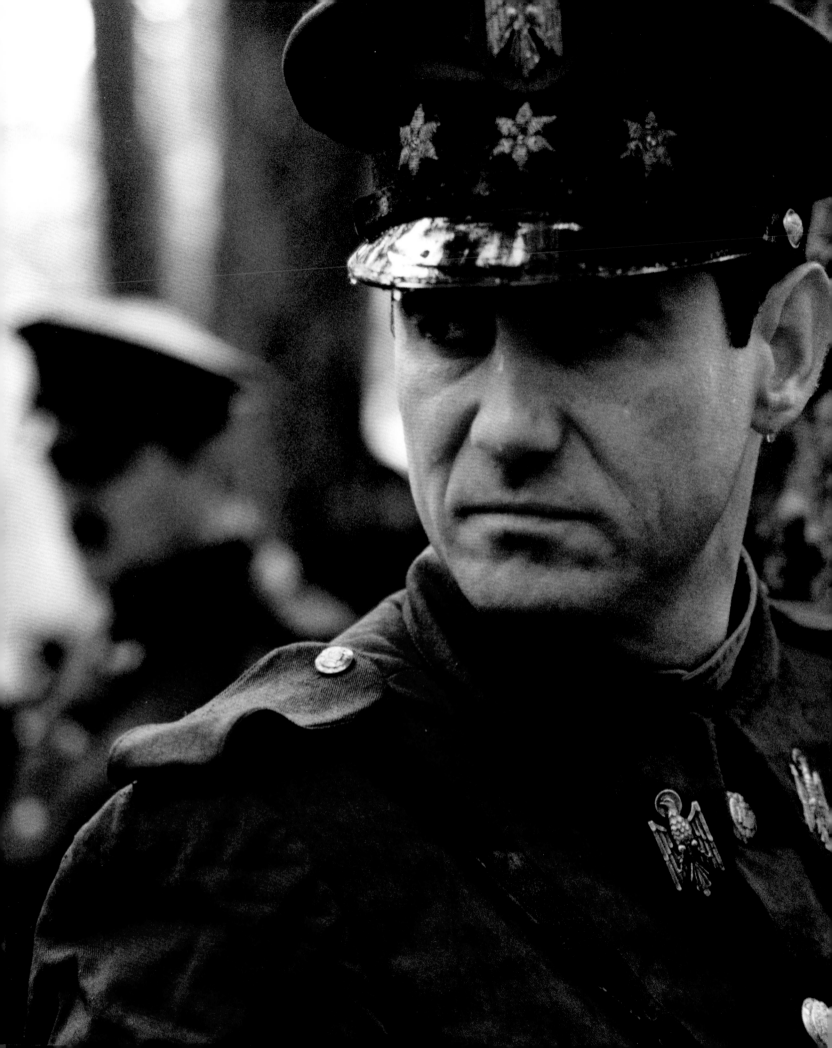

opportunity to do things in our own language," he says. "When the story was changed from the Mexican Revolution to the Spanish Civil War, it was clear we had to do more about it, like a triptych, three pieces of a theme. It was a very important political and cultural exchange when Mexico opened its doors to the Spanish exiles, so the Spanish Civil War was very important in our lives. So, finding a way of telling a story of that period of time in Spain became very, very striking and important for us to do. As the second film, *Pan's Labyrinth* is a different stage of how that [thematic idea] evolved, with the third movie yet to be done. But *Pan's Labyrinth* itself became a combination of our work and the highlight of our careers."

The Spanish members of the *Pan's Labyrinth* cast and crew had their own very personal perspectives. Actress Maribel Verdú, who plays Mercedes, Captain Vidal's housekeeper, recalls growing up under the Franco dictatorship, but hers was not "that gray Spain, that black Spain," she explains. "I had a wonderful childhood. These days, people remember it because it's our history and we lived it. But we don't live immersed in that history."

Actor Sergi López, who plays Captain Vidal, was born in a seaside village outside Barcelona, in the autonomous region of Catalonia. "When the Fascists won we were forced to endure Francoism and punishment for all who thought differently," he reflects. "Franco died in 1985, when I was ten years old, so it was very present in my infancy and my country. Catalonia was a place that received special punishment, so all of us know that history very well."

David Martí and Montse Ribé of DDT Efectos Especiales were part of the breed of Spanish filmmakers who, as with del Toro and his friends in Mexico, were breathing new life into their native film industry. "Before our generation, [Spain was] known for comedies and Civil War and post-war movies," Martí explains. "But Montse and I, and a lot of the directors we work with, were born in the seventies and we grew up with all those Steven Spielberg and George Lucas movies, like *E.T.* and the Indiana Jones films, horror movies like *The Thing* from John Carpenter, and *Superman*. When we all started to make movies everybody in this field, from directors and art directors to makeup artists, wanted to make movies like the ones we saw growing up. Little by little, everything started to change."

Ultimately, del Toro's talented collaborators on *Pan's Labyrinth* brought their own unique backgrounds—from the energy of the relatively untested makeup effects department and production designer, to the hardy veterans of del Toro's previous productions. "It was difficult, but what made it great was that dynamic of a small group of people who each assumed their role and responsibility," notes Guillermo Navarro.

With the support of Tequila Gang, del Toro began putting together the pieces. Producer Bertha Navarro had worked with production designer Eugenio Caballero on a few films, including *Cronicas* (2004), a suspense thriller set in Ecuador and directed by Sebastián Cordero, the producers of which included Alfonso Cuarón and del Toro himself. That film had required sets to be designed and built on location, which would be the production approach

26

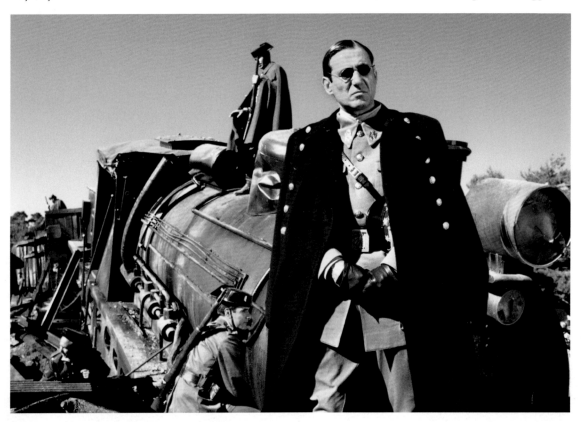

LEFT Vidal scowls at the handiwork of the rebel forces he is charged with destroying.

OPPOSITE Schematic by artist Raúl Villares of the old mill that has become the headquarters of Vidal's military operation.

INSERT A concept sketch of the sabotaged train by Raúl Villares.

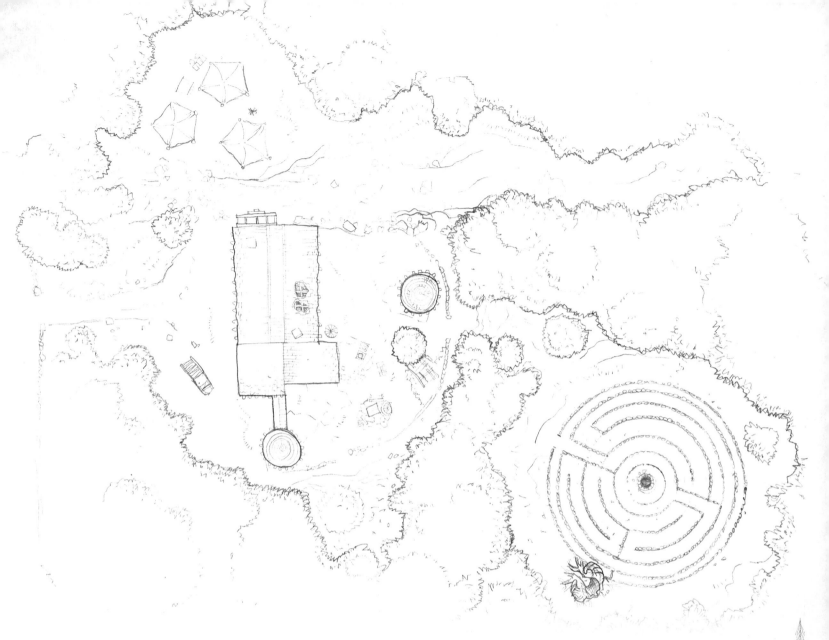

to *Pan's Labyrinth*. But del Toro, eager to apply the tools he had developed doing big studio films, had a big vision for *Pan's Labyrinth*, and Caballero was a relatively untested designer in his twenties whose previous experience was on smaller films in Mexico.

"I brought in Eugenio Caballero, who was very young," Bertha Navarro explains. "And Guillermo said, 'Do you think he will make it, Bertha?' I told him, 'He will, he will. I swear it.' I always want to give young talent a step forward, to grow."

When *Cronicas* was screened at the Cannes Film Festival, del Toro took Caballero to dinner, told him the story, and offered him the project. "Although the script was not ready yet, he had the whole story in his head," Caballero recalls. "After all these years, it still amazes me how clear he was on the story and characters, the connections and smallest details. Then he said, 'I'm going to go write the script and I'll look for you later.' I was young and it was definitely a challenge. I knew I needed to learn a lot of things before and during the process. From all the subjects Guillermo discussed, I needed to research fantasy

and that period of time in Spain. I also wanted to find out what I wanted to say as a creator. I had about five months for research, from that first conversation in Cannes to when he would come back and present the script."

"My first contact with *Pan's Labyrinth* was when we went to a restaurant I know in Barcelona and he ordered three big orange juices and he spent the next three hours telling me the story," recalls composer Javier Navarrete, who had also scored *The Devil's Backbone*. "I don't think I ever read the script of *Pan's Labyrinth*."

One of del Toro's key story meetings was over another meal, this time with Alfonso Cuarón in London. "I remember perfectly well this amazing dinner," Cuarón recalls, "amazing because Guillermo said, 'Can I tell you a story of what I'd like to do next?' And when he finished, it was so clear—the movie was already there. At that point, I was doing *Harry Potter* and I was okay economically. I was able to say, 'Okay, let's go into preproduction. Let's start financing, you and me, and see what happens.' And then we started to self-finance the preproduction of the film."[2]

Del Toro waited for the end of his children's school year and then moved his family to Madrid in the summer of 2004 to lay the foundation for the production. In the year of preproduction that followed, he would work on the screenplay, raise financing, assemble his cast, and carry out location scouting.

Del Toro recalls the production began with funding struggles. "Everybody . . . turned us down," he laments. "But I can say that Tele 5 and Wild Bunch came on board immediately."

Tele 5, a German TV station, was part of a European network of television sister stations. Wild Bunch, which would take charge of the film's worldwide sales, was a German distribution company. The production structure began to come together, with Alfonso Cuarón's company, Esperanto Filmoj, as co-producer alongside Tequila Gang, along with a complex web of distributors that included Picturehouse, a film production and distribution company founded by New Line Cinema and HBO films (both divisions of Time Warner) in 2005. The Mexican side of the production included some production funding and plans for the sound design, final sound mix, and other postproduction work to be completed in Mexico City. The film would be presented by Telecinco, a Spanish media company that ultimately put up the lion's share of the budget, making *Pan's Labyrinth* a Mexican and Spanish co-production.

"It took maybe two years to come to a good agreement with the Spanish co-producer, Telecinco," Bertha

Navarro recalls. "It was a tight budget for Guillermo. It all went to the film, the image. But Guillermo came from that discipline [of not having money]. We're not going to sit and do nothing because we don't have the money. Sometimes being poor helps. There is this drive, 'We *are* going to do it!'"

Going in, del Toro's plan was to do as much of the film as possible physically and in-camera, with computer-generated (CG or CGI) characters kept to a minimum. In particular, Doug Jones would play the Faun and Pale Man, with DDT putting the actor in costume and makeup. After meeting Jones on *Mimic*, del Toro had since cast the whip-thin actor as amphibious paranormal investigator Abe Sapien in *Hellboy* so *Pan's Labyrinth* would be their third collaboration.

Visual effects producer Ed Irastorza and supervisor Everett Burrell headed the team at CafeFX, a California visual effects studio that would handle the film's digital effects work. Looking back, Jeff Barnes, then senior executive producer at CafeFX, roughly estimates that if they had charged industry rates, their bill would have added somewhere between $800,000 to one million dollars to the budget. At the time CafeFX was launching a new production company, Sententia Entertainment, and Barnes felt "a producer credit of sorts" would make up for offering the production a reduced fee by providing the studio industry-wide publicity. Del Toro and Cuarón decided to give Sententia Entertainment an associate producer credit and agreed that the company would be "actively involved" in the co-creation of some of the

BELOW Early concept for a stone frog by William Stout that would later evolve into the more organic toad in the tree seen in the final film.

OPPOSITE TOP Actor Doug Jones in the process of being transformed into the Faun by DDT *Efectos Especiales*. The headpiece reveals some of the mechanisms that allowed remote puppeteering of facial features.

OPPOSITE MIDDLE LEFT David Martí focuses on some painstaking detail work.

OPPOSITE BOTTOM Fully transformed, Jones's Faun meets Ivana Baquero on the greenscreen set of the underworld throne room.

28

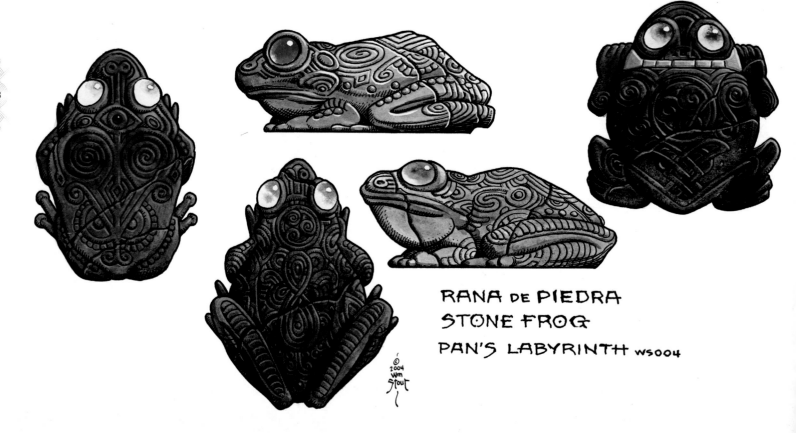

RANA DE PIEDRA
STONE FROG
PAN'S LABYRINTH WS004

© 2004 Wm Stout

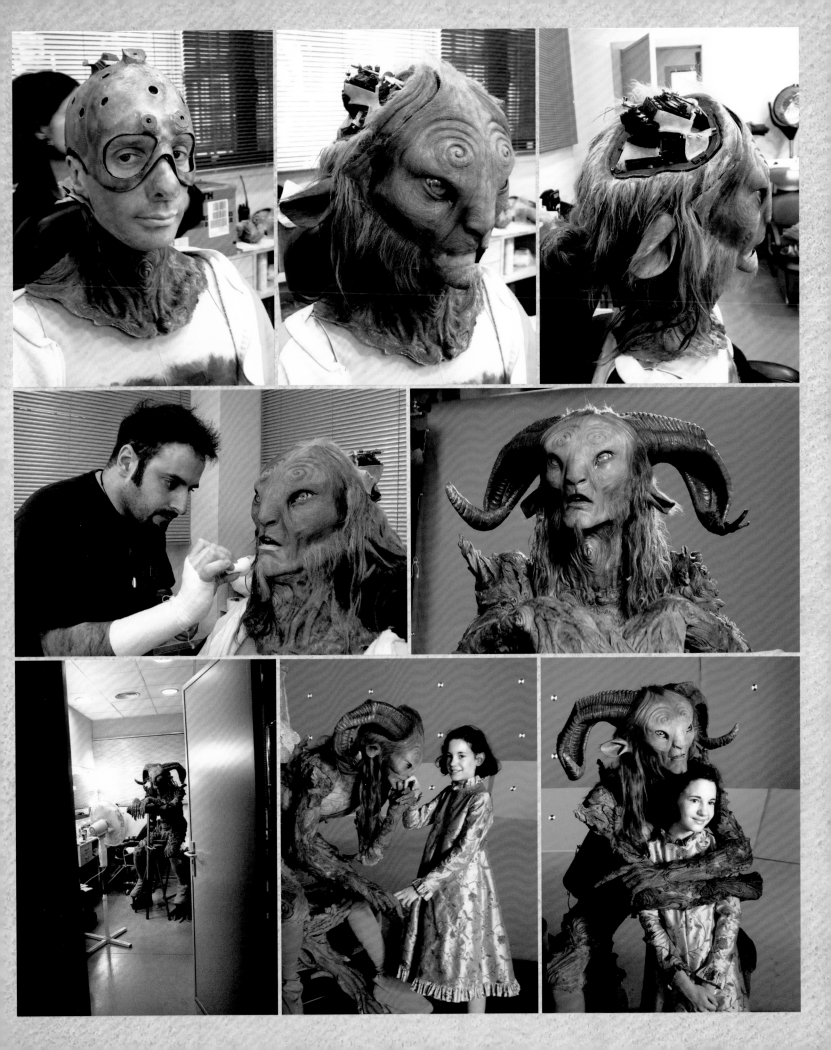

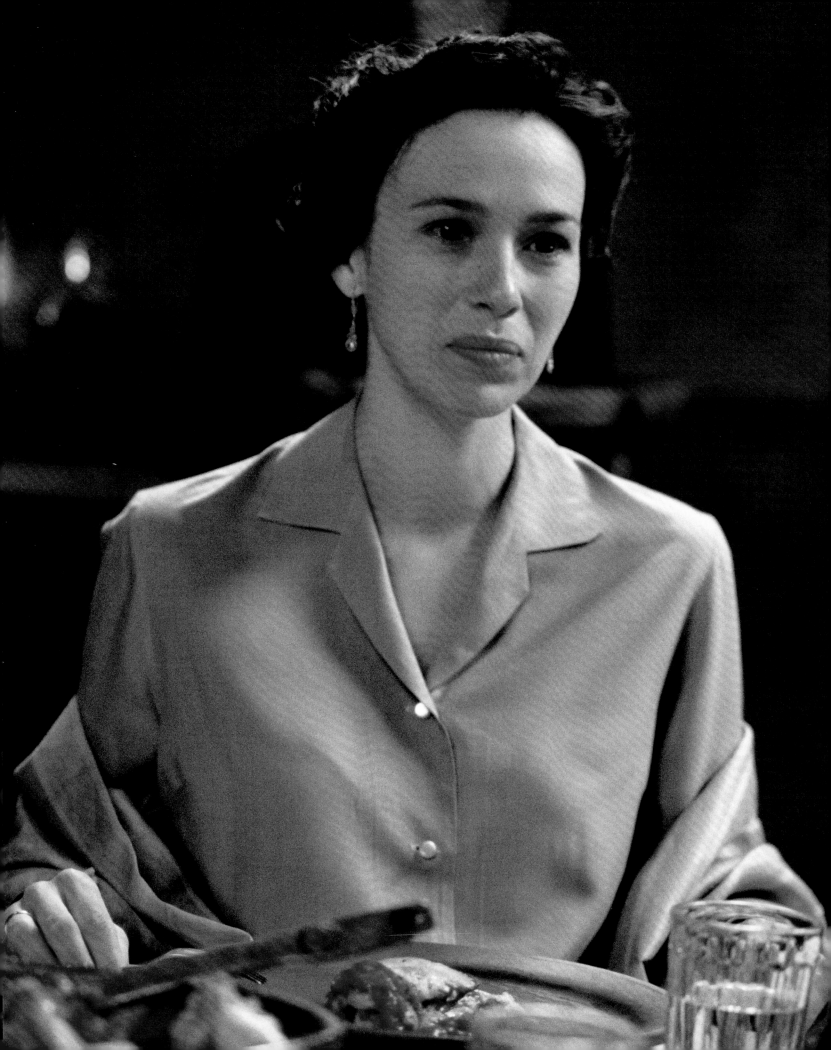

ABOVE Álex Angulo as Doctor Ferreiro, physician to Vidal's pregnant wife and secret supplier of medicine and care to the embattled rebels.

OPPOSITE AND BELOW Ariadna Gil as Carmen, whose marriage to the ruthless Vidal resembles a Faustian bargain, not the loving bond and happy future she hoped for.

film's visuals. CafeFX itself would also be credited as an associate producer.

The key to the production was casting, and straight off del Toro ran into resistance when he voiced his desire to "cast against type" for many key roles, in particular the casting of Sergi López as the evil Fascist Captain Vidal. "A famous Spanish producer told me that Sergi was 'a comedian, not even a real actor' and that I didn't know this because I was not 'from around here,'" del Toro recalls. "He warned me, 'You will fire him.'"

But del Toro had seen López as the title character in a 2000 French thriller *Harry, un ami qui vous veut du bien* (known as *With a Friend Like Harry* in English-speaking markets), and directed by Dominik Moll. "Sergi's character in the movie was a guy who seemed really likeable and, at the same time, was incredibly menacing," he recalls. "I knew that Captain Vidal needed to look and act like a gentleman, to be very polite and composed, but also very menacing. I thought those qualities were ideal and I wrote the part in *Pan's Labyrinth* for him because of that."

Del Toro met López in Barcelona and told him the tale of *El Laberinto del Fauno*. "Guillermo has a capacity for seduction—he's intelligent, charismatic, and has a tremendous talent for telling stories," the actor notes. "I said, 'Of course I'll do it.' He convinced me simply by the way he told the story. When a guy like Guillermo tells you a story you are in awe. Guillermo was sufficient reason for me to do the film—to this day he's the best coach I ever had. But also, of course, it was the character.

It was a chance, as a Catalan, to give testimony about the Spanish Civil War and about those who lost, the Republicans. It was impossible to turn it down."

López adds that del Toro did not delve into the politics, or the nature of fascism and Franco. Instead he provided layers of detail, such as a cracked watch Vidal carries that belonged to his dead father (a motif inspired by a fascist propaganda film of the Franco period).[3]

"He told me, 'I think you could embody a mythic, historic villain in the history of cinema,'" López recalls. "It was brilliant of Guillermo to create a character so monolithic. They always say a character needs different sides, but this character doesn't have *any* light. He's bad with himself, with the little girl, with everything. But he is still so full of detail. He is alive. It was like candy, a chocolate, to do this character. It's playful and fun to embody a Fascist, the evil of the film."

Casting director Sara Bilbatúa recalls the casting of López as a happy day—a key piece of the puzzle was in place. The role of Ofelia's pregnant mother went to Ariadna Gil. "Ariadna was an established actress in Spanish cinema and did a wonderful job with Carmen," Bilbatúa says. "Carmen is a very pathetic character. She's sick, suffering, always with a grimace on her face. Ariadna played her character with sincerity and lent an elegance to a very tricky role."

The casting director notes another good example of casting against type: the selection of the late Álex Angulo (tragically, he lost his life in a car accident in July 2014)

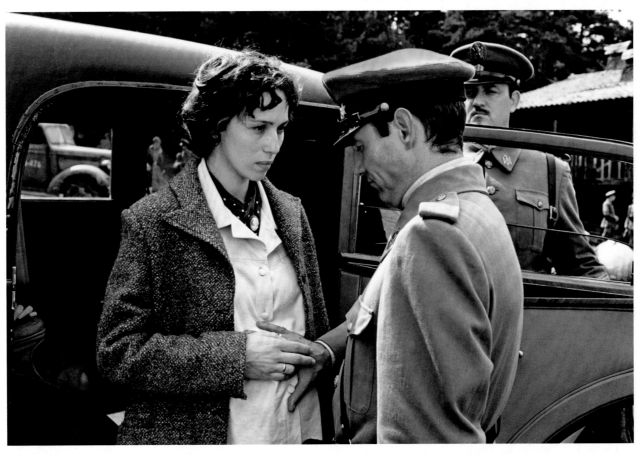

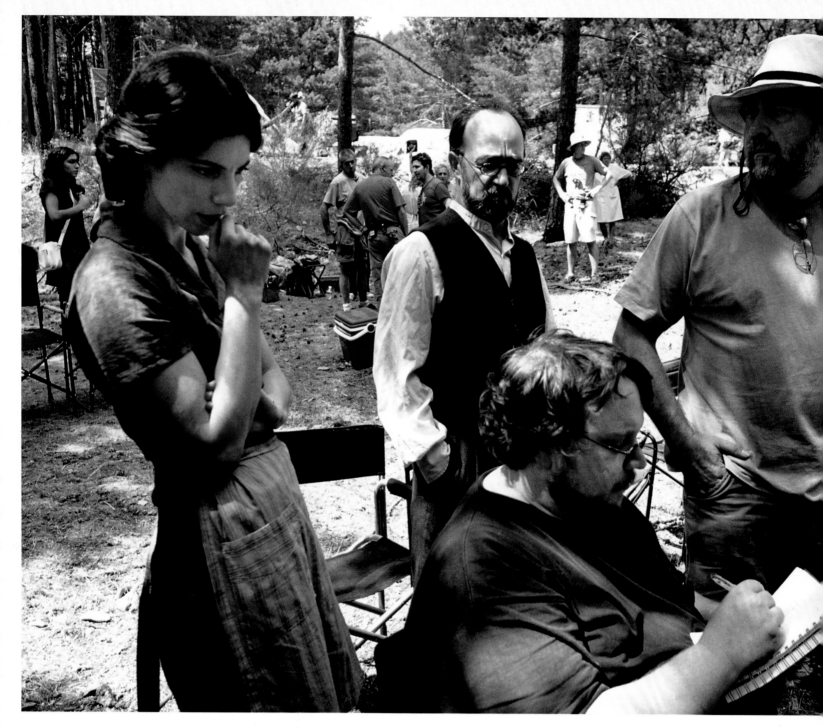

to play Doctor Ferreiro, the physician who looks after the ailing Carmen but is also secretly bringing medicine and care to the Republican freedom fighters hiding in the forest. "Álex Angulo previously played a killer priest, an evil man, in the film *El Día de la Bestia*, something that was, of course, altogether different," Bilbatúa notes. "In the Spanish Civil War, the doctors were so important, so you can imagine them as towering, commanding figures. But Guillermo didn't want that. Angulo is not very tall, but I think he played the part of the *pequeno gran hombre*—the 'little big man'—wonderfully. The doctor is a very valiant character, a kind of superman in the film. I remember being on a bus and talking to Guillermo on [my cell] phone and both of us realizing that Álex Angulo would be absolutely perfect for the role of the doctor."

Another key part to be cast was Mercedes, Captain Vidal's housekeeper, who befriends Ofelia and becomes her protector and a maternal figure. Her brother is one of the insurgents and she, too, is secretly helping the cause. Many actresses were considered for the part, including Ariadna Gil. Del Toro knew Maribel Verdú from her work in Cuarón's 2001 film, *Y Tu Mamá También*, but there was some initial reticence to cast her in the part. "For the character of Mercedes, we went in circles for a while," Bilbatúa recalls. "Maribel seemed like she would be a good fit, but we were weighing whether she was perhaps too sophisticated for the role as the Captain's servant. But she did a wonderful job and was incredibly generous in the role."

ABOVE Del Toro brainstorms an idea at the main location while Maribel Verdú, Álex Angulo, and Guillermo Navarro look on.

OPPOSITE TOP Verdú, who received international recognition in Alfonso Cuarón's 2001 film, *Y Tu Mama También*, was similarly celebrated for her role as Vidal's housekeeper, Mercedes, who secretly aids the rebels and takes Ofelia under her wing.

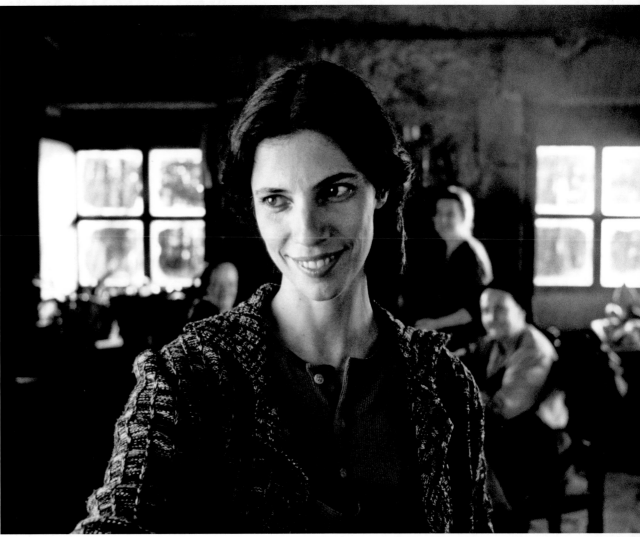

Del Toro met the actress for dinner and handed her a script. "I read it that same night and I was awake the whole night, absolutely exhilarated by what I had read," Verdú recalls. "I kept waiting for the sun to rise. When it was a decent hour, nine thirty in the morning, I called him and said, 'Guillermo, I am head over heels for this project!' I've always played strong characters and this was a gift. The character is wrapped up in the fantasy of the film and, at the end, I get to be a bit of a heroine."

Bilbatúa, who also worked with del Toro on *The Devil's Backbone*, feels her work in casting children on that film was helpful when casting the role of Ofelia. But *The Devil's Backbone* had an ensemble of boys and was anchored by veteran actors Federico Luppi and Marisa Paredes as the operators of the orphanage, with rising star Eduardo Noriega as the scheming groundskeeper. In *Pan's Labyrinth*, the key elements of the story, and a vast number of scenes, revolved around young Ofelia.

"Ofelia was our obsession in *Pan's Labyrinth*," Bilbatúa declares. "We had to search for a little girl who had an incredible imagination, was courageous, and had a great deal of self-esteem and confidence. For a director it's courageous to do a film with a child protagonist. It would have terrified me to know that I had to put my film in the hands of an eleven-year-old girl! At times, directors are seduced by this fantasy that they want someone who has never done anything, but it was important to me that this girl have some experience with a film production."

An exhaustive search began, with at least three hundred girls screen-tested, the casting director estimates. Then came the day when Bilbatúa was e-mailed a still photo of Ivana Baquero, an eleven-year-old actress from Barcelona. "When I saw her photo, I froze," she recalls. "I called her agent, who had just begun representing her. I also knew her parents. We had done screen tests with a ton of girls, but when she did her screen test, my hair stood on end. She did the sequence where she puts her ear to her mother's belly and speaks to the baby: '*Ten mucho cuidado, cuando vienes aquí, porque aquí las cosas son muy mal. No quiero que mi madre le pase nada.*' ['Be very careful when you come here, because things right now are very bad. I don't want anything to happen to my mother.'] I thought, 'My God!' Guillermo loved it, and his wife was there and she also really liked Ivana. For Guillermo it was important that everyone present be in accord, because Ofelia was the key to casting the film. Originally, Guillermo wanted someone who was younger, a street urchin. Ivana had a different aspect to her. It was undeniable that she was very smart, and I

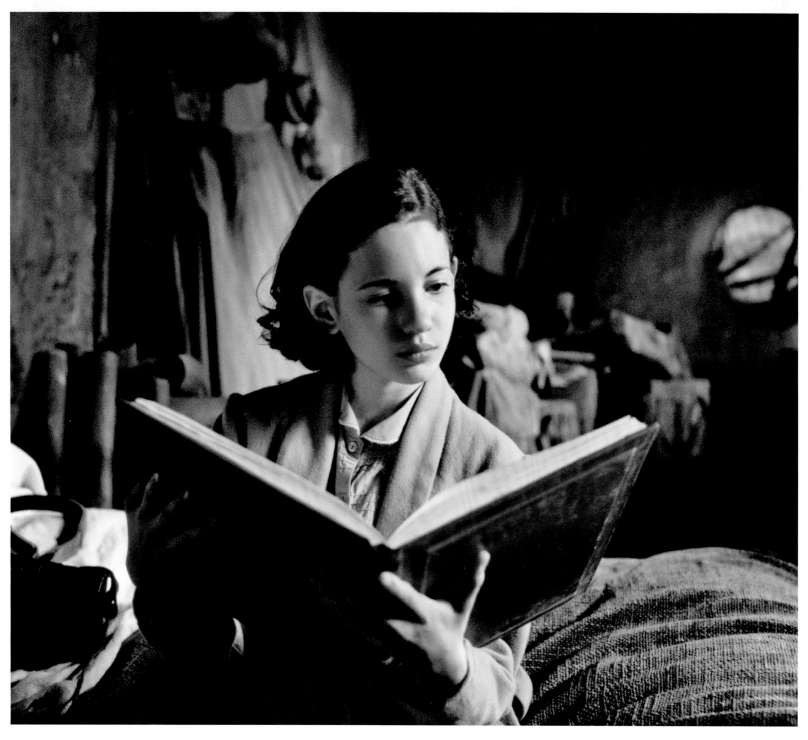

knew that was something we needed in our girl. The other girls didn't have the same grounding as Ivana."

After her first audition, Baquero got a callback to meet the director, as the actress recalls: "I fondly remember the moment when Guillermo approached me with the script of *Pan's Labyrinth* in his hands and said, 'Ivanita, this is the script of the movie. If you want the role, it's yours.' At the time I was only eleven, so my parents read the script with me. I fell in love with the story and everyone around me encouraged me to do it. Everyone saw its potential straight-away. Having been taught in an American School [a US-accredited institution allowed to operate by the

Spanish Ministry of Education], I was not too familiar with the details of the Spanish Civil War. So, as part of Ofelia's character development, I studied the background of the war. That helped me to better understand Ofelia and submerse myself in her reality and empathize with her struggle."

"There was so much art and love that went into *Pan's Labyrinth* that it was impossible that the movie would not grow and change during filming," Bilbatúa reflects. "There's always risk, of course. The risk in this film, from my perspective, was Ofelia. But once we had Ivana the film had wings."

ABOVE When Ofelia opens the *Book of Crossroads* its blank pages magically fill with the tasks she must complete to reclaim her place as princess of the underworld.

OPPOSITE Baquero poses with the mandrake prop. In the film, the Faun gives Ofelia the mandrake so she can heal her sick mother.

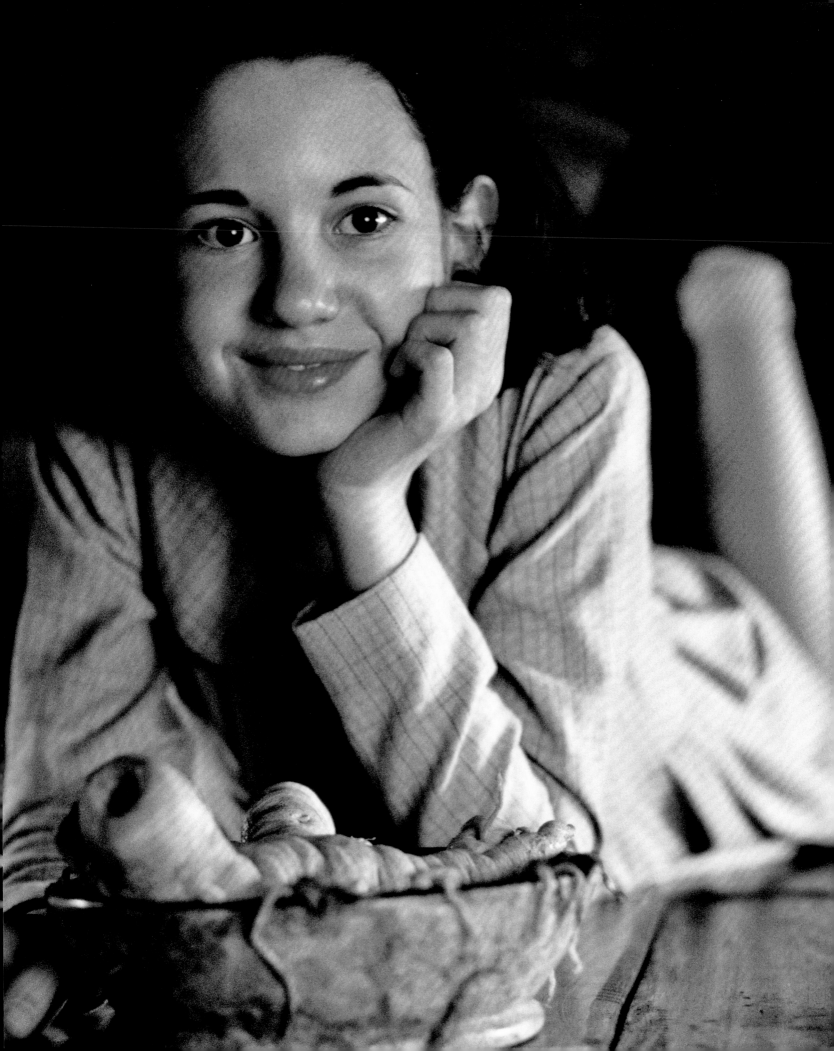

The movie takes you through a world that is completely in the mind of the girl. The biggest challenge in terms of film language was being able to walk [into the fantasy world] from the reality of a historic time within the world of the military group where the girl lives. We had to create symbols and a process to allow the girl to be the thread that puts all this together for the audience. We had to do what we called bridges, going from one world to the other. Everything had to be created; we had to build sets. We decided the movie was full of risks and we had to do it in a very risky way. —GUILLERMO NAVARRO

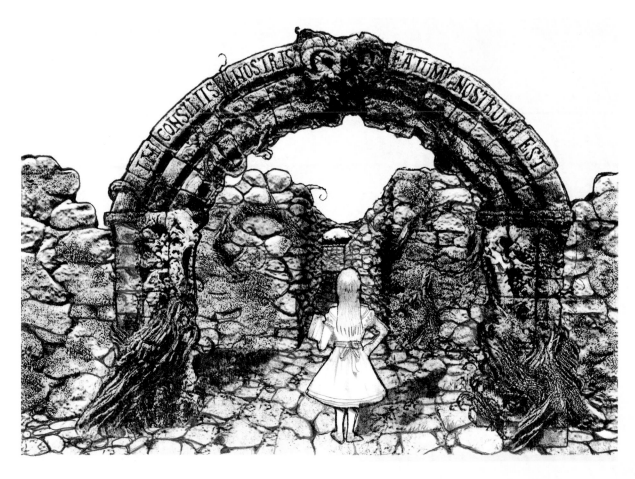

A LABYRINTH is a place and a state of mind, from patterns drawn upon cathedral floors to standing structures built by ancient cultures. With a labyrinth as the film's central image, the production design team researched the types and looks of labyrinths, from their use in Celtic culture to the trim vegetative walls of elaborate garden mazes, before deciding on an ancient place of stone.

CHAPTER 3
CONJURING WORLDS

All the sets would develop from conceptual design to final builds, and del Toro began the process by personally selecting a team of conceptual artists, starting with Carlos Giménez. "A small group of us, we started designing even before Eugenio showed up so that he would land on a sort of concept track and be surrounded and supported by a really strong crew," del Toro explains.

The art department was set up in Madrid, in a space surrounding del Toro's own office. "It was beautiful because Guillermo's office was in the middle of the art department," Eugenio Caballero recalls. "So we had a lot of access to each other."

In the five months prior to receiving the screenplay, Caballero's research had delved deep into the tale's fascistic atmosphere—along with studying the Franco era he had even visited the concentration camps at Birkenau and Auschwitz that bear witness to the Nazi's machinery of genocide. Much like del Toro pours his ideas into his famous notebooks, Caballero creates production design books and had filled his *Pan's Labyrinth* book with inspirational and reference imagery; included were period photographs of the Civil War, images of northern Spain, genocidal conflicts from the Balkans to Africa, and reproductions of the fantasy artwork of Arthur Rackham and other Victorian-era illustrators.

TOP Concept art by Raúl Monge imagines Ofelia as Lewis Carroll's Alice on the threshold of the labyrinth and its realms of wonders.

RIGHT Labyrinth arch detail, concept art by Raúl Monge.

OPPOSITE Labyrinth concept art by Raúl Villares imagines the stone steps spiraling down to the portal where Ofelia encounters the Faun.

37

ABOVE Concept art by Raúl Monge for the stele at the bottom of the labyrinth, with carved imagery of the Faun and a girl holding an infant, foreshadows Ofelia's protective role with her infant brother-to-be and her final task.

TOP LEFT Conceptual art by Raúl Monge of the monument Ofelia discovers during the drive to the mill.

MIDDLE LEFT Final construction for the stone monuments.

BOTTOM LEFT Another interpretation of the monument, this time by Carlos Giménez.

LEFT Entryway into the labyrinth, final set piece.

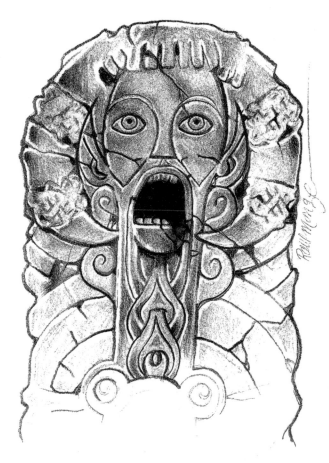

ABOVE Steps leading to the bottom of the labyrinth and the symbolic stele, concept art by Raúl Monge.

FAR RIGHT Stone monument face, concept art by Raúl Monge.

BOTTOM Sergio Sandoval's take on the monument involves a ram's head design that evokes the Faun.

BELOW On location, construction on the labyrinth steps begins.

"When Guillermo came back with the script, I presented this book to him," Caballero says. "It was, I think, the moment he felt we were aiming toward the same goal. [Doing reference books] was already my process for many films. The creative thing about making a film is the opportunity to speak in a new way. My books are a tool and a good reference, and reflect for me the feeling of the film. The [*Pan's Labyrinth*] book itself was like an antique notebook numbered with ink stamps. The documents I saw from the Franco era, when they wanted to control everything, inspired me, and that style is reflected in the book. It was a beautiful and useful tool for exploring ideas with the director or a producer, director of photography, and all the people who work with you in the art department."

In del Toro's story, the three tasks that Ofelia had to perform would take her into fantastical realms. To del Toro, it was important that there be a clear division between the worlds of reality and fantasy. There would

be "eye protein" rules separating each, but they would also be connected—Caballero recalls that was del Toro's first ground rule. "In a certain way, there was a mirror between both worlds and the question was always how to play with this idea in a cinematic and poetic way, without being too obvious," Caballero notes. "The other things we knew were that the world of fantasy had to be warmer than the real world, that there was this big contrast between them. Those were the first two ideas."

"There was a lot of discussion of the script and the input of production design, pulling together the things that would deal with the parallel realities," adds Guillermo Navarro. "In the beginning of the movie the girl discovers a little piece of the stone eye and puts it into that sculpture, the insect comes out, and she relates to it. You're already in a fairy land, in a world where anything can happen."

For set decorator Pilar Revuelta, a veteran of *The Devil's Backbone*, her process on a movie begins with the script and understanding the story "organically." From there she embarks on many meetings with the director and production designer to nail down the look of the world. "You talk about their total vision for the project, the textures and style," Revuelta explains. "With Guillermo it's easy, because he gives you a ton of information. Guillermo will have his little notebook, where he writes in red ink. At meetings he would draw elements of the story, things he already understood visually. What's funny is he would write upside down so we could see from where we were sitting.

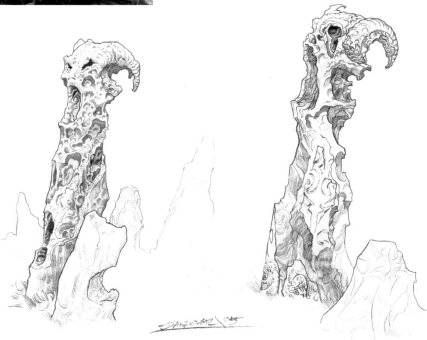

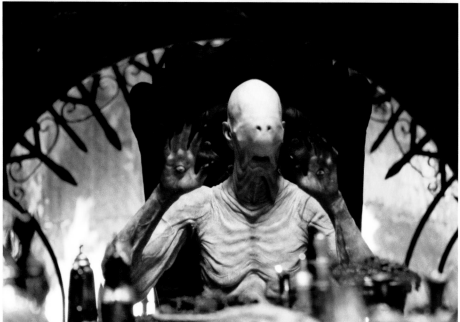

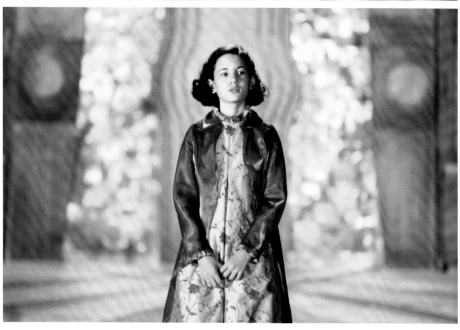

My contribution starts with photos and references that I show the production designer for things like furniture, things that will contribute to the style of the film. In *Pan's Labyrinth*, for example, we did color swatches. The film has three major journeys, so we wanted three different hues."

The first journey is Ofelia's troubled reality, the world of Vidal's garrisoned mill, so blues and other cold colors were dominant. The second journey is the fantasy realms, where warm colors rule (such as the glow from the chimney in the otherwise terrifying Pale Man's lair). The culmination is a third, and final, journey—the vision

of the underworld kingdom. "In the kingdom, reds and golds appear," Revuelta says. "These are the things we discussed early on, so that the film felt whole and that the acting, set decoration, the lighting, and wardrobe all moved in the same direction."

The design and building of sets on location and the soundstage moved forward under physical guidelines that would give sharp contrast to the worlds. The real world had to look plain but also harsh, with straight lines and angles. The fantasy world was organic and curved, with ornate and detailed environments. But the parallel worlds, in Ofelia's mind, would also affect and reflect each other.

OPPOSITE A grim Vidal (top), menacing Pale Man (middle), and a resplendent Ofelia in the underworld kingdom (bottom). Each image speaks to the film's color palette—cold hues for the real world, warm colors for fantasy realms, and glorious gold and red for the mythical kingdom.

ABOVE Concept sketch by Raúl Villares of the old mill where Vidal leads his military operations against the rebels.

LEFT A craftsman at work on the miniature set of the underworld kingdom.

"I think of the fantasy world as what happens below, because Ofelia enters by going down into the labyrinth, and she also goes down into a tree," Revuelta says. "The fantasy world is made up of circles, spheres, and I think that conveys descent. Things in the fantasy world are fragile and they'll break on you. But the fantasy world, at its core, is like a rough tracing of the world above. It's just as dangerous and full of pain. But I think the fantastic world helps this little girl understand what's happening around her in the real world. In the end, it's the other side of the same coin."

The iconography included shared elements between worlds. Keys figure prominently, for example—in the real world, a key locks away the storehouse of valuable food and medical supplies; in the fantasy world, a key is integral to two of Ofelia's tasks. There would be echoes and funhouse mirror reflections between worlds, with Captain Vidal emerging as the scariest monster of all. As the story unfolded, both worlds would begin to bleed into each other, intertwine, and meld.

The location sets featuring the mill and its attendant structures, along with the nearby labyrinth, were originally planned for northern Spain. "Forests in the north of Spain tend to be more fantasy-like, the shapes of trees a bit curved and sculptural," Caballero explains. "But we knew the forest belonged to the real world and

one of our rules for the real world was that it had straight lines and angles. So we found this beautiful location, a pine forest, near Madrid. Pine trees are extremely straight, almost like spikes or jail bars. Even though that forest was not our first instinct, I think it was one of the most interesting decisions we made in terms of locations, because the forest is like a jail for this girl."

The script, however, referred to trees heavy with green moss, which pine trees do not have. The art department's solution was to create it. And so, during filming the "moss squad" would head into the forest to dress the trees with a mixture of sawdust and pigments—"breaking nature's rules," Caballero says.

They had to break a lot of nature's rules in the forest—the location had dry and drought-like conditions. "We had the moss squad, but we also had to add a lot of ferns and plants, almost like set pieces in nature," Guillermo Navarro notes.

When they learned about the arid conditions at the forested location—the dead grass was "completely golden crisp," del Toro recalls—the production had to design a complex irrigation system in a half-square-mile radius around the mill. "We planted grass, we watered the ferns and planted new ferns, we started greening the trees with this biodegradable [moss]," he explains.

"EL LABERINTO DEL FAUNO"
CAMA HABITACIÓN NORTE ③

Two months before filming began, the dry conditions resulted in a massive forest fire in Spain's province of Guadalajara (spelled the same as del Toro's hometown in Mexico) that presented the production with an unexpected problem. "Because of this huge forest fire, the [government agency that was in charge of the forests] dictated that no explosives, fires, matches, or any ignited things could be done in their forests for at least a

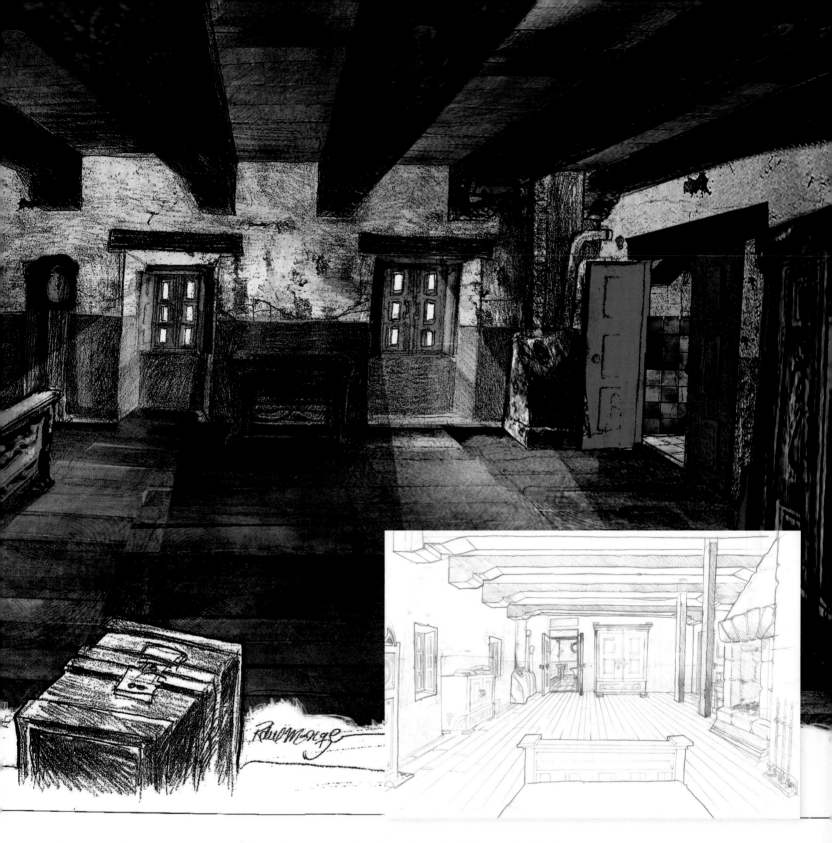

few years—and we were a war movie!" del Toro laments. "So we were unable to fire blanks for the pistols or create explosions." This meant the production had to find an ingenious solution for simulating the battles between Captain Vidal's Fascists and the Republican guerrillas.

The sets evolved from conceptual designs to final blueprints and technical specs that would allow Moya Construction, a Spanish firm, to build the final sets for filming. The mill and other major location sets had

always been planned by del Toro to be fully functioning, so that the camera could follow, without cut, the characters as they moved from indoors to outdoors. The mill and labyrinth were also planned to be close enough in proximity that Ofelia would be able to quickly and easily move between them. Fortunately, the chosen location near Madrid allowed for space between the two sets, while keeping both in sight of each other, visually aligning the portals into both worlds.

TOP The mill bedroom where Carmen and Ofelia spend their first night, conceptual art by Raúl Monge. The design conveys the austere and oppressive atmosphere of Vidal's command post.

OPPOSITE LEFT AND ABOVE Concept art for Carmen and Ofelia's bedroom and bed by Raúl Monge.

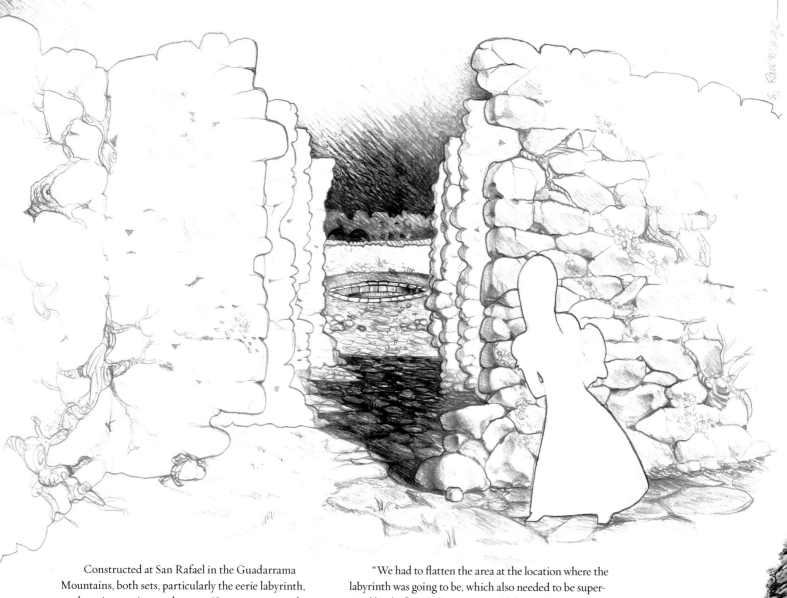

Constructed at San Rafael in the Guadarrama Mountains, both sets, particularly the eerie labyrinth, made an impression on the crew. "It was strange at the labyrinth, especially being by yourself," says CafeFX's Everett Burrell. "It was impossible to get lost because it wasn't that elaborate. But it was weird. There is one wall they didn't put up for a while so you could have easy access to it, but once they sealed it up you had to go through it to get to the center."

The labyrinth represented the threshold into the fantastical realm and a portal for Ofelia's potential return to the underworld kingdom. The location set included the old rock walls and steps circling down, with a soundstage set in Madrid continuing the steps down to the open area featuring a centerpiece sculpted stone pillar with carved rings radiating outward.

"We had to flatten the area at the location where the labyrinth was going to be, which also needed to be supervised by the [Spanish government's] forest department, because we couldn't cut any trees," del Toro adds. "As a result, there are trees coming out of the walls of the labyrinth. But I thought that was good, it gave the labyrinth a better look, and we started repeating that element in the more [soundstage] set-oriented areas of the labyrinth. And then we needed to do the core of the labyrinth, and that needed to be excavated because you needed to see Ofelia going down into the pit. The logistics of this construction were multiple and complex, so it was really challenging for the production designer, Eugenio. The good news is that Eugenio landed in the hands of Moya Construction, which in my opinion is the best set construction company in Spain and one of the best in the world. Moya was supporting but also very demanding of Eugenio. And I think Eugenio really rose to the occasion and got beautiful sets in return."

Interior soundstage spaces included Ofelia's bedroom and bathroom, the Captain's quarters, the mill's kitchen and dining room, the Pale Man's lair, and the throne room of the fairy-tale kingdom. It was a fairly short preproduction period, Caballero recalls, and a rush to build and film. "We had a lot of sets in a short period of time and a limited amount of soundstage space to build in," he says.

LEFT Labyrinth portal set under construction.

TOP Conceptual art of labyrinth entry to the portal by Raúl Monge.

OPPOSITE Artwork of the labyrinth steps leading down to the portal and stele by Raúl Monge and Raúl Villares.

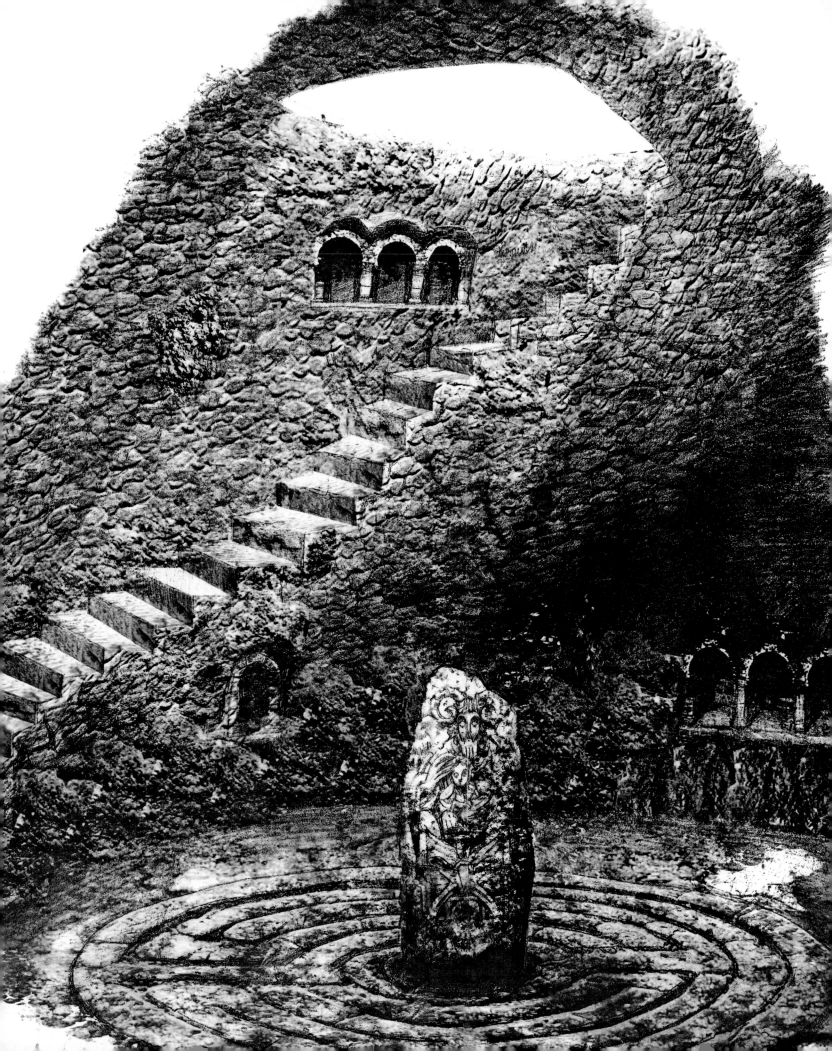

"EL LABERINTO DEL FAUNO"
DETALLE VIDAL ②

CASA, TOREO Y BODEGA

PAN'S LABYRINTH WS·001

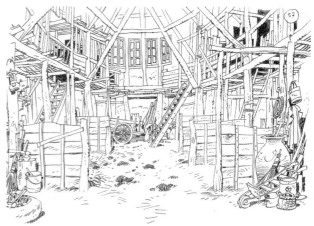

TOP AND OPPOSITE BOTTOM Vidal's quarters, conceptual art by Raúl Monge. The Captain's sanctum was designed to be utilitarian and reflect the orderly logic of military culture.

LEFT William Stout art depicting an early idea for the mill's design.

ABOVE Concept art of a barn at the mill by Raúl Monge.

INSERT A page from del Toro's notebooks featuring his early concept for the mill.

- La República ordena que Asturias sea reprimida de manera violenta e inmediata. La legión y los moros (ejércitos colonialistas) al mando de Franco lo hacen.
- En España antes de la guerra ya no nos soportábamos los unos a los otros. Eso no cambiará jamás.
- ¿Cuántas veces se sobrevive? Todas las que sean necesarias. Yo me he salvado 3 veces. Tengo dos balas en la cintura.
- De medio millón de muertos 50% fueron ajusticiados
- El llamado de un animal nocturno.
- Lo que ya no aguantamos son los piojos. Mírame.
- Les lleva algunas cartas de sus seres queridos.
- A cargo de la Guardia de asalto en Barcelona hacían redadas.
- Dormitorio de la niña en el ático. bajo un tragaluz

- En la iglesia destruida la niña se sienta como un cuervito en uno de los brazos de la cruz caída y enciende 2 linternas.
- En la guerra hay víctimas vivas y víctimas muertas
- Lodo, LODO por todas partes, como textura, como color, los zapatos siempre sucios molestan a

"We simply had no money, so we needed to maximize the stages and be smart about it because sometimes the sets changed over very quickly," del Toro adds.

CafeFX digitally extended a number of key sets, with greenscreen incorporated into the practical labyrinth core to provide the illusion of a stairway circling to the bottom portal, while the underworld throne room was realized with a few set pieces (notably the floor and the base of three thrones) on a largely greenscreen stage. Otherwise, *Pan's Labyrinth* was mainly a built and tactile world, both in terms of its real and fantasy realms. "The big stone house and labyrinth, among other locations, were built from scratch, so shooting in them made it definitely easier to understand the mood and slip into its world," Ivana Baquero says. "The level of accuracy and detail on all the sets made it great to work in them. The sets, creatures, and every single element were carefully crafted works of art!"

"You would arrive to the set and be entranced," says Sergi López. "Everything was there to help you. Say you're playing Vidal and all you have to do is shave. But you see the set and everything is in your favor—you're not alone. I come from the theater, where there can be empty spaces and you have to imagine. But it was easy to draw inspiration from the places Guillermo put us. They gave the impression you were a character in a dream."

The production design and sets were created in tandem with the costume department headed by the

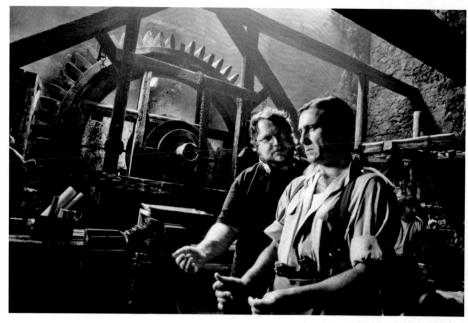

ABOVE Del Toro and López discuss a shot on the set of Vidal's private quarters.

award-winning Spanish costume designer Lala Huete. Del Toro hails her as "one of the unsung heroes of the movie," not only because of the incredibly detailed period wardrobe Huete's department created, but the circumstances under which she worked. "She had a huge loss in her family and she never, ever brought it up as a pretext to not deliver," del Toro says.

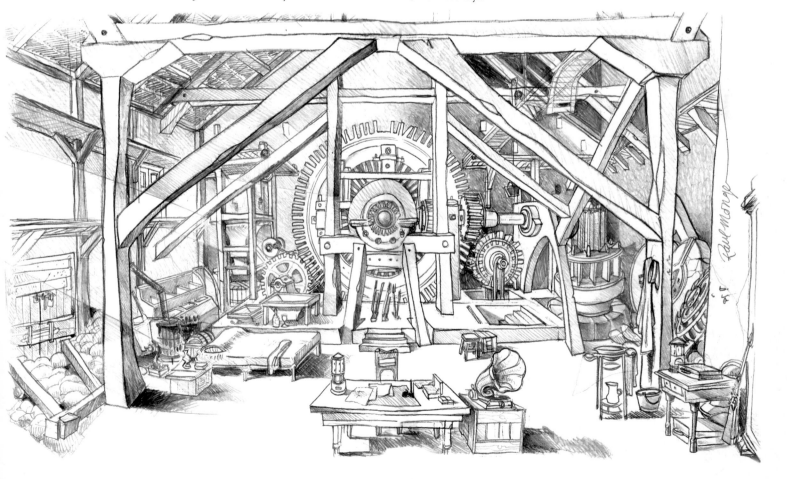

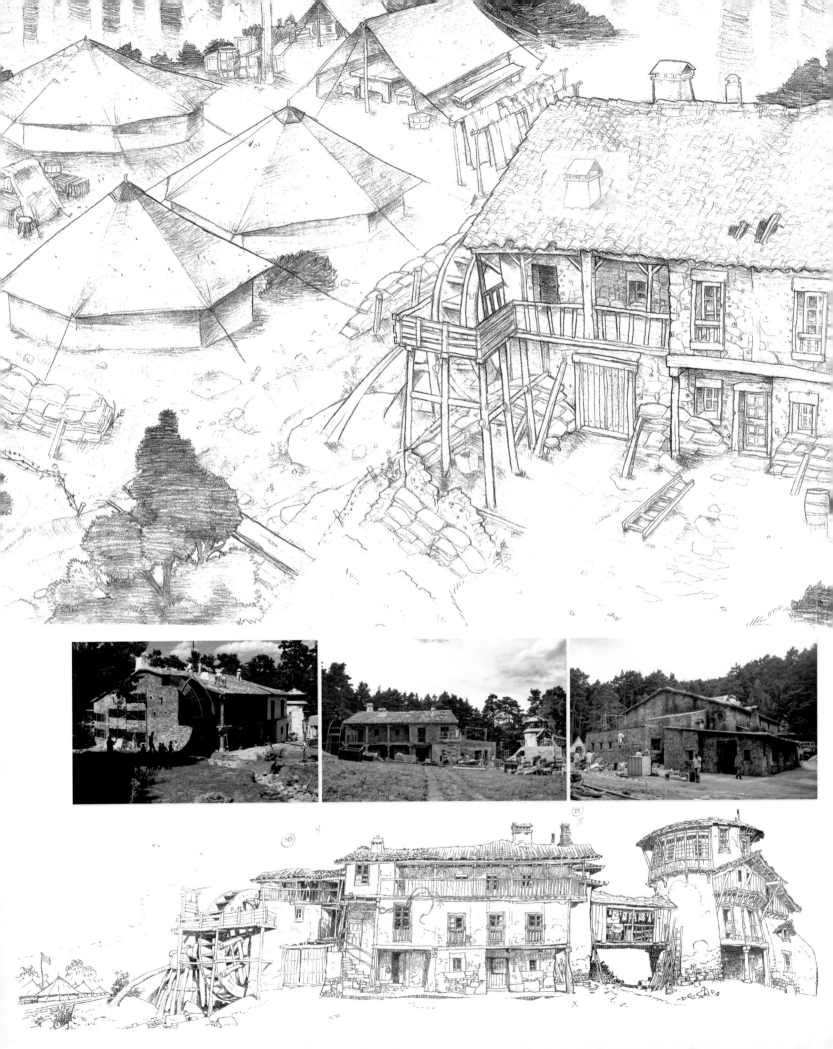

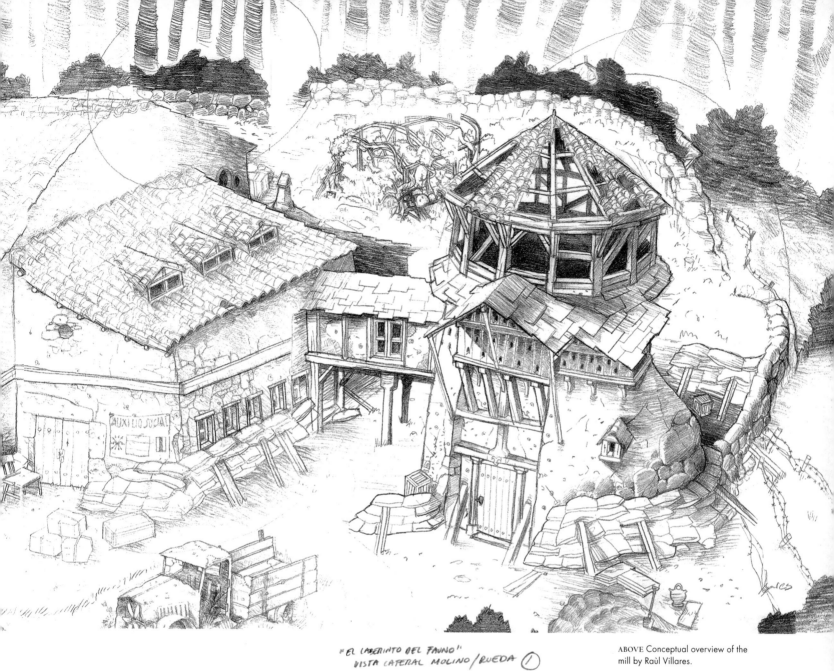

"EL LABERINTO DEL FAUNO"
VISTA LATERAL MOLINO/RUEDA ①

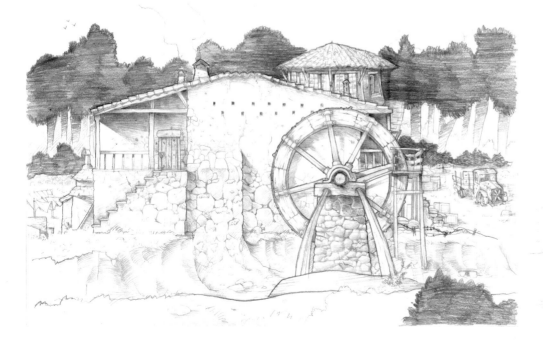

ABOVE Conceptual overview of the mill by Raùl Villares.

BELOW AND OPPOSITE BOTTOM Mill concept art by Carlos Giménez.

OPPOSITE MIDDLE Mill set under construction.

LEFT Mill concept art with water wheel by Raùl Villares.

Lala Huete and her department meticulously fabricated and tailored virtually all the period costumes. In del Toro's production philosophy, "If you have bad wardrobe, you have a bad movie; if you have bad production design, you have bad wardrobe. For me, wardrobe and production design are a single department."

The costume design subtly blended into the world of the film, right down to the color of the early Franco-era military police uniforms. "Their uniform is historically accurate except it is not the correct color of blue—Lala and I very carefully varied the shade of blue in the pantone scale until we found one that was in harmony with the color palette of the movie," del Toro explains. (In addition to the military police, Vidal's forces included the civil guards, who wore green uniforms.)

Some of the costumes evoked the story's fairy-tale roots—a green-and-white dress that Ofelia wears on her first task evokes the dress shown in the classic illustrations of *Alice's Adventures in Wonderland*, while in a magical final scene Ofelia is wearing red shoes that recall the ruby slippers Dorothy wore in Oz. A green nightgown that Ofelia wears when she enters the lair of the sinister Pale Man was an "iconic piece of wardrobe" for the director.

"I wanted the wardrobe to tell you things about the characters," del Toro adds. "The shiny shoes that Ofelia's mother buys her are precious little things that tell you how the mother views the child. The Captain had to have incredibly tight boots and gloves, sort of like he is being held together, and Lala tailored that uniform to perfection. Mercedes has this beautiful woolen shawl on her shoulders that is period accurate but also gives the motherly warmth she feels toward Ofelia, whereas the mother is kept in colder tones—one of the tricks was I wanted Mercedes to look more like the mother of Ofelia than Carmen does, and the wardrobe supports that."

Before filming, there were the usual rehearsals and personal preparations for the actors. As leader of the military forces, López was coached on thinking and acting like a soldier, from how to ride a horse to making a

BELOW Vidal and his command and household staff await the arrival of the captain's pregnant wife, their costumes meticulously designed by Lala Huete.

TOP LEFT For innocent Ofelia, the harsh reality of her stepfather's mill is its own living nightmare.

OPPOSITE Ofelia, wearing her "Alice"-style dress, prepares to face her first fantastical task.

52

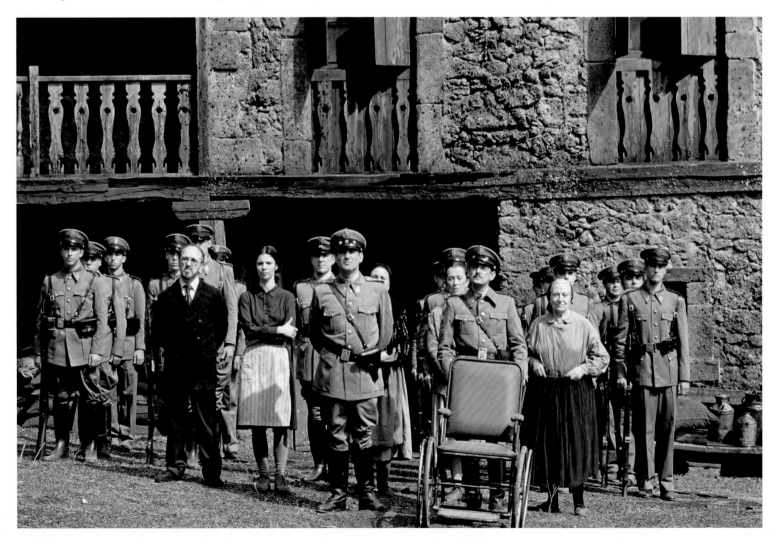

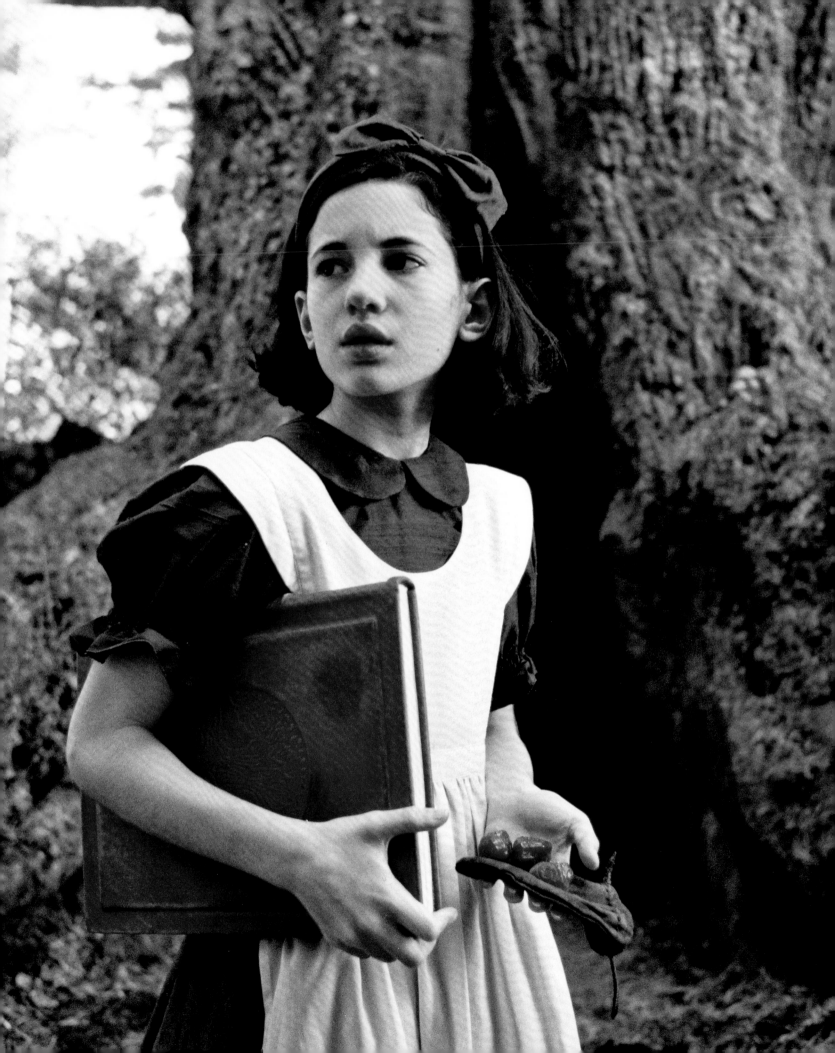

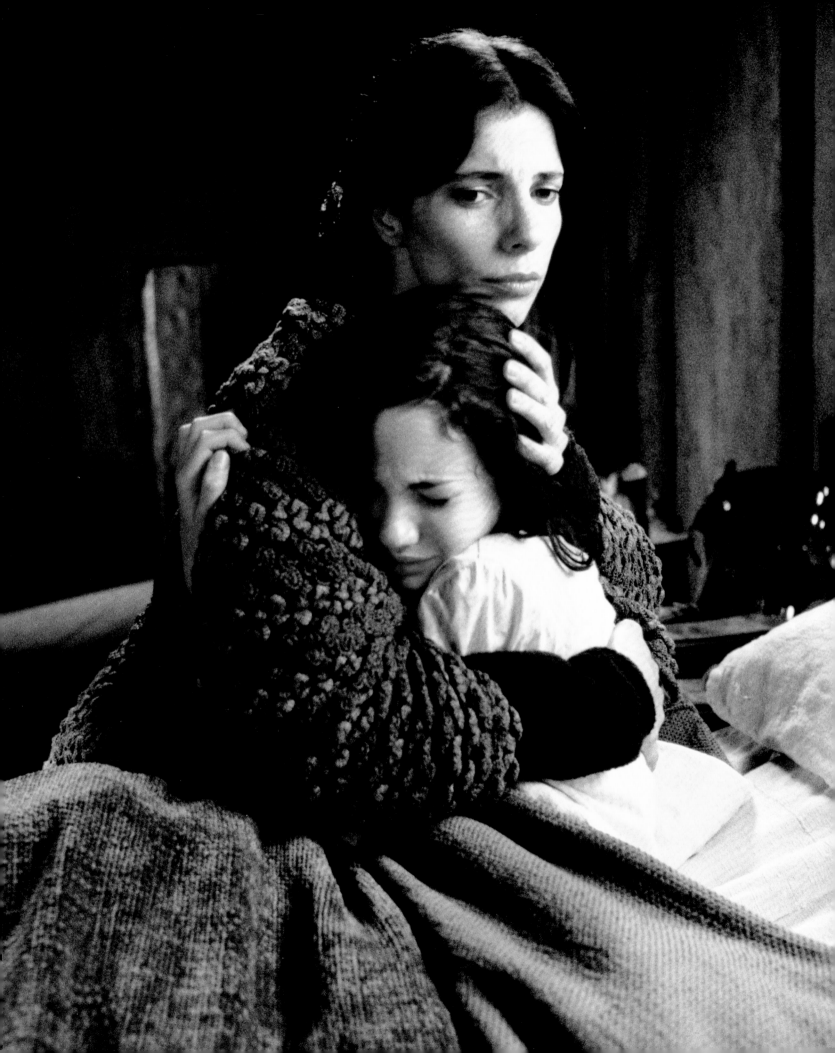

proper military salute (not too high, not too low, "right at the button on the hat," the actor notes). López's character would be self-absorbed and self-conscious about his appearance; always well groomed and impeccably turned out in uniform.

"We rehearsed off-camera quite a lot with Guillermo, as he wanted to make sure everything worked and made sense," Baquero adds. "He was very meticulous and specific in every scene with what he needed and wanted us to do, so rehearsals were vital in the process. And working with such first-class cast members was a very positive experience for me. They were all extremely sweet and generous with me. Even after all these years, I still keep in touch with a couple of them."

Del Toro had specific insights as to how each actor could bring their respective characters to life. For Mercedes, he wanted Maribel Verdú to keep her character's physical motions to a minimum, to not gesticulate with her hands. "I don't move my hands unless, of course, I'm cooking, or I need to kill Sergi," she says with a laugh, referencing their character's dramatic confrontation later in the story. "Otherwise my hands are at my waist. Everything Guillermo asked of us was concrete. For example, Mercedes always stands very straight and when she talks to you, she doesn't lean in. Everybody does that—when you talk to someone you lean in, to give them importance. But she refuses to bend."

Before filming, del Toro had a special assignment for film composer Javier Navarrete involving Verdú's character. Although traditionally composers write and record music in concert with the imagery of the final film, del Toro wanted a lullaby for Mercedes to hum to Ofelia during a key scene in the shoot. "And, quite naturally, most of the score came from that song, that lullaby," Navarrete notes. "This melody became the main theme of the movie."

"The only easy time I ever had on *Pan's Labyrinth* was with the music; it was one of the easiest scores I ever had," del Toro recalls. "When we found the lullaby I found the movie's heart. I had the lullaby with me on my Walkman or iPod and I would listen to it during the shoot and be moved to tears. I would truly be charged! It was sort of an amulet that kept me going."

Navarrete, who had first worked with del Toro on *The Devil's Backbone*, felt there was a huge contrast in their working relationship on this new film, a spirit of confidence in themselves and each other. "I quite liked the first movie, but it was more, 'Let's see what happens,'" he muses. "His briefing for *Pan's Labyrinth* was very clear. He wanted a melodic score that everybody could understand. He said, 'Don't write for your friends. Write for the taxi driver, the man of the street, for everyone. And please make a melodic score.' He was very clear about this."

The composer characterized the music for the Faun as not melodic but atmospheric, with "harmonic progressions" linked to that mystical character. "Captain Vidal doesn't have a melody, although there's like a military

drum, little touches here and there to illustrate the action," Navarrete explains. "But the girl has a melody, a theme, as do the guerrillas in the forest who represent a kind of light in a dark story. They represent hope in the real-life world."

The Faun himself (often called "Pan" by the production, although it is not the Pan of mythology), was one of DDT's major challenges. But as with DDT's other work on the film, including a giant toad residing in a dead fig tree and the child-eating Pale Man, del Toro wanted his special effects department to avoid the typical movie monster look. "Let's put it this way, if an American company did Pan or the Pale Man they wouldn't look like superheroes, but they would be more beautiful than they are in the movie," David Martí muses. "Pan would have more muscles, that kind of thing. It's a more European look for the monsters. They couldn't look slimy and disgusting, but they had to be iconic and scary."

Martí recalls the first Faun design they saw was a "cute" image of a fat old goat man by legendary American artist William Stout. Another early idea imagined the Faun as a much younger character. The next version of the script described an adult with goat legs, and conceptual artist Sergio Sandoval provided several illustrations

(continued on page 58)

ABOVE AND OPPOSITE Del Toro drew a stark contrast between the maternal influences on Ofelia: Carmen wants her child to abandon fairytale dreams and grow up; Mercedes is protective and provides unconditional love.

55

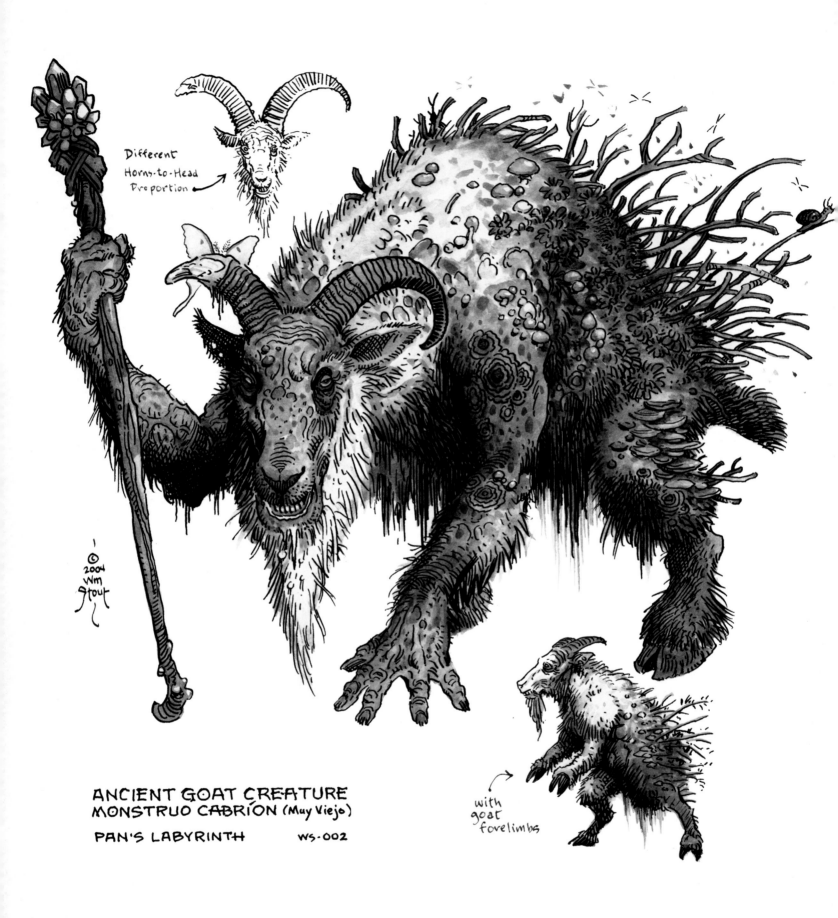

Different
Horns-to-Head
Proportion

© 2004 Wm Stout

with
goat
forelimbs

**ANCIENT GOAT CREATURE
MONSTRUO CABRION (Muy Viejo)**

PAN'S LABYRINTH WS-002

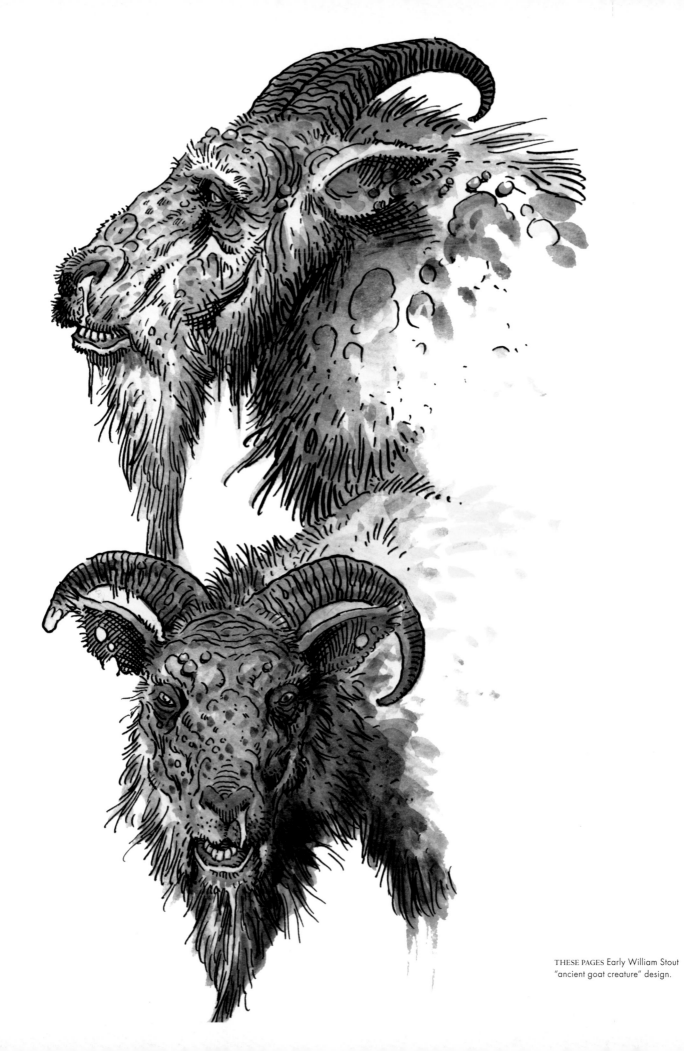

THESE PAGES Early William Stout
"ancient goat creature" design.

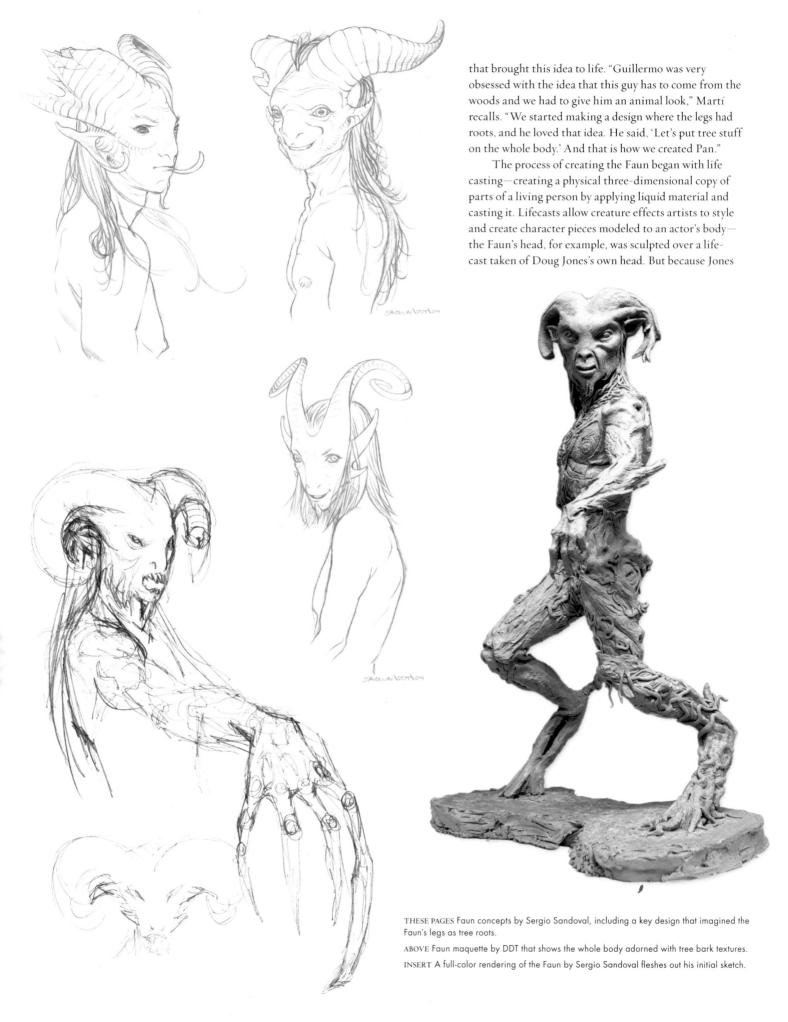

that brought this idea to life. "Guillermo was very obsessed with the idea that this guy has to come from the woods and we had to give him an animal look," Martí recalls. "We started making a design where the legs had roots, and he loved that idea. He said, 'Let's put tree stuff on the whole body.' And that is how we created Pan."

The process of creating the Faun began with life casting—creating a physical three-dimensional copy of parts of a living person by applying liquid material and casting it. Lifecasts allow creature effects artists to style and create character pieces modeled to an actor's body—the Faun's head, for example, was sculpted over a life-cast taken of Doug Jones's own head. But because Jones

THESE PAGES Faun concepts by Sergio Sandoval, including a key design that imagined the Faun's legs as tree roots.

ABOVE Faun maquette by DDT that shows the whole body adorned with tree bark textures.

INSERT A full-color rendering of the Faun by Sergio Sandoval fleshes out his initial sketch.

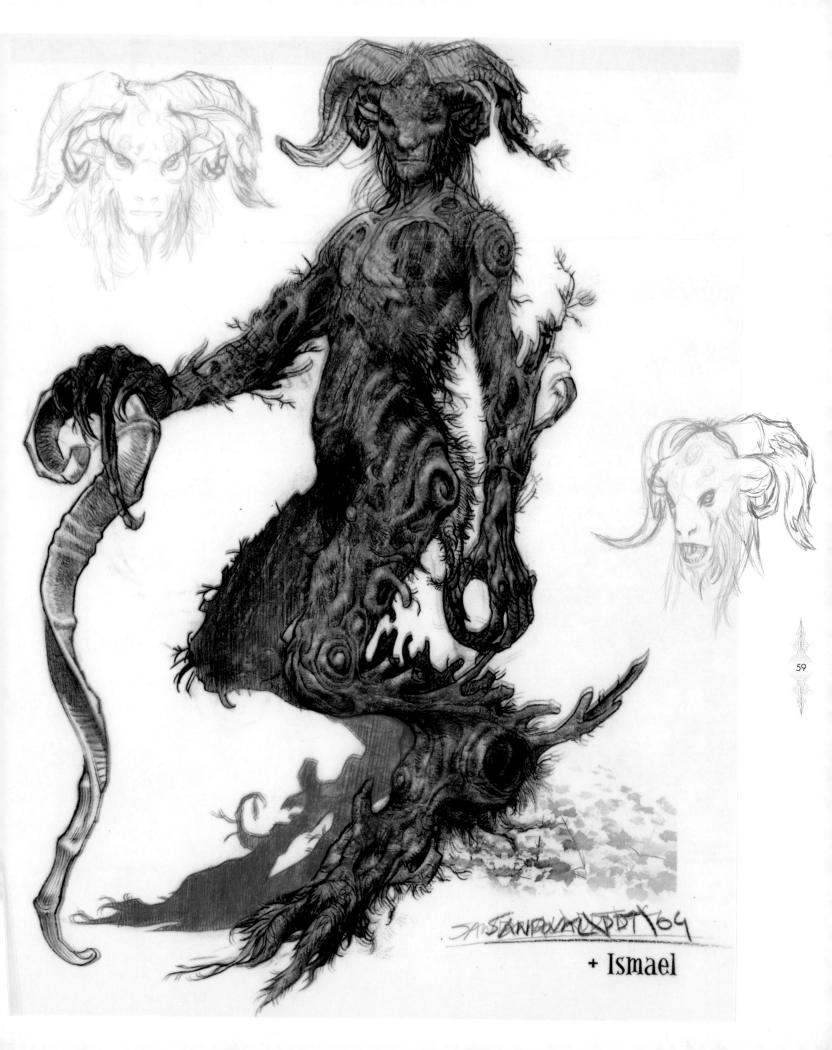

+ Ismael

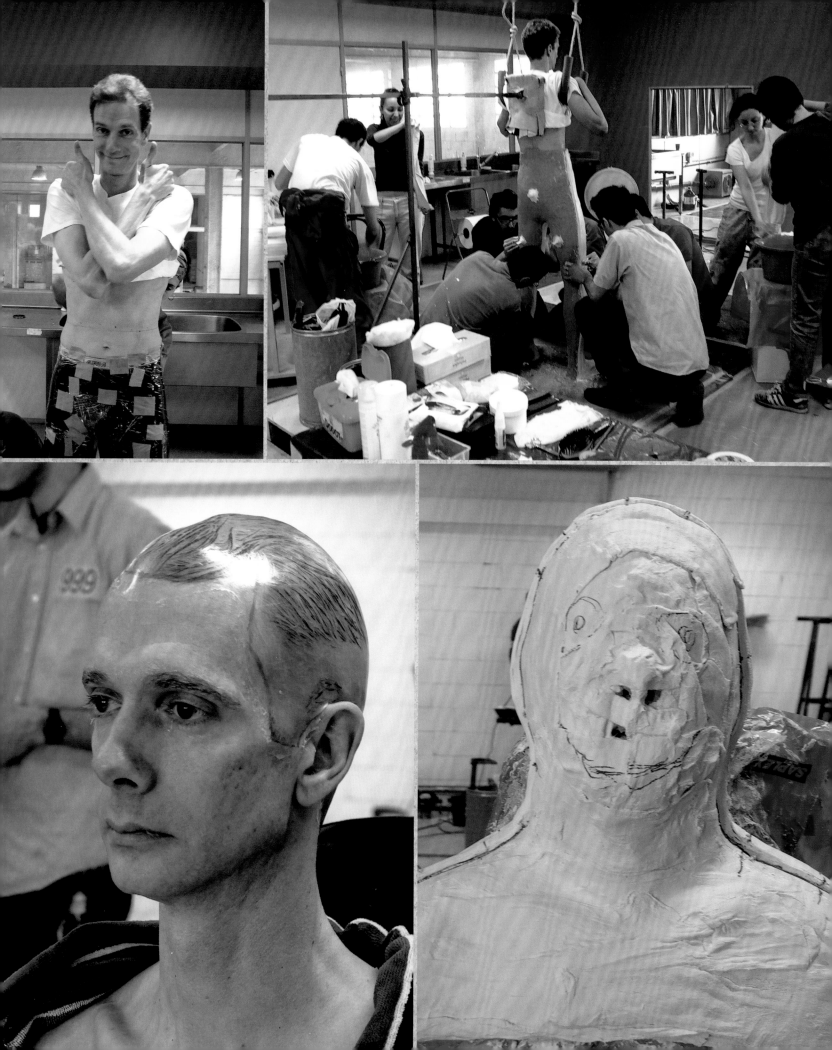

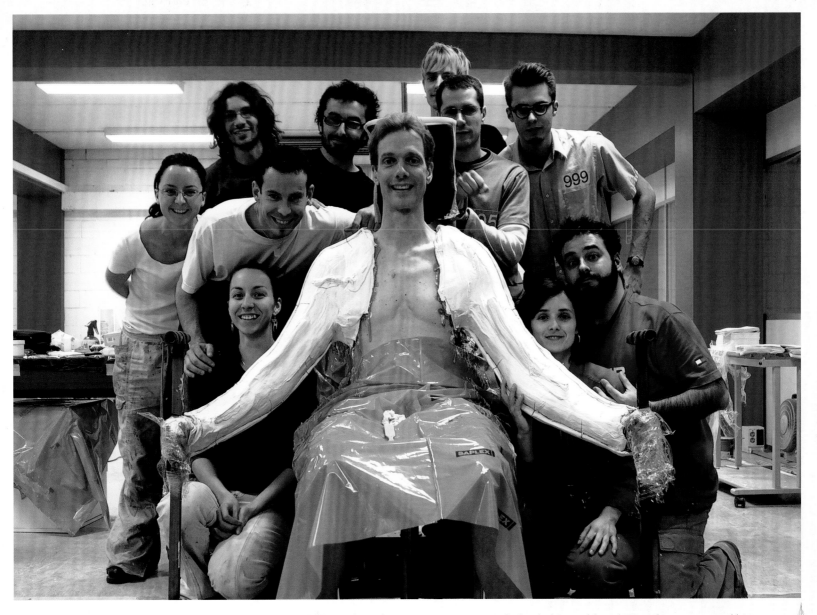

THESE PAGES Doug Jones undergoes the difficult lifecasting process under the expert care of DDT's technicians.

wasn't going to be available until April 2005, DDT began with earlier lifecast pieces taken of the actor for *Hellboy*. "We started with some [lifecast] pieces that our good friend from Spectral Motion, Mike Elizalde [creature/makeup effects supervisor on *Hellboy*], sent us," David Martí explains. "Later, when we had Doug, we molded him completely—even his teeth. We did it in two halves, the legs, and then the torso and arms. But the process is always hard and we prepared everything [so it could be applied] as fast as possible."

The complex costume included prosthetic pieces for the Faun's legs, and, as a test, DDT prepared a rough goat leg shape out of foam to see if that worked on the actor. Jones distinguishes between a creature costume, designed specifically for an actor to wear, and makeup, which is the application of prosthetic pieces, skin coloring, and other enhancements—the Faun was "the combo platter," he says.

The ram's horns were heavy with battery packs and servos that allowed DDT to remotely puppeteer facial features and other details. The face was a mask with a mouth section that would move naturally when Jones

spoke his dialogue, although Faun dentures covered his own teeth. There was a body suit that went on in multiple pieces, including an independent torso piece that came down and underneath his pectorals and allowed freedom of movement. The legs were separate pieces hooked to a belt; the Faun's long hand and fingers were gloves. The bottom half included "zigzagging" shaped goat leg pieces attached to the actor's own legs, which were wrapped in greenscreen-like material for the sake of the visual effects department. "This design had never been done before, and I conceived it to save money on VFX," says del Toro. "If you watch carefully, in some shots you can see Doug's real legs in the shadows on the floor—we ran out of money for VFX!"

"[CafeFX] could wipe away from the knee down and what remained was the prosthetic piece that went from the knee back, and then diagonally came underneath my green foot and a tree stumpy type of foot underneath mine, this thing built around a metal stilt," Jones explains. "It wasn't like a circus stilt. I was going *clunk, clunk, clunk*—a flat piece of metal hoof. It was more stable than it sounds, but it made me seven feet tall."

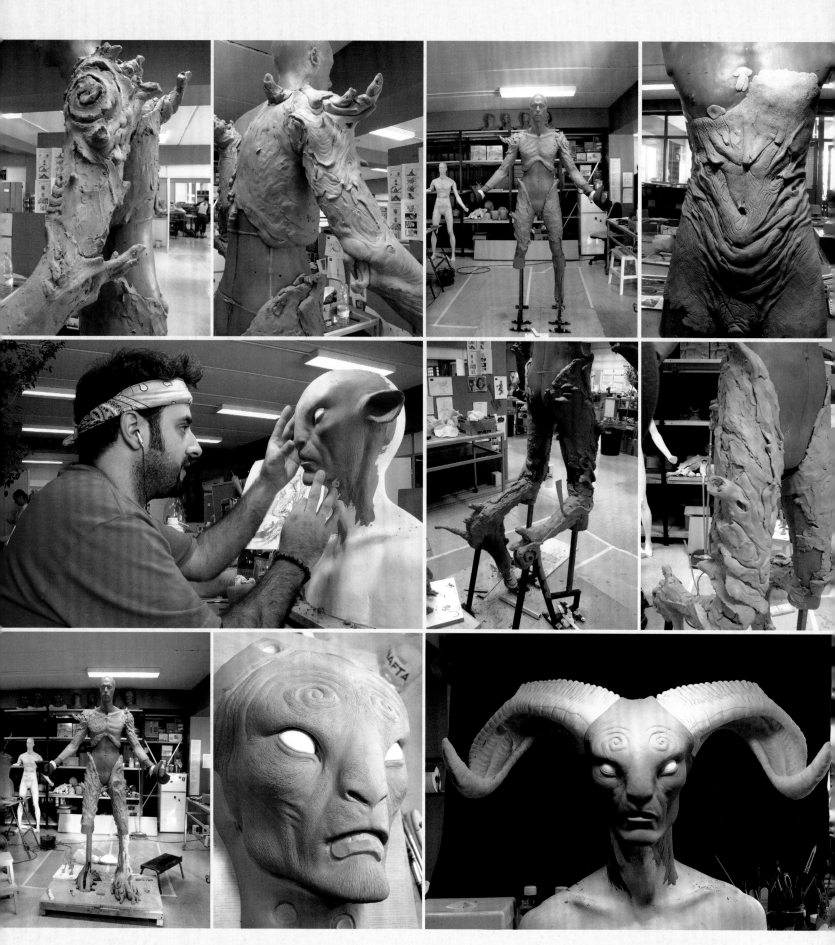

THESE PAGES Using the lifecast of Doug Jones, the DDT team begin work on constructing the Faun costume.

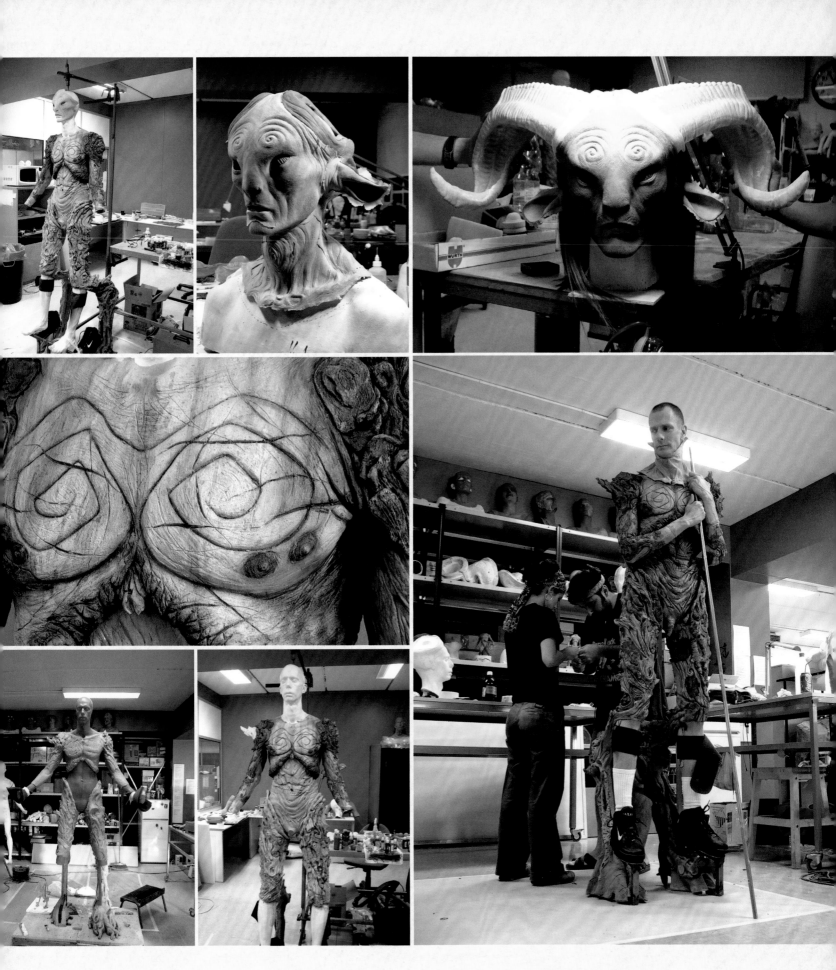

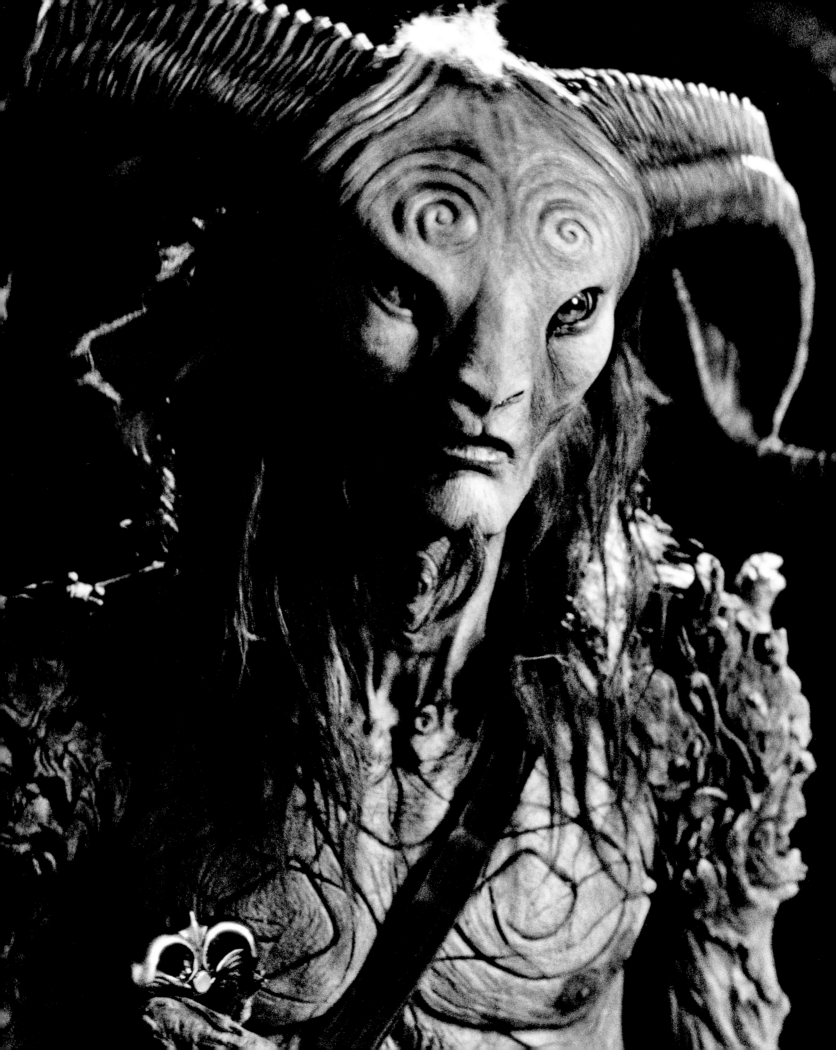

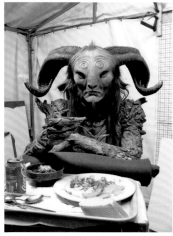

"Guillermo loves practical effects and he wanted to create the Faun, Pale Man, and a giant toad and have us enhance them to feel more alive and believable," explains Jeff Barnes. "He specifically wanted to get the performance for Pan and the Pale Man out of Doug Jones, so we did CG enhancements for that. We did subtle things to help sell the reality of all the creatures."

It was late in preproduction that a new iteration of the script imagined the Faun as aging backward, becoming younger the closer Ofelia gets to completing her tasks and fulfilling her destiny. "I pushed [DDT] on creating three or four different stages of the Faun," del Toro explains. "Most people don't notice it in the movie, but it's noticeable to me. As the movie progresses, and the Faun becomes younger and more beautiful, he also becomes less trustworthy and sinister. I thought that reversal was important at a storytelling level. The first time he appears, he's like a bumbling old fool, he is shaking and looks almost like a jester. As he becomes younger he's now eating raw meat and feeding it to the fairies and is a little more ambiguous. And then he looks beautiful, even as everything is going to shit around him, so he seems to be receiving nourishment from the conflict."

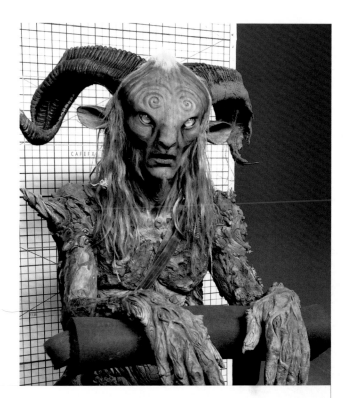

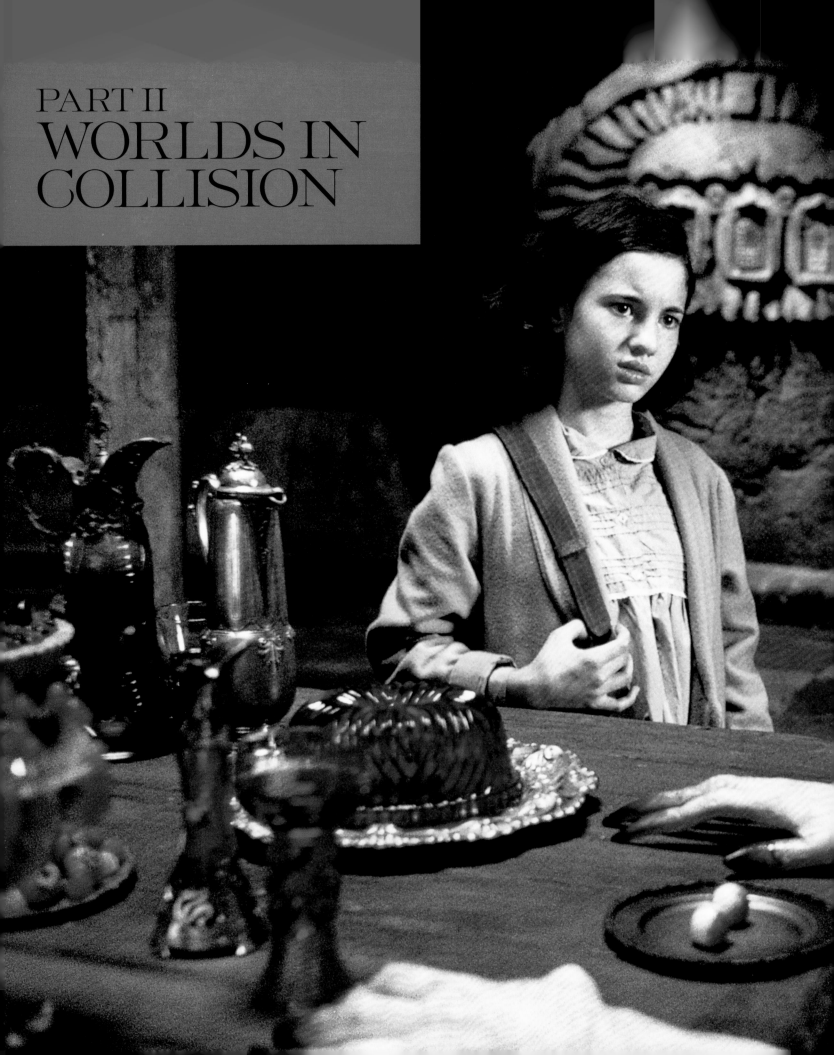

One of the ideas at the beginning was we knew we wanted to build at least part of the fantasy world because of the rules of how these two worlds collide and integrate. The main concept of the script was the fantasy world is supposed to be scary in certain moments—but it is the world that is the most clear in our young character's eyes. At the end, in my opinion, the fantasy brings hope into this terrible reality she is living. Somehow she knows the fantasy world was created for her, to save her from that reality. —EUGENIO CABALLERO

PAN'S LABYRINTH BEGINS with a fallen Ofelia, bleeding and breathing hard—but the blood is drawn back into her body, time is flowing backward, back to a fairy-tale legend. As the camera tracks across a seemingly deserted and dark kingdom, a sonorous narrative voice tells a strange tale about a lost princess:

CHAPTER 4

THE TOAD IN THE TREE

"A long time ago, in the underground realm, where there are no lies or pain, there lived a princess who dreamt of the human world. She dreamt of blue skies, soft breeze, and sunshine. One day, eluding her keepers, the princess escaped. Once outside, the bright sun blinded her and erased her memory. She forgot who she was and where she came from. Her body suffered cold, sickness, and pain. And eventually she died. However, her father, the king, always knew that the princess's soul would return, perhaps in another body, in another place, at another time. And he would wait for her until he drew his last breath, until the world stopped turning. . . ."[1]

The little tale is told as the camera tracks across a subterranean kingdom as lonely and quiet as a graveyard at night, save for the shadowy form of the little princess escaping up circular steps to the surface world.

The view of the kingdom was a miniature set created by Spanish special effects master Emilio Ruiz del Río. "I was such a fan of Emilio Ruiz and it was an honor to meet him," says visual effects supervisor Everett Burrell. "He was famous for his forced-perspective miniatures. He'd build them on shelves and hang them on location, in the foreground, so you'd actually have them instantly composited in-camera. He built this big miniature of the fantasy underground city and we added a little CG girl running around the side of it. They push in and look up and transition into the location that is about a six-hour drive outside Madrid, an old destroyed church we shot in Belchite."

PREVIOUS PAGES Ofelia encounters the slumbering Pale Man.

OPPOSITE TOP Conceptual art by Raúl Villares for the scene that would be shot at the real Belchite ruins.

OPPOSITE MIDDLE LEFT Shot of ruins with conceptual art added.

OPPOSITE BOTTOM LEFT A concept miniature used as reference for a life-size foreground set for the Belchite sequence.

OPPOSITE BOTTOM RIGHT Detail art for ruins by Raúl Villares.

THIS PAGE Underworld kingdom details by Raúl Villares.

The ruins represent the outside world of blinding sunshine and forgetfulness, with a human skull among the rubble bearing mute witness to the devastation in the aftermath of fascism's victory. The location itself is historic—there, in 1937, Republican and Franco forces clashed in the Battle of Belchite. The town was destroyed, but its ghostly ruins remain as a memorial. Guillermo Navarro recalls they arrived at the location without actors and so early in the production they were practically "off schedule." The establishing scenes were shot at the end of the day, toward the magic hour when the sun is low to the horizon, and the cinematographer notes that because of the tight budget they didn't have the resources for a big lighting setup. "That was pretty much natural lighting, so I'm very careful about when to do it," he says. "It was a very iconic place. It represents the tragedy of the war."

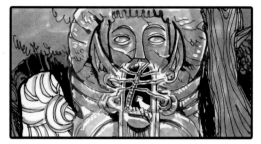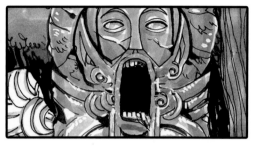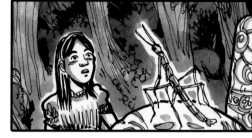

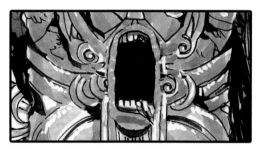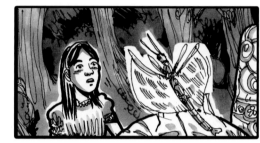

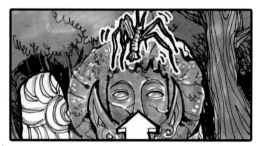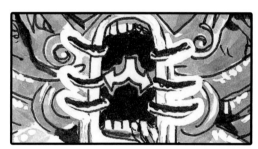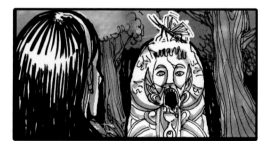

Ofelia and her mother are introduced as they arrive at the mill. Ofelia, a book lover who brims with imagination and wonder, is an intruder here, a place where magic and wonder do not exist, where one must accept the way things are. Del Toro's screenplay originally had Ofelia and her mother arrive by train, with Captain Vidal

waiting at the station. "The idea was that at the train station you would see a little of the context of the war," Caballero says. "But it would have been too much concrete information. I think it was a wise decision to take away the train station. It now works like a tale: 'Once upon a time, in a mill in the middle of a forest . . .' It's a better way into the film."

"The mill has been turned into a kind of barracks dominated by men, whose hardness and search for vengeance is embodied by Vidal, the Fascist," Pilar Revuelta notes. "So it is a cold world, where almost all of the architecture and furniture is made up of straight lines—everything is cutting, rough."

The props department built a lot of the furniture for the mill, including the work desk and folding bed in Vidal's quarters, the kitchen table, and the bed where Ofelia and her mother sleep that first night at their new home. For impressionable Ofelia, these and other pieces of furniture were designed and built to convey the mill's ominous atmosphere. "There were strong pieces made out of very hard, dark wood to give you the sensation, as

ABOVE A storyboard sequence by Raúl Monge showing the winged stick bug crawling out of the mouth of the ancient monument. The stick bug later transforms into a winged fairy and leads Ofelia into the labyrinth.

BOTTOM LEFT Sketch of the railway station, a location unused in the final film, by Raúl Villares.

OPPOSITE TOP LEFT An early depiction of the stick bug from Guillermo del Toro's personal notebooks.

OPPOSITE TOP RIGHT A model of the stick bug created by DDT. This model would be digitally scanned so that CafeFx could create a CGI version of the creature.

OPPOSITE BOTTOM RIGHT Bald fairy models created by DDT for scanning by CafeFx.

when you were a child, that everything is looming and out of proportion," Revuelta says. "The table where the soldiers eat is very big; the bed where the mother sleeps is immense. The whole idea of being out of scale was important to that place."

Because of Carmen's fragile condition she does not sleep with her new husband, allowing Ofelia to happily curl up in bed beside her. It is here that as her mother drifts off to sleep, Ofelia places her ear to her womb and tells her unborn brother a story of a land of sorrows where each night, upon a dark mountain, a magic rose blooms that will bestow immortality to anyone who plucks it.

The strange winged stick bug then appears in the bedroom. It sees an illustration of a winged fairy in a book Ofelia has brought to bed and transforms into the story-book image, one of three fairies Ofelia will meet. "Our challenges included bringing some of the characters to life, and the stick figure insect and fairies were our first task," Burrell explains. "Anything involving CG characters is difficult, because it involves not only modeling but animation. For the stick bug design we used lots of references of leaves and tree bark, to get an organic vibe. As the insect repositions into the fairy, Guillermo wanted it to look painful, with bones cracking—once the transformation is complete, the fairy cracks her neck, a Bruce Lee kung-fu thing. All the fairies are bald because [our ability to create digital hair] wasn't quite there yet, at least in our budget range. We had just started doing fluid dynamics and hair and fire, and we were prepared to do it, it was just an extra cost. Guillermo said, 'Fuck it. They're bald.'"

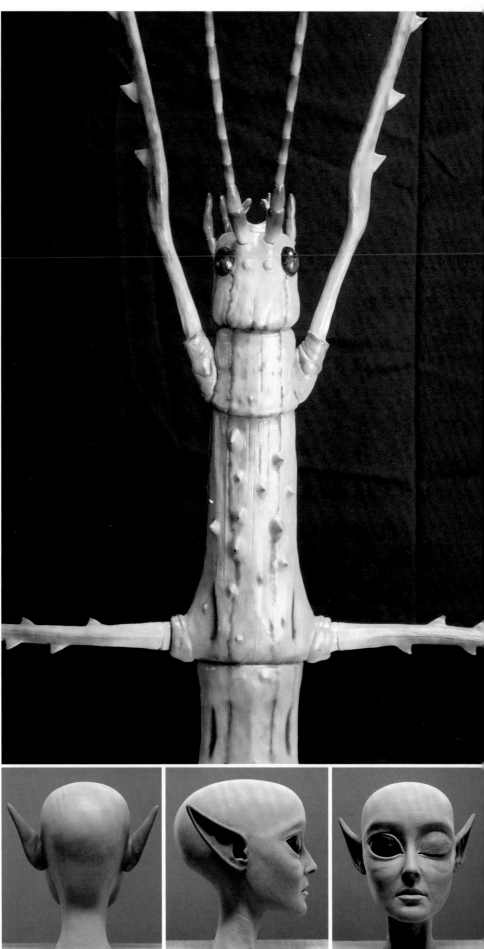

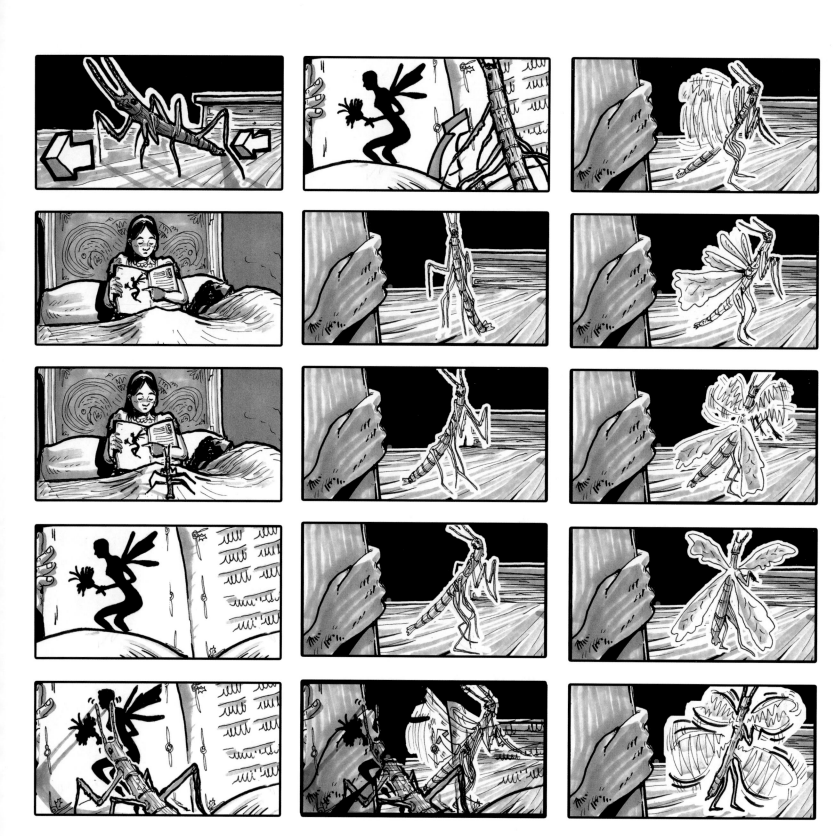

THESE PAGES Storyboard sequence by Raúl Monge showing the stick bug turning into the classic winged fairy pictured in Ofelia's storybook.

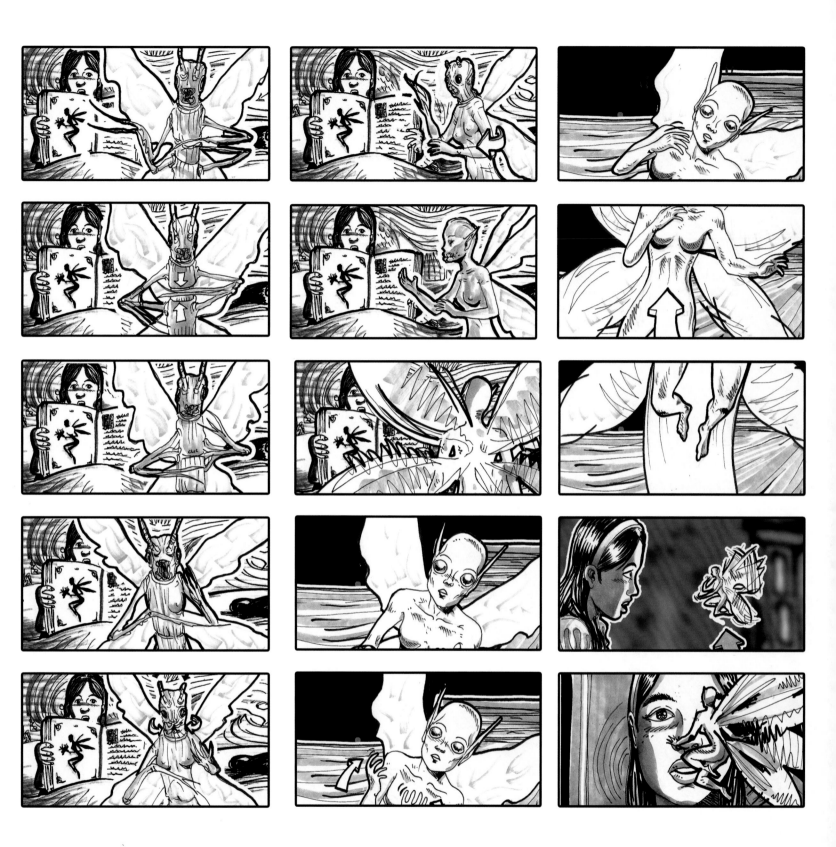

"The fairies were a perfect example of what I mean by managing adversity," says del Toro. "I saw the design, with and without hair, and thought, *They look more insect-like without hair.* And voila! Savings and better creatures!"

That first night, the brutality of the real world is revealed in a savage scene where Vidal joins the questioning of an older man and his son found wandering the forest. They explain they were hunting wild rabbits, as will be discovered when Vidal thoroughly searches their bag and finds a dead rabbit. But first, without hesitation, Vidal uses a bottle from their bag to bash the younger man's nose to a flattened and bloody mush, before shooting the father and finishing off the son.

In that horrifying moment the ruthless monster festering inside Vidal's well-groomed exterior is revealed. Filming the scene was something else, López recalls, and began with the actor who played the victim wearing a prosthetic nose and López wielding a specially constructed bottle, the bottom half of which was made of foam. "This is about precision," López explains. "I said to Guillermo, 'Okay, so I'll hit him in the face and break his nose.' And Guillermo says, 'No, no, no! Do it as a game. The goal of the game is to level his face, to leave it completely flattened.' That gives you an idea of what to do. You're not just going to kill him; you're going to leave the protuberance of his nose as if it was a plane. While filming, Guillermo was saying, 'Harder, hit him *harder!*' And we're two actors and we laugh a bit [between takes]. That's how it was. It was a lot more fun than the

end result on screen—that gives you goose bumps. But Guillermo fills you with information and never leaves you stranded. He never says, 'Go look for the character.' He tells you how the character *breathes!*"

"Guillermo's directing style starts with his being a people person and an observer who absorbs everything," says Doug Jones. "I've noticed on all the movies I've done with him that he directs each actor differently; his voice, his delivery, his demeanor is different. He will find the space we live and communicate in. It's like he creates a control panel with buttons for every actor, so on set he knows you well enough to press the buttons that work for that scene. With me, the most direction I got on *Pan's Labyrinth* was before the movie started. We had lunch one day and he told me to look at barn animals, goats and cows, to see how they move their hind quarters, how their hoofs meet the ground, how they disperse their weight, or shake off flies—it was about the physicality of the Faun."

Ofelia enters the labyrinth that first night at the mill, guided by the fairy, and finds a well with steps circling down to a space with a central pillar carved with images of the Faun, the lost Princess Moanna, and a baby. Although the fantasy world rules included warm colors, the labyrinth is seen at night and cinematographer Navarro felt it was "too much of a stretch" to make it warm, so a green-blue palette was used. It became the thematic color scheme for Ofelia and the Faun—later, when the Faun visits Ofelia at the mill one night, the same green-blue effect is used.

BELOW A storyboard sequence by Raúl Monge plots, in excruciating detail, Vidal's brutal bludgeoning and execution of a young man, along with the shooting of his father.

OPPOSITE TOP In contrast to the storyboards, the final scene was filmed outdoors.

OPPOSITE BOTTOM Concept art by Carlos Giménez for the stone steps that lead to the portal.

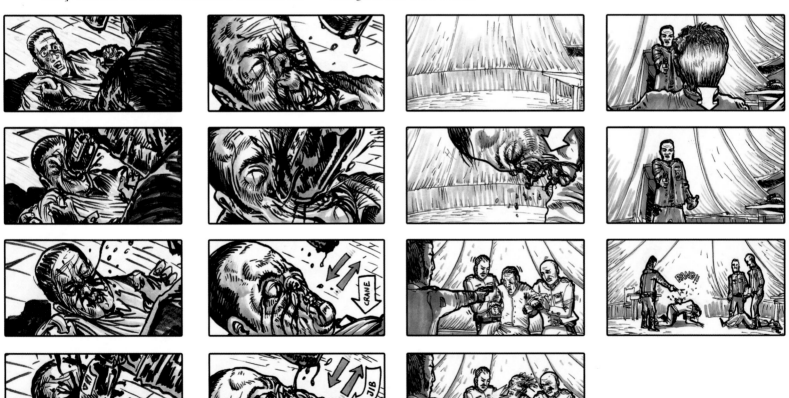

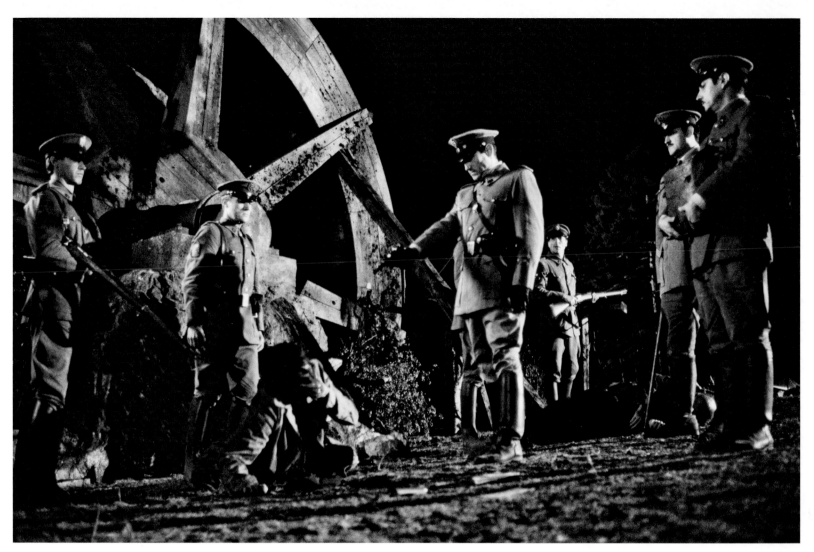

When the old Faun appears, as if awakened from slumber, he tells Ofelia that *she* is the lost Princess Moanna. Here, deep within the labyrinth, is the last of the portals that were opened by her father to allow her return. But first, before she can go back, she must prove herself. And so the Faun gives her the *Book of Crossroads* that will instruct her on the three tasks she must successfully complete.

Jones had first been introduced to Ivana Baquero as himself, but because she was so young, it was decided that she should see him getting into the Faun makeup to avoid any potential fear factor. "I was about halfway through the process, where she could still see that tall, skinny guy she had met earlier," Jones recalls. "And she had this childlike wonder, 'Oh, my gosh! So that's how you put that on!'"

"The Faun and the creatures did not frighten me," says Baquero. "I did my first movie when I was eight and participated in a couple more before *Pan's Labyrinth*. They were all genre films, so by then I was used to seeing monsters, prosthetics, and wax bodies. But Doug Jones was unbelievably good! He acted the whole movie in Spanish! And he managed to pull it off so gracefully even after all those hours to get the prosthetics on! I admire him so much."

Although Spanish actor Pablo Adán dubbed the voice of the Faun in the final film, Jones had insisted on learning and delivering his lines in Spanish. "Doug Jones is just

amazing," del Toro adds. "He delivered above and beyond what he needed to. I was going to allow him to say his lines phonetically, just to sound like the lines. He delivered them in a very heavy American-accented Spanish, but it made his performance more beautiful and powerful."

For Jones's part, the Faun costume and makeup was the most comfortable he ever performed in. "When you're

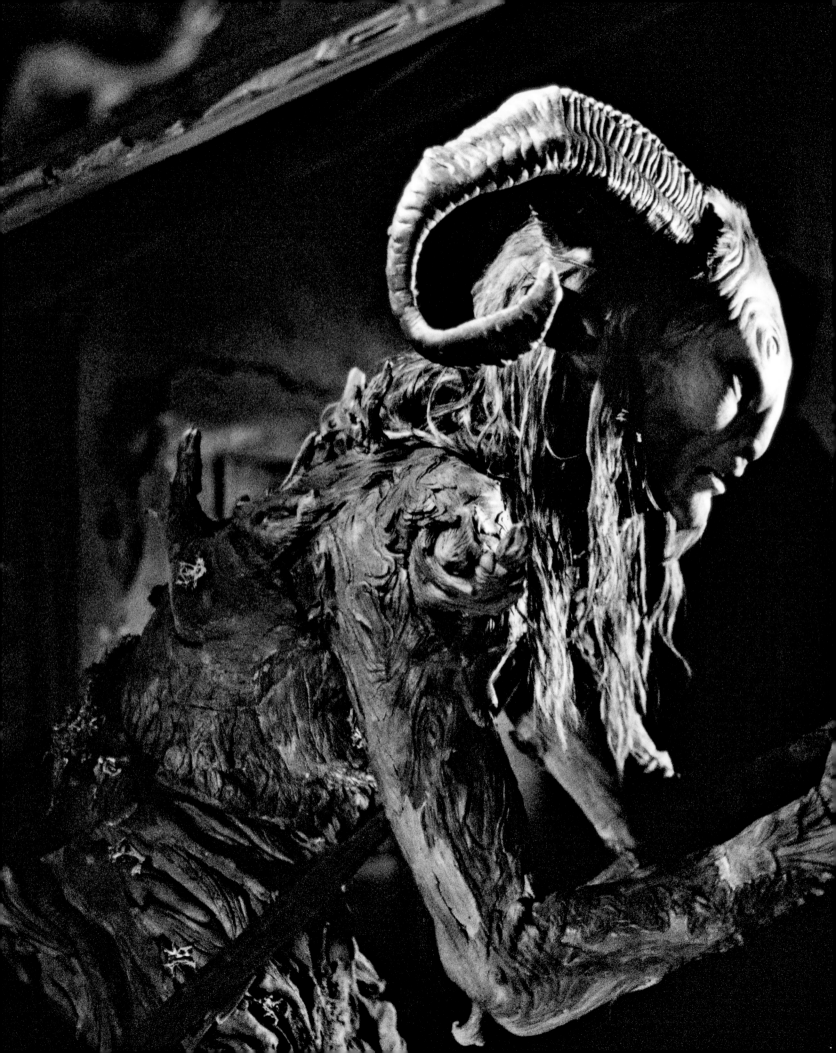

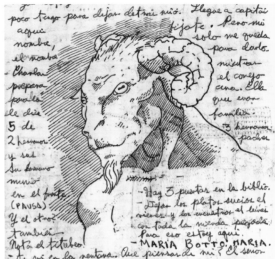

wearing something from head to toe, that's a complete transformation of your entire body," the actor explains. "It often requires many different mechanical bits, buckles and snaps and glue and aesthetic pieces. There's always something pushing or pinching, and you always come out of it with red marks on you somewhere. That's just part of the deal. Well, when the Faun makeup came off every day, there were no red marks—nothing! It was the most balanced weight dispersed design I have ever worn. I marvel at DDT. I told them this had never happened to me before and they should be very proud of themselves.

"But there were challenges, oh my goodness," Jones adds. "I was up on stilts, I had prosthetic legs zigzagging behind and under my feet. The mask that re-created the top part of the Faun's face had eyes wider than my own, so I had to look through pinpricks in the tear ducts, which means that I had no peripheral vision, which affects your balance. I would have to clear a path and walk through a couple of times in rehearsals to make sure I had my footing. So, in the film I don't walk around much. I might take a step or two and plant myself and deliver dialogue. Foam latex covered my ears, and the ram horns on the headpiece is where they hid the batteries and motors that operated the eyebrows, the eyelids, the ears that wiggle. The DDT folks had to puppeteer all that and when they turned it on it it'd go zzzzzzzzz on the top and sides of my head. And some scenes with Ivana we would be close and talking softly in Spanish and I'd be *pretending* I could hear her. Talk about a challenge! And because of the way the legs were configured, and the little tail sticking out of my butt, I couldn't sit in a regular chair. My resting place was a bicycle seat contraption with a T-bar that I leaned forward on. When the camera was going it was the most comfortable suit and makeup combination I ever had. But at rest, you couldn't really be. So it made for very long days. Of course, in the end it was all worth it."

77

LEFT The Faun is both obsequious and threatening in his interactions with Ofelia.

TOP RIGHT A page from Guillermo del Toro's notebooks offers an early interpretation of the Faun.

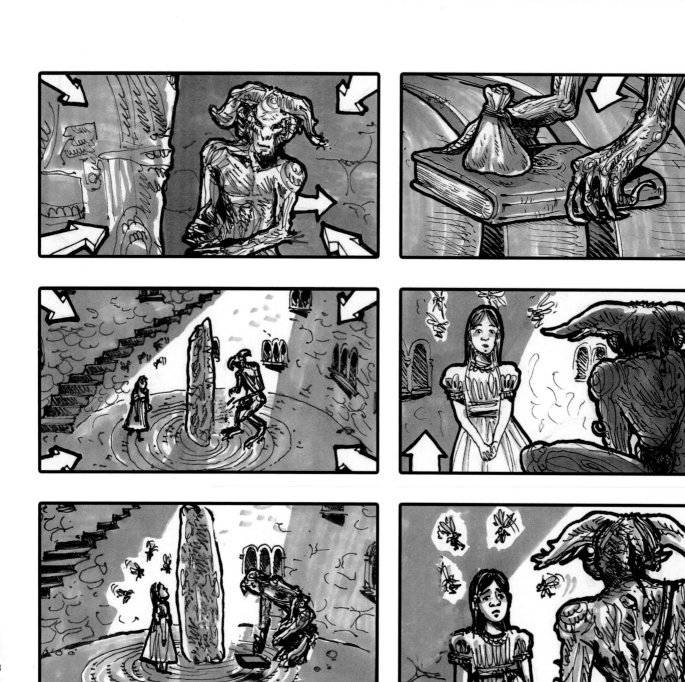

78

THESE PAGES A storyboard sequence by Raúl Monge follows Ofelia's first encounter with the Faun and his fairy emissaries and her first experiences with the *Book of Crossroads*. When she opens the magic book, its blank pages fill with imagery pertinent to each stage of her quest.

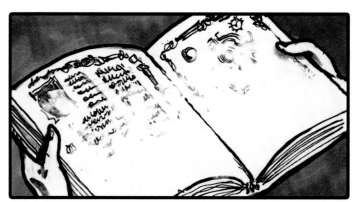

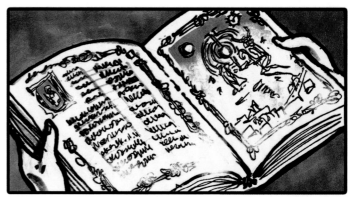

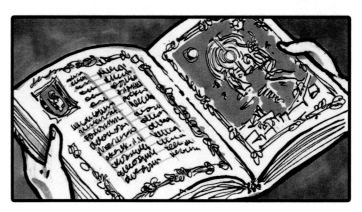

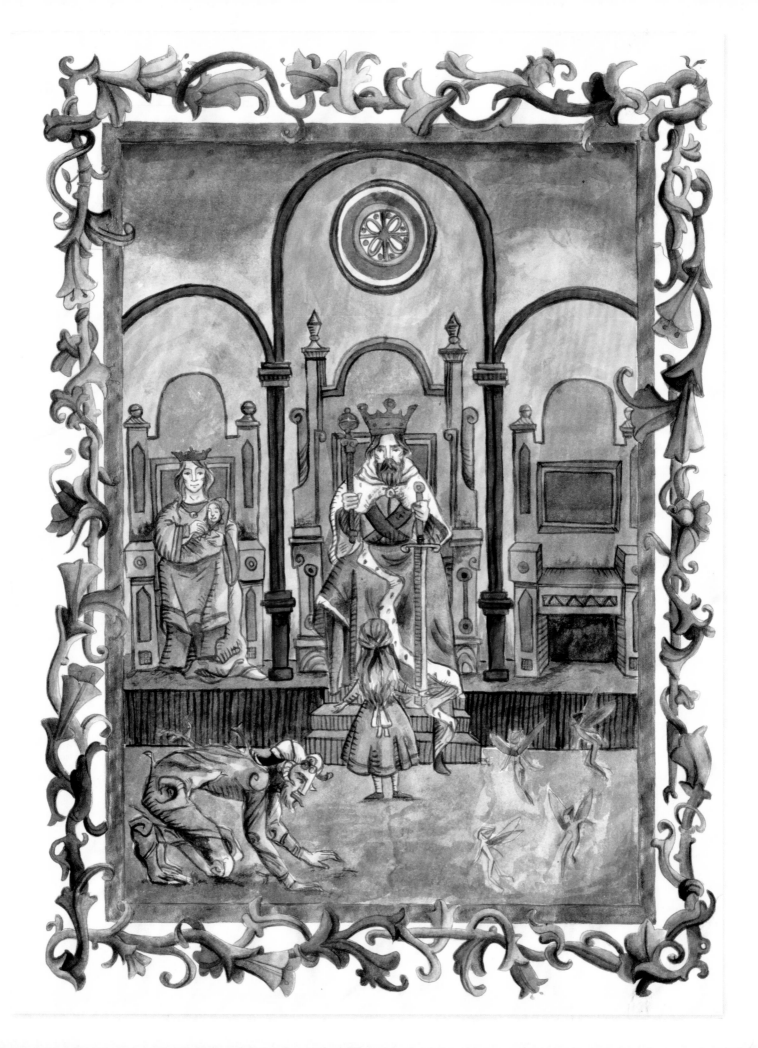

THESE PAGES Pages from the *Book of Crossroads* illustrated by Esther Gili, with calligraphy by Maria Luisa Gili: The princess stands before the king and queen at the end of her quest (opposite); Ofelia's descent into the fantastical fig tree (top left); the task and temptation that awaits Ofelia in the Pale Man's lair (top right).

BOTTOM RIGHT Maquette of the withered fig tree that is dying because of the life-sapping toad that now dwells within.

INSERT An early sketch for the toad in the tree task page from the *Book of Crossroads* by Carlos Giménez.

WHEN THE FAUN GIVES Ofelia the *Book of Crossroads* she officially begins the three tests required to regain her fairy-tale throne. It is a magical book—when she first opens it in the labyrinth, there are only blank pages; but when she is ready to embark on her quest and opens the book at the mill, the first task magically appears on a blank page. In fairy-tale language and imagery, a story is recounted of a time when the local woods were young and home to magical creatures that protected one another and slept in the shadows of the gigantic fig tree that grew on a hill near the mill. But now the branches are dried and the trunk is old and withered, because a monstrous toad has settled within the tree and won't let it thrive. To complete her task and allow the tree to live again, Ofelia must put three magic stones into the toad's mouth and retrieve a key from inside its belly.

The tree on the hill is one of the film's iconic images, its shape echoing the Faun's horns and even the curvature of Fallopian tubes. As del Toro once scribbled in his notebook: "The fantasy world should feel UTERINE, INTERIOR, like the subconscious of the girl . . ."[2] Arriving to her first test, Ofelia wears the dress her mother has made for her that purposefully recalls the one worn by Alice when she tumbled down the rabbit hole into Wonderland.

The art department's design of the tree began with a del Toro notebook drawing and took form as a physical set of plaster and molds, dressed with real branches and CG touches by CafeFX. "What I really liked about *Pan's Labyrinth* is we built it in a very beautiful way, using the mix of traditional ways of construction with top-of-the-line visual effects to complete the whole puzzle,"

(continued on page 85)

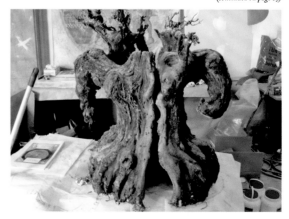

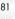

81

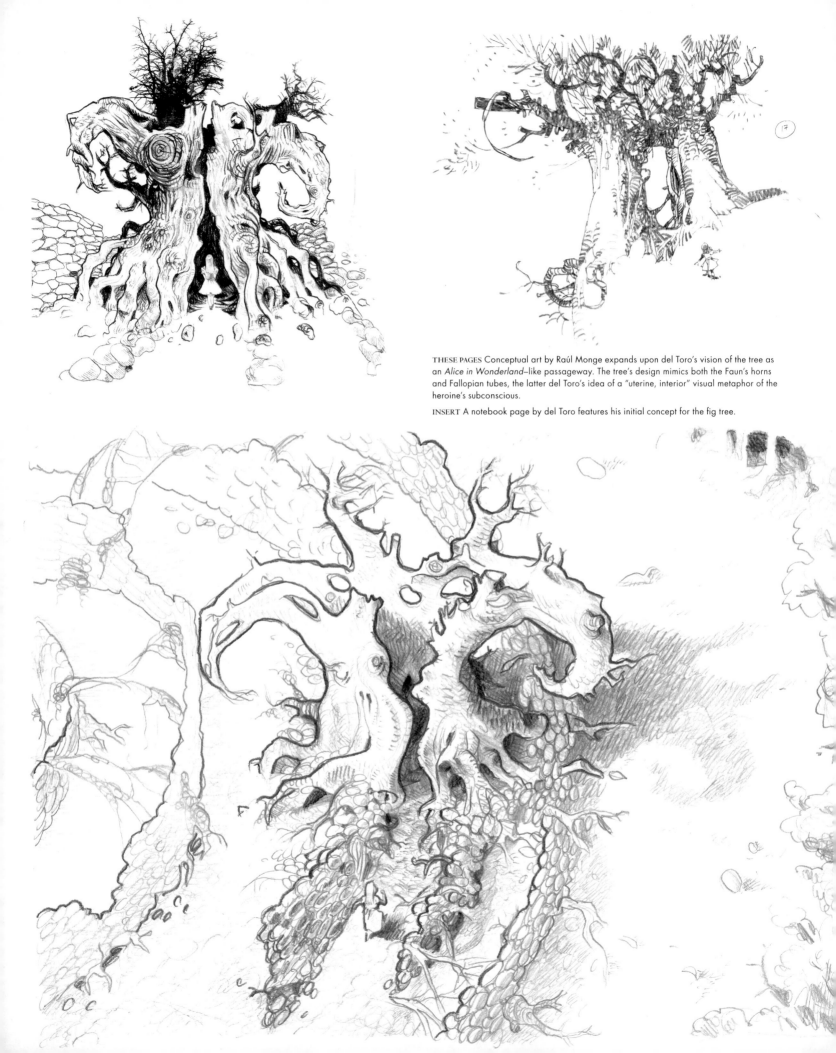

THESE PAGES Conceptual art by Raúl Monge expands upon del Toro's vision of the tree as an *Alice in Wonderland*–like passageway. The tree's design mimics both the Faun's horns and Fallopian tubes, the latter del Toro's idea of a "uterine, interior" visual metaphor of the heroine's subconscious.

INSERT A notebook page by del Toro features his initial concept for the fig tree.

- Engranajes gigantes TRITURAN a alguien en el laberinto.
- "Please forgive me" le dice la princesa a Abe Sapien.
- Puede volver la piel dura a voluntad, como acero.
- Johann es un "gizmo guy" HB le odia pansen Alemán.
- Estos se consiguen en el mercado negro IIIrd cat un tooth fairies, illegal, very hungry and not very nice.
- Liz an HB go to Brooklyn, Abe & Kate go X.
 - HB le arranca la cabeza a un ídolo de piedra.
 - Fauno con planta hecha con un fémur.

ALICIA.

- Árbol viejo y caído.

 - Abe rescata a la princesa de los sabuesos del príncipe y la cura mientras ella está convaleciente en cama

- La primera vez que Abe ve a la princesa es tan solo un avistamiento y no hay contacto alguno.
- Pelean por poseer la tercera pieza de la corona y los ayudan los duendecillos que son dilatantes.
- El príncipe puede transformarse en animales.
 - Obtienen la corona y prenden a la princesa. Abe mismo se roba la corona para rescatarla de su prisión. Manning quiere soltarlo.
 - teñir el vestido de Ofelia p/funeral.
- Ojo hombre Pálido: - Rojo
 - Después de hallar una cantera para construir nuestros principales decorados en Navarra el humilde viejecillo que nos la mostró, llama a su sobrino, un pijo de Donosti que nos pide un cuarto de millón (£ 250,000) por usar la cantera 4 meses. Con esto nos retrasa 2 de 10 semanas de preparación.
- Silencio en la banda sonora o luego una nota o dos.

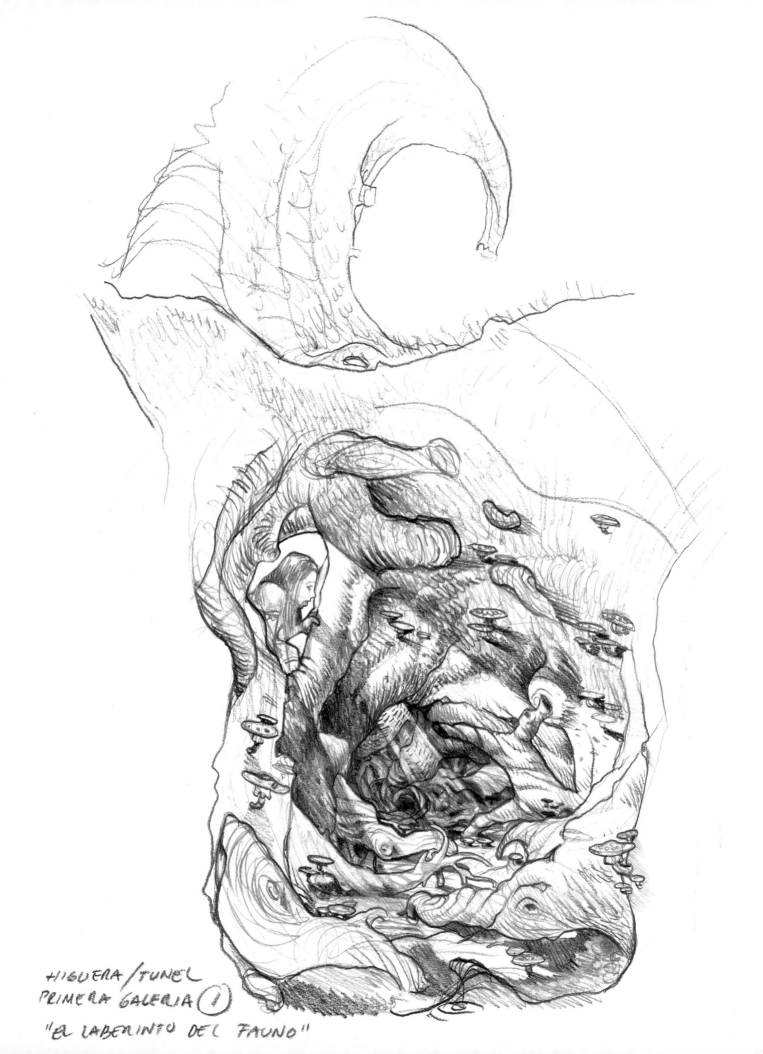

HIGUERA / TUNEL
PRIMERA GALERIA ①
"EL LABERINTO DEL FAUNO"

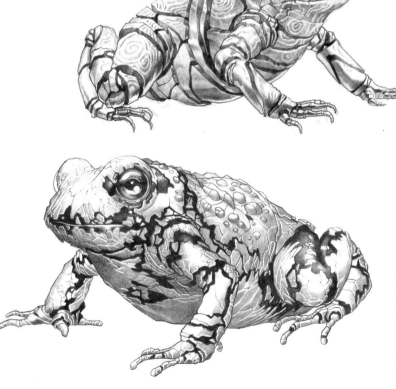

"EL LABERINTO DEL FAUNO"
TUNEL RAICES
CORTE ②

TUNEL ②

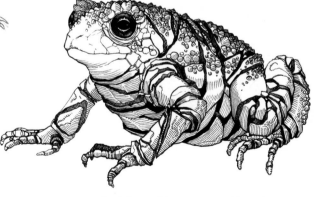

atop the creature, the toad's dimensions also grew, as *Cinefex* magazine reported, "to the size of a baby hippo . . . putting great demands on DDT co-owner Montse Ribé . . . who planned to puppeteer the five-foot-long foam latex puppet from inside."[3]

OPPOSITE AND ABOVE LEFT A detailed view of the "uterine" tunnel by Raúl Monge.

TOP RIGHT Digital concepts for the construction of the tunnel set.

TOP LEFT Ofelia in the tunnel sketch by Gabriel Liste.

ABOVE Toad concepts by Sergio Sandoval. Del Toro wanted the "tests" for Ofelia to be based around stone, wood, and metal, like the three doors in the Pale Man's lair. At this point in the toad design, the stone element is still present.

INSERT Tunnel interior concept by Carlos Giménez.

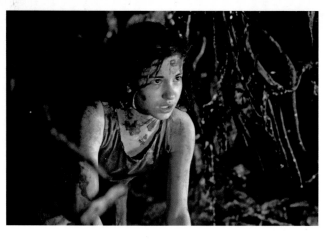

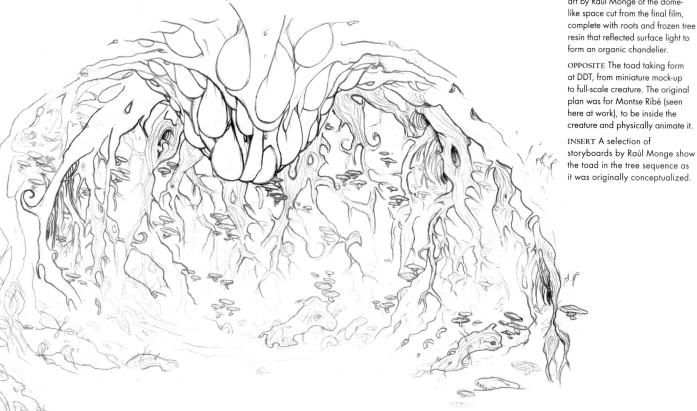

The plan was for DDT to build a giant toad that could make the initial movement that precedes jumping, with CafeFX taking over from there. "The jumping was going to be digital," says del Toro. The director wanted the giant toad to be made out of lightweight foam, with a thin silicone skin covering certain areas, but it would soon become apparent that the creature would still be too heavy.

DDT's mixing machine and oven were too small at the time to handle the large creature, so they outsourced the mold to be filled with foam. "The only pieces made of silicone were the eyelids," says Martí. "If we had made it entirely out of silicone it would be twenty times more heavy, and our frog was heavy enough."

"We had many meetings about that frog and I kept saying to David, 'It's going to be too heavy, it's going to be impossible to sustain,'" del Toro recalls. "I was never as good a sculptor and makeup effects guy as David and Montse are, but I knew the logistics because I ran a shop for a decade. The warning was 'too heavy' and it turned out to be as difficult as predicted.

TOP LEFT Ofelia crawls into the tree, film still.

ABOVE AND BELOW Conceptual art by Raúl Monge of the dome-like space cut from the final film, complete with roots and frozen tree resin that reflected surface light to form an organic chandelier.

OPPOSITE The toad taking form at DDT, from miniature mock-up to full-scale creature. The original plan was for Montse Ribé (seen here at work), to be inside the creature and physically animate it.

INSERT A selection of storyboards by Raúl Monge show the toad in the tree sequence as it was originally conceptualized.

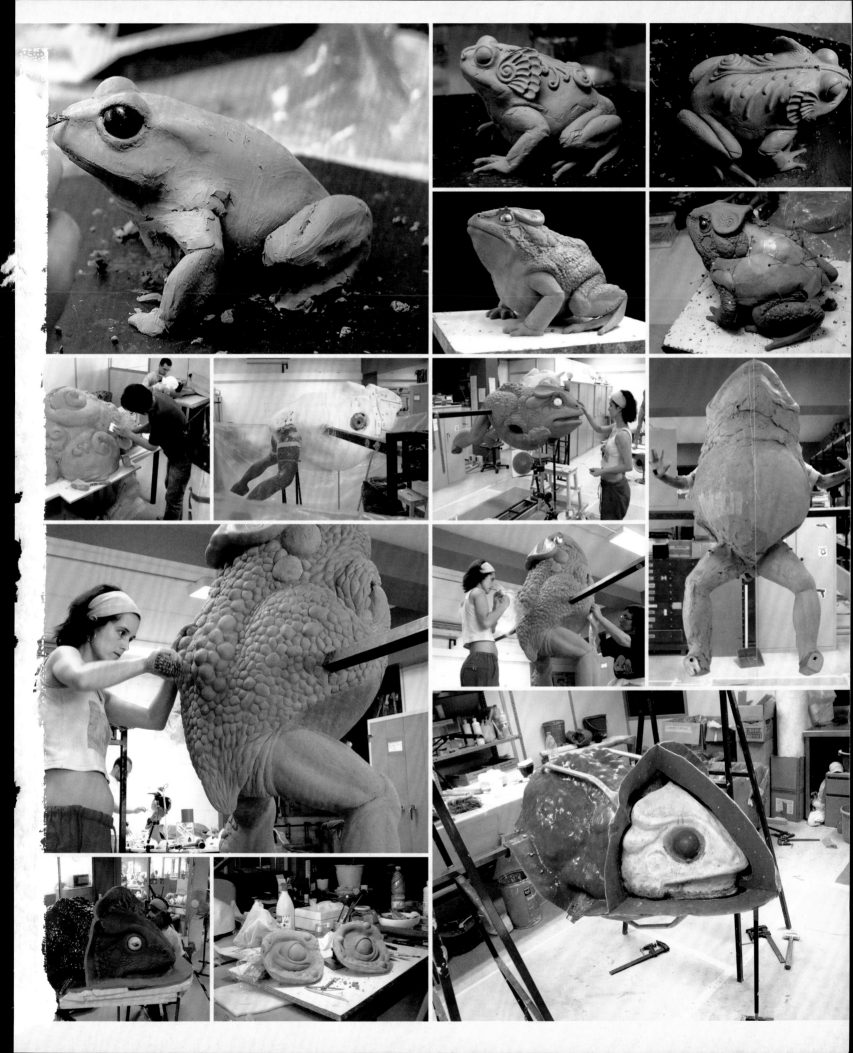

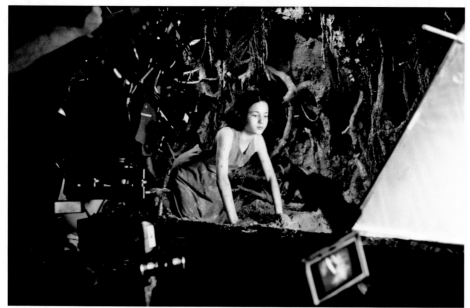

horribly rapid decision making, I decided to put Ofelia and the frog in the root tunnel and I rewrote the script so that Ofelia would tempt the frog to eat all three stones at once, pretending they were bugs, as opposed to one by one," del Toro says.

The decision was made that the domed set would be scrapped and CafeFX would do most of the toad as a CG creation. When the toad's tongue lashes out it's another CG effect, with a practical silicon tongue used only when it makes contact with Ofelia. When the tongue laps up the bug offered in Ofelia's outstretched hand—and, unknowingly, the stones—the toad vomits up its insides. The resultant goo was a physical gelatin mold that accompanied CafeFX's creation of what Burrell calls "a big CG sack" for the outer skin that withers and melts, leaving both the puddle of vomit and the key Ofelia seeks.

Burrell recalls the synergy between CafeFX and DDT as positive, "one of the best ever" examples of teamwork between the effects disciplines in his experience: "Guillermo used us both, practical and CG, and used us to his advantage."

"I always believe things happen for the best," del Toro concludes. "Everyone thinks of the director as a dictator, but it's not that. You know when you have to do it the way you want it. But I think the big difference in being a first-time director, and one who has directed six or ten movies, is that with experience you learn to identify adversity not as adversity, but as opportunity. That distinction makes you much more flexible."

"The first day we tested, after the first or second shot, Montse came out from underneath the frog trembling and covered in sweat," del Toro continues. "Montse needed to make one big move, and she was doing her best, but she could not even move the frog slightly."

"We'd need a cable to make it run or jump," David Martí recalls. "The frog was one of the last things we shot and we were all tired and super stressed. Guillermo wasn't happy with the frog; he was not happy with the whole thing."

With a creature that was too heavy to animate by a person, and too cumbersome to rig on the half-built set, del Toro decided to rework the entire sequence. "In

88

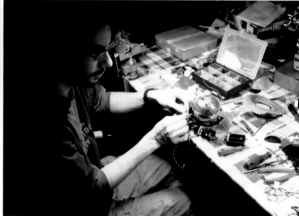

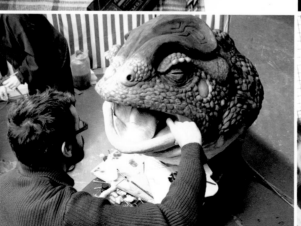

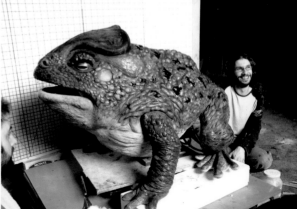

TOP On-set, Ivana Baquero begins the arduous tunnel crawl.

ABOVE DDT artists at work on the slimy tunnel beetles.

RIGHT The final toad proved too heavy to physically animate and would largely be visualized on screen as a CG creature created by CafeFX.

OPPOSITE Dirty and dazed, Ofelia emerges with her prize—a key vital to completing her second task.

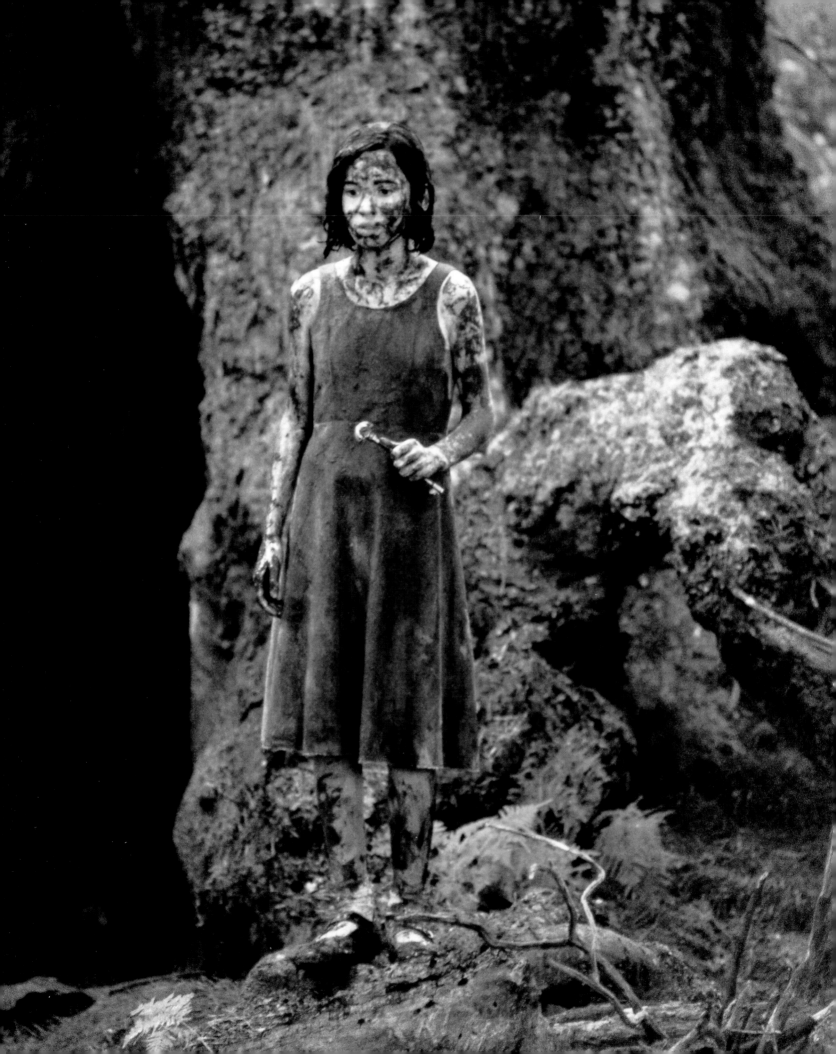

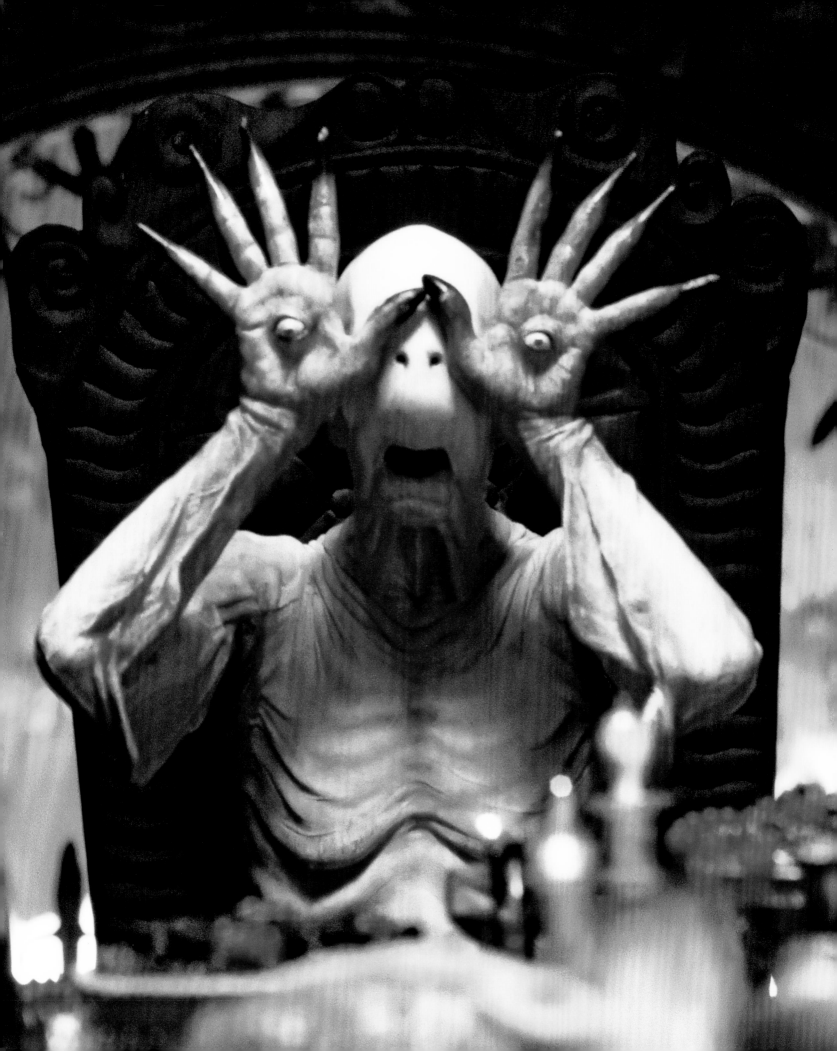

It's fun to play the villain. There's something [childlike] about it. Primitive. You say to a kid, "We're putting on a play of Little Red Riding Hood. Do you want to play Little Red Riding Hood or the Wolf?" Well, it's obvious: the wolf. It's liberating. You can do things you wouldn't normally do—like eat people. It's also playful. The whole aspect of play is very important to me in acting. I don't need to look for the evil within me or get into a dark place where I imagine that I could kill a kid. . . . What I do is imagine that I love killing a kid. Get it? There's no humanity [in Vidal]. He's unbalanced, sick. A monster. But in no way do I pretend to understand him. I'm playing the part. I'm the wolf. —SERGI LÓPEZ

CHAPTER 5
THE MONSTER'S BANQUET

ONE OF THE FILM'S "VISUAL RHYMES" can be found in the way that aspects of the real and the fantastical mirror each other (such as the key that is important in both worlds). There were even mirror sequences, the most important being the banquets presided over by two monsters—Captain Vidal's somber dinner party at the mill and Ofelia's second-task encounter with the monstrous Pale Man, who sits alone at a lavish, and untouched, banquet table. Both Vidal and the Pale Man sit at the head of their respective wooden tables, and both have a roaring fire behind them.

Vidal's dinner, over which he presides like a feudal lord, represents real-world power as embodied in the guest list, which includes local dignitaries and a priest. All of them are complicit in the brutal operation to exterminate the Republican holdouts. It's not just a dinner—it's a statement of purpose and resolve. "The war is over and we won," Vidal announces. "And if we need to kill every one of these sorry sons of bitches to settle it, then we'll kill them all. . . ." Vidal declares he is here by choice, to see his son born into a "new, clean Spain."

Even as they are partaking of a sumptuous feast, Vidal announces that the local populace will be granted a single ration card per family. The priest, heartily heaping food on his plate, agrees that if people are careful, one should be enough.

There is not a happy atmosphere around this dinner. When one of Vidal's lieutenants recalls General Vidal, the Captain's father, he describes the brave man's death on a battlefield and the watch he cracked so that his son would know the exact hour and minute of his death. The son, who is constantly tinkering and cleaning a cracked watch while in his inner chambers, dismisses the story. "Nonsense, " he says. "He never owned a watch."

"There's something about the character's world that doesn't permit reflection or questions," López says. "He appears to be monochromatic, but there are the details. He has his watch, a memento from his father. The watch was there from the beginning, the watch of his father who died. But when they ask about his father, and he speaks of him, you can tell there's something there, a hatred. He doesn't have any admiration for him. All these details serve the character. You go on discovering matrixes to the character's pathology."

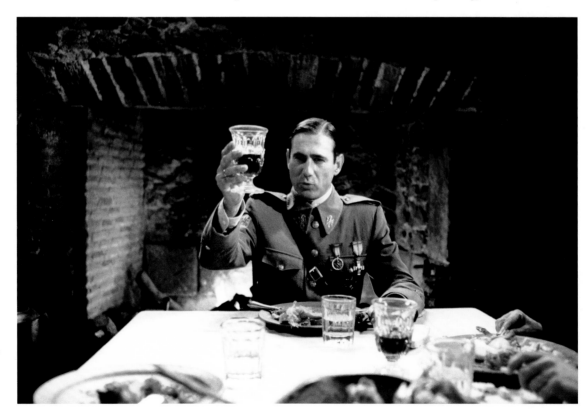

OPPOSITE AND RIGHT The Pale Man awakens at his banquet table, while Vidal toasts Franco's new Spain, as reality and fantasy parallel each other in these dining rooms lorded over by the respective monsters that rule each realm.

Del Toro gives special attention to the priest at Vidal's dinner. During his research for *The Devil's Backbone*, one of the most personally horrifying discoveries for the director was the Catholic Church's participation in Fascism's rise in Spain. "The words the priest speaks at the table in *Pan's Labyrinth* are taken verbatim from a speech a priest used to give to the Republican prisoners in a Fascist concentration camp," del Toro once explained. "He would come to give them communion and he would say before he left, 'Remember, my sons, you should confess what you know because God doesn't care what happens to your bodies; he already saved your souls.' . . . The Pale Man represents the Church for me. [He] represents fascism and the Church eating the children when they have a perversely abundant banquet in front of them . . . a hunger to eat innocence."[1]

Ofelia will soon enter the Pale Man's lair, but there is a delay—the second time she opened the Book the pages bled, the fantasy world reflecting the real world as she discovers her mother bleeding. The full moon is nearing and the concerned Faun visits Ofelia; she explains what happened. The Faun gives her a mandrake, a magical, humanoid-looking plant. To heal her mother, each morning she must place the mandrake in a bowl of fresh milk, along with two drops of blood, and put it under her mother's bed. With this remedy delivered, the Faun warns of the monster Ofelia will find on her next task, and the banquet table of which she is forbidden to eat or drink on pain of death.

LEFT The *Book of Crossroads* reveals the bloody reality of Carmen's possible miscarriage in this storyboard sequence by Raúl Monge.

OPPOSITE Ariadne Gil as Ofelia's mother Carmen, with Maribel Verdú as Mercedes.

BELOW Navarro sets up a shot with Baquero and Gil.

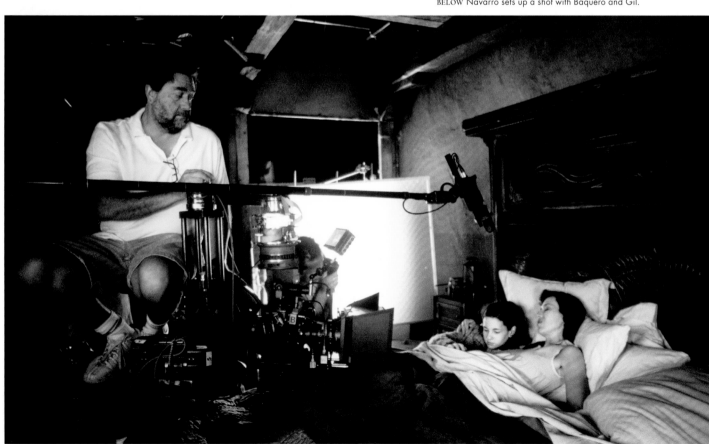

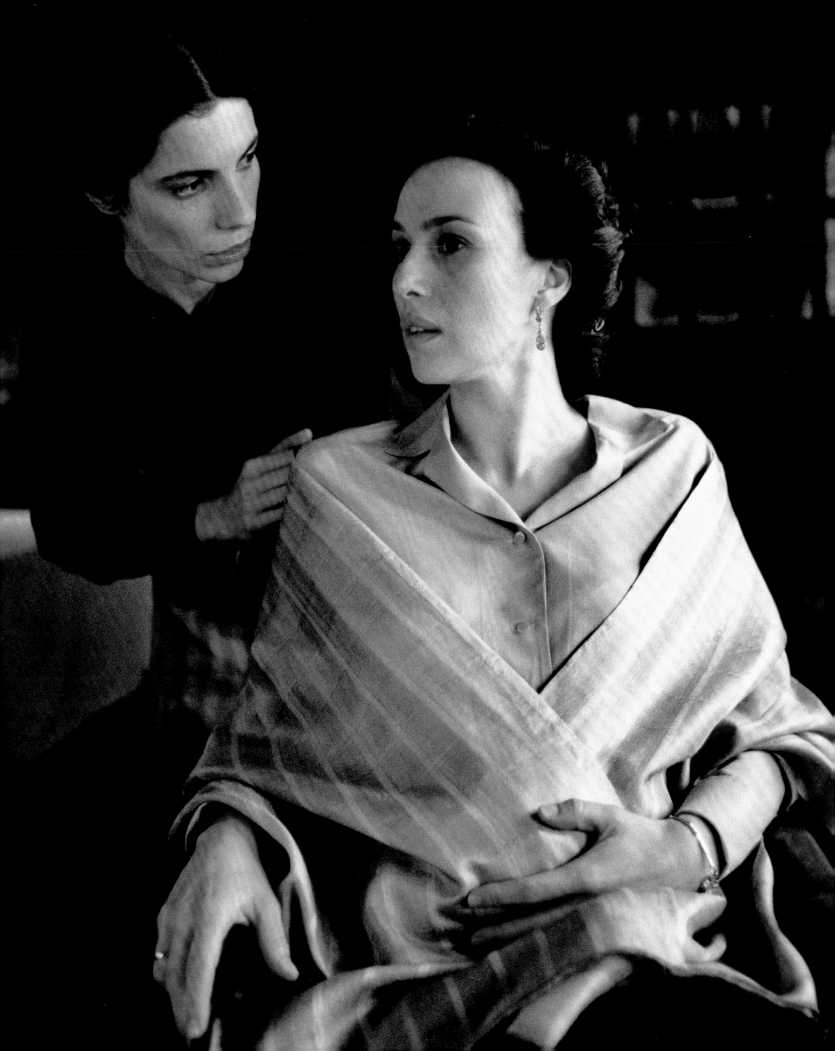

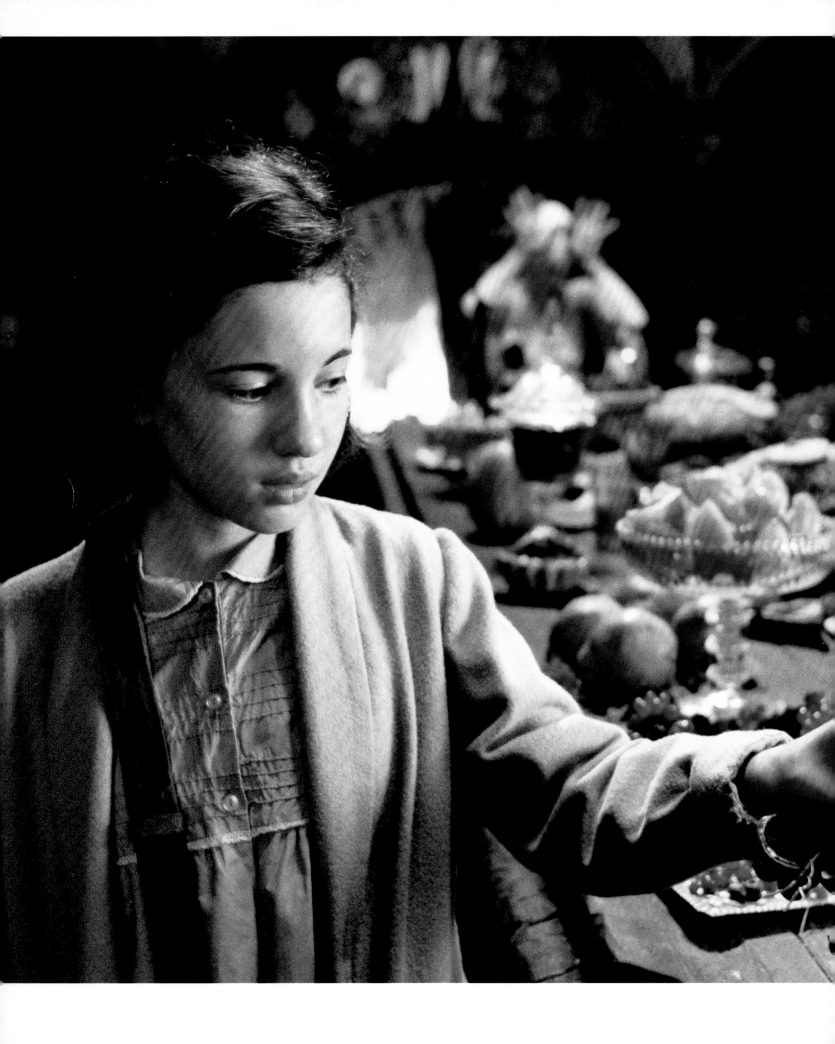

Accompanied by three fairy guides assigned to her by the Faun, Ofelia traverses a magic portal and enters a chamber where a banquet table can be seen in front of a fire. Startled, she sees the ghastly pale and eyeless figure sitting at the head of the table, silent and trancelike. Ofelia completes her task, but as she turns to leave, the lavish banquet table proves irresistible. She succumbs to temptation and eats a plump grape, awakening the monster. The creature slowly takes a pair of eyes from its plate and inserts them into stigmata-like cavities in its palms. It haltingly stands and advances on Ofelia. . . .

Guillermo Navarro notes that the sequence purposely avoids the horror conventions of darkness and shadow. "We had discussions about the basic color of the corridor and we insisted it had to be very red, like blood," he says. "We created a chimney [to match] the dinner scene with the Captain where he has a similar chimney behind him. There are all kinds of symbols. It's an essential scene, the innocence of this girl doing this task and how brave she is going where there is this [creature]. In all these fable stories you have these rules you have to fulfill. But her intuition takes her through this space. In order to go through things you do not follow the rules. You follow your heart."

Eugenio Caballero recalls "creative differences" concerning the bloodred look. The pillars and arches resemble gothic and religious architecture, and he had assumed the space would have been carved out of natural stone, as in ancient Petra and the ruins of pre-Hispanic dwellings and pueblos. As the set developed in black-and-white pencil sketches he had never imagined a

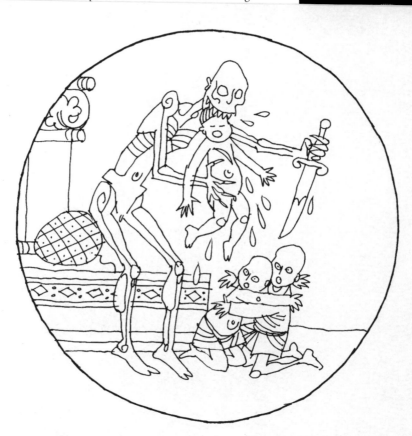

akens.
us
ling the
ren,
by

pt art

asis of
an's lair

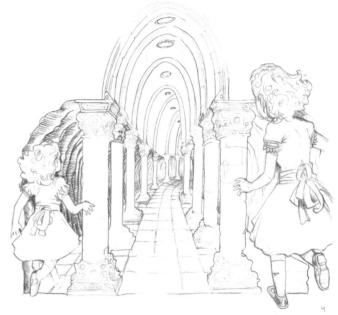

"We were close to the build, and Guillermo said, 'That rock should be red, like it's part of a human body,'" Caballero recalls. "I was shocked by the proposal. I said, 'I think we're breaking the code here because even when we're creating something that is fantasy, everything looks real.' A rock looks like a rock, a wooden beam looks like a wooden beam. But Guillermo had that concept very clear. At the end, it was a hell of a decision. We prepared some tests. One was a sort of dark, dried blood color, and I was convinced that it would add to the complexity of what we already had, this reference to gothic and religious architecture."

"I also made sure that the entire banquet was red—as if made of blood," says del Toro. "The perversity of this ogre—it has all that food in front of it but eats only children."

Del Toro's bloodred aesthetic extended to the checkered pattern on the floor, which was originally supposed to be black and white. The space, he decided, had to reflect the inward nature of Ofelia's quest. "There are two types of fairy tales," del Toro explains. "One is about facing the outward monsters; the other about traveling inside your subconscious, your imagination, the Jungian depths, and *Pan's Labyrinth* is very much that. It's about the girl dreaming about going back into the womb of the

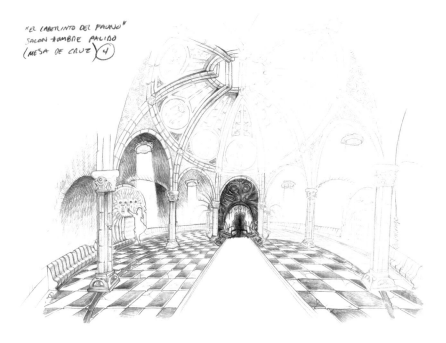

The production designer was proud of his department's work on the sequence—but there was a lesson he learned in the lair. "It was a beautiful set," Caballero recounts, "with the big table and those arches, that cave over the Pale Man. We made 'wild [movable] walls' to shoot. I felt we had taken everything into consideration. We had this big chimney, a mirror of the one in the real world of Captain Vidal. The special effects [department] made a huge fire with gas, but something was not done properly and [someone hadn't anticipated] how the smell of burning gas would [be ventilated from the] set. Guillermo didn't feel well that day, which is not good. We fixed the problem, but it was a big lesson for me. I was coming from smaller films, where even the technique of a wild wall was a big problem with the builders I worked with. Now, I think of a set as a film machine, not just a beautiful space. You have to take everything into consideration in terms of practicality. On *Pan's Labyrinth* I suddenly had to think through all of these big problems."

The Pale Man went through a long design evolution. Bertha Navarro recalls that when they were preparing for *Pan's Labyrinth*, she and del Toro would visit Madrid's

OPPOSITE TOP LEFT The lair features a blood red corridor— "like the inside of a body," del Toro says—to visually echo the theme of the heroine's journey into interior and subconscious space.

OPPOSITE TOP RIGHT Corridor concept by Raúl Monge.

OPPOSITE BOTTOM LEFT Pale Man concepts, such as this example by Raúl Monge, included a withered old man on a throne.

OPPOSITE MIDDLE RIGHT The Pale Man's throne under construction.

ABOVE A view of the Pale Man's lair by Raúl Monge.

BELOW RIGHT A translucent "nerve ghost" as first imagined in del Toro's notebook.

FAR RIGHT In this iteration of the nerve ghost by William Stout, the apparition disgorges a skeletal horse jaw, an idea that would be transposed to earlier versions of the Pale Man before being dropped from the film.

mother for me, you know?" he chuckles. "And I wanted all the fantasy to be womb-like. The tunnel on the frog set was very womb-like; the fig tree looks like Fallopian tubes. I just instinctively knew the Pale Man's lair needed to feel almost like the inside of a body, because that was where I instinctively felt the fantasy was."

Other ideas fell by the wayside, such as having the ghosts of the dead children the Pale Man has eaten coming out of the walls to chase Ofelia. "And they were going to be translucent ghosts, so you could see their skeletons and nerves," del Toro recalls. "But the budget and the technology were not on my side. So, I said, 'Okay, instead of the ghosts of the kids, I'm going to have a pile of shoes, because that is more eerie.' I always remember as a kid that whenever you saw a car accident, for whatever reason there was always a shoe on the pavement. The image of the little shoes with this sort of chimney behind also evokes the concentration camps."

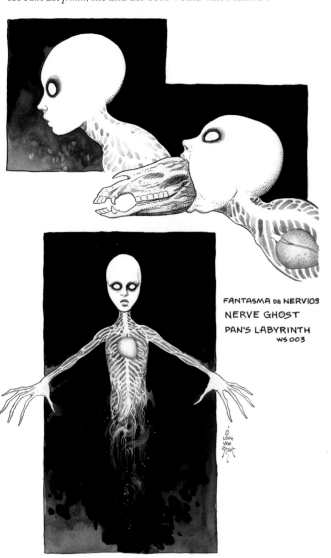

FANTASMA DE NERVIOS
NERVE GHOST
Pan's Labyrinth
WS 003

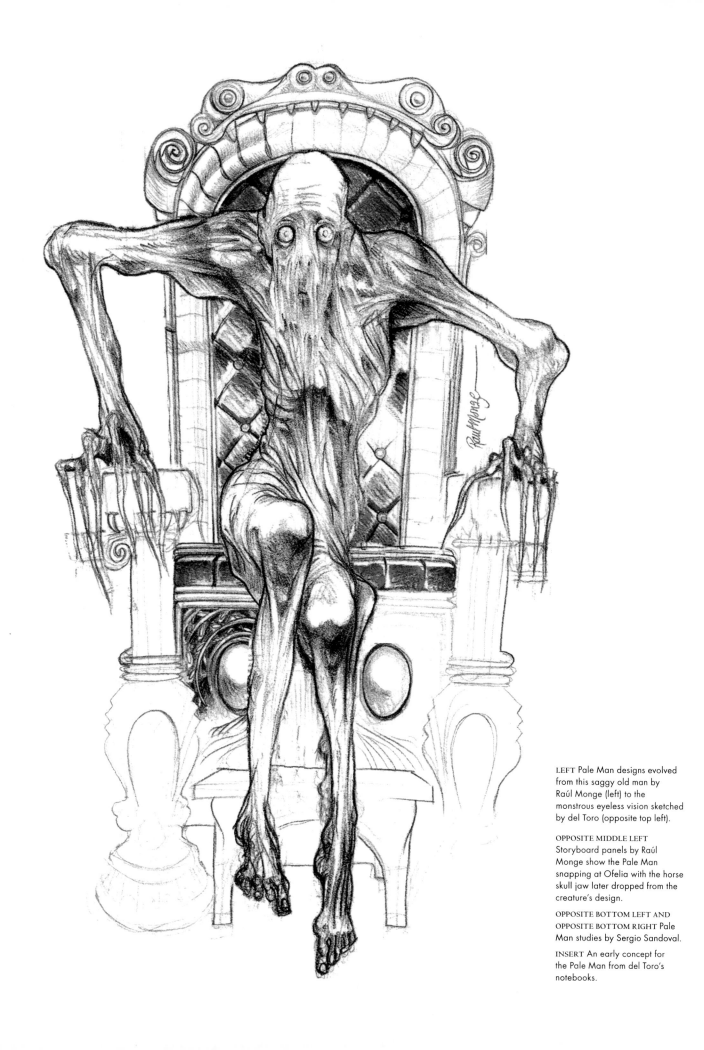

LEFT Pale Man designs evolved from this saggy old man by Raúl Monge (left) to the monstrous eyeless vision sketched by del Toro (opposite top left).

OPPOSITE MIDDLE LEFT Storyboard panels by Raúl Monge show the Pale Man snapping at Ofelia with the horse skull jaw later dropped from the creature's design.

OPPOSITE BOTTOM LEFT AND OPPOSITE BOTTOM RIGHT Pale Man studies by Sergio Sandoval.

INSERT An early concept for the Pale Man from del Toro's notebooks.

representaban a la élite. Sus puntos de vista políticos eran del hombre de la calle. Quizá por ello su odio hacia los nazis o los "Enemigos extranjeros" anticipa incluso la posición de E.U.A. ante la WWII.

Los años 30's y los 40's ven una explosión de Héroes de todo tipo.: La araña, la Sombra, Doc Savage, Capitán América, Superman, El vengador, etc. etc.

Hellboy es hijo de los pulps, Kirby y Sgt. Rock (1959, Kaniger)

- Charles Fort (1874, 1932, New York) Ciego, como J.L. Borges.

- Desde el momento en que nacemos, iniciamos un largo camino hacia la muerte. Se llama vida y se aprende al final.

→ Pasar de la _____ última pieza de
la corona _____ a la subasta.
- La _____ un trozo de
espada _____ a H.B
si la _____ tocan
se "mueve" _____ y lo matará
cuando el _____ "malo"
nueva _____ por fin
_____ arma!

- One eye, One

- Ya no quedan espadas. Nunca las hubo. Lo sé

- Reliquia/subasta

- I pity the fool.

- It's like walking in on yourself.

- Hellboy pelea con "Iron Shoes" en algún momento de la cinta.

- La punta de la espada localiza la posición de Hellboy

- Sim Cung para un papel en el grupo de profesores de U.M

- Hellboy encuentra al Ídolo en Praga y _____

6 wings for the fairies.

but he wanted
body. I think that
ent, a poetic

come up with a
a scene where the
Del Toro asked
him. "The first
of you, to reach
explains. "And
he came over with
looked at it and said,
"Yes, yes, yes! This
grab the fairies
them with your
nk about it? Let's
he hands with the
e evil eyebrows.
makeup, we were
oney, Guillermo
ch better than the
y bad time and
ld not be as iconic

99

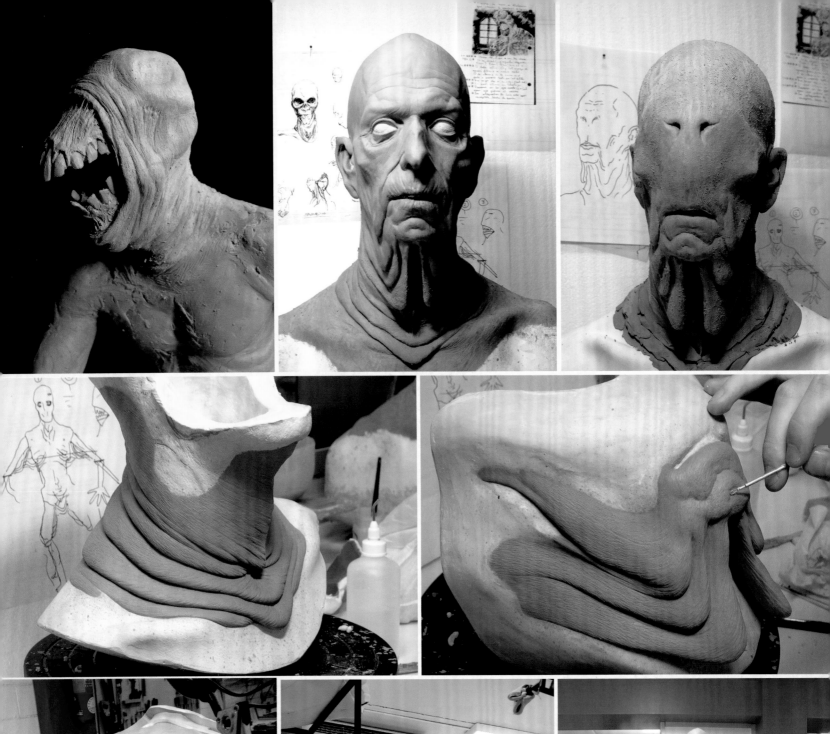
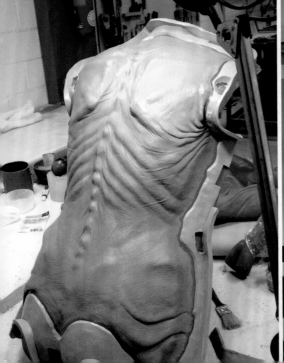
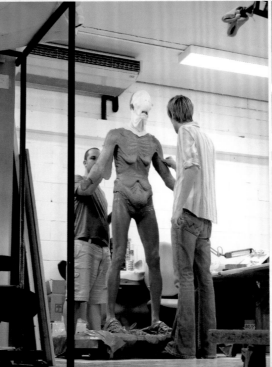
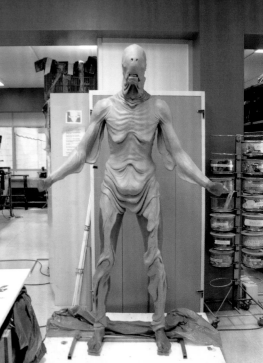

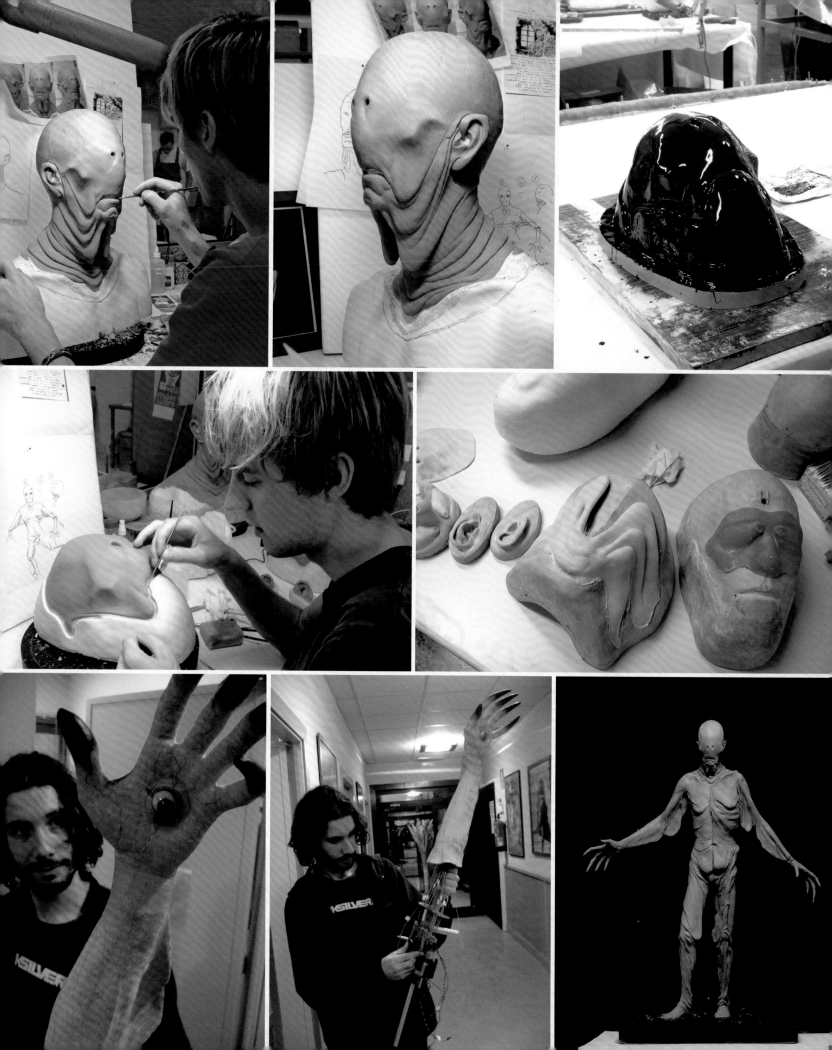

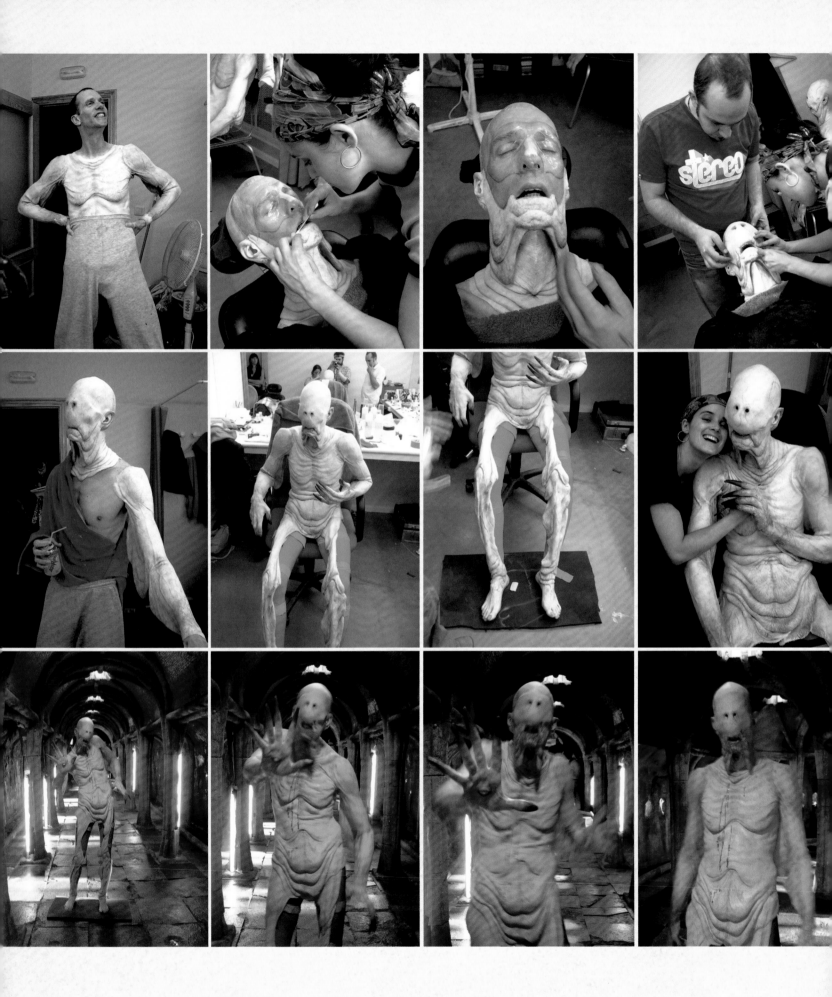

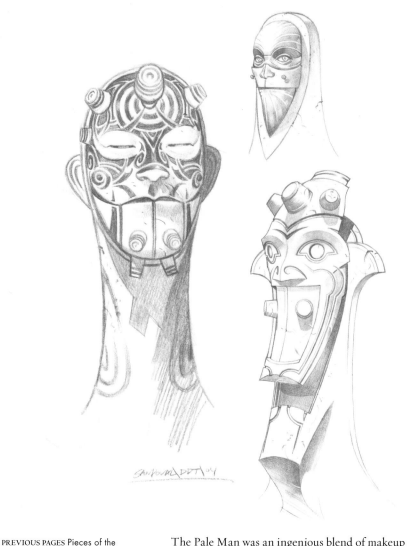

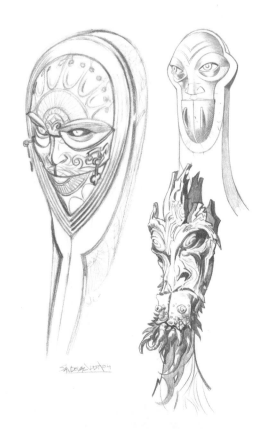

PREVIOUS PAGES Pieces of the Pale Man take form in the DDT shop, including an earlier design that was far more human looking than the eyeless final version.

OPPOSITE The design included greenscreen leg wrappings for Doug Jones that, in the final film, only reveal the spindly prosthetic leg pieces. DDT's Montse Ribé can be seen cozying up to the terrifying Pale Man (middle row, right).

ABOVE AND FAR RIGHT An early concept envisioned the Pale Man as a carved wooden figure, as in these studies by Sergio Sandoval.

ABOVE RIGHT The DDT team, including David Marti and Montse Ribé on left and Arturo Balserio and Xavier Bastida on right, pose with Doug Jones as the Pale Man.

The Pale Man was an ingenious blend of makeup and prosthetic pieces from head to hips, with Doug Jones's own legs wrapped in greenscreen and the actor wearing prosthetic versions of the creature's spindly legs. "In postproduction they could digitally wipe away my real legs and what you saw was the prosthetic leg responding to my steps and body language," Jones explains. "It was another brilliant design, because it's minimal CG to remove something as opposed to creating [legs] that have to move."

"There were no mechanics, but there was the blending and gluing down of the edges of the head, neck, and arms," Jones adds. "It took time to get it all on perfectly and time to take off, the tearing down and ungluing. The removal and cleanup process can be the most traumatic for your skin, but the folks at DDT are so protective and caring with their actors. As they were removing the Pale Man makeup the first night, I was looking at the time and it was getting so late. They'd take it off but I'd soon have to put it back on again. According to the usual rules, you're supposed to clean up all over at the end of the day. But we were working in Spain, not with the American unions. So I told them to just take my head and hands off and leave the rest—the arms and torso and everything—and I would wear it back to my hotel. They put saran wrap around it, so it wouldn't stick, and I wore a big sweatshirt over it. I

ended up wearing that body around for four days in a row. It was the sacrifice you make to get things done on time and [with a tight] budget. By the time I could take it off all the way, that was the best shower of my life!"

Although Jones did not have to cope with ringing motors in the creature's head like he did with his Faun getup, his sight was restricted—the Pale Man's nose and profile was flattened and the actor could see through only the nostrils, which were two inches from his eyes. "That was difficult," Martí says, "because he had to act, to walk, he had to chase Ofelia. But Doug Jones always wants to have his time with the makeup because until he has it on he doesn't know what he can and cannot do. So he will observe himself in a mirror and start to move. He started to walk like the Pale Man, with this kind of hanging, heavy body because he has been sitting for such a long time. Guillermo liked it from the very beginning.

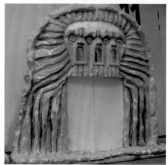

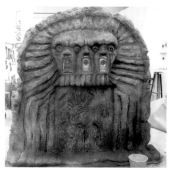

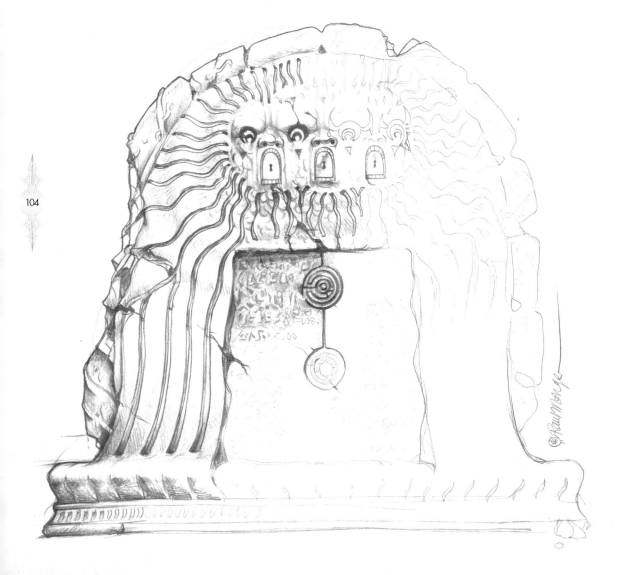

104

TOP Del Toro and Baquero eye a prop on the Pale Man set. On the wall behind them are three tabernacle-like doors, one of which Ofelia must choose to open, using the key won from her first task.

OPPOSITE The idea of the three doors was inspired by an early del Toro notebook concept of the Pale Man as a wooden figure with drawers.

LEFT Raúl Monge concept art for the three doors from Ofelia's challenge.

ABOVE The doors under construction prior to filming.

INSERT Ofelia makes her choice at the tabernacle, sketch by Raúl Monge.

"EL LABERINTO DEL FAUNO"
LAPIDA PUERTA
SALON HOMBRE PALIDO
BOCETO

—Inicio libreta nueva. Conocí a Steven Spielberg y me dijo lo mucho que le gustaba "Hellboy" Alucinante. "La flexibilidad vence a la rigidez."

-Bulbos.

Semillas.
Dentro de la castaña vienen 5 semillas que hay que sembrar justo debajo de las raíces del árbol viejo en luna llena. Regarlas con un chorrito de su pis. El muñeco de madera con la llave secreta.

8/9/04
encontramos un ... al lado del ...

-El oro es ponzoñe muy pero muy mortal de los cuerpos de todas Europas. En el nuestro podría ser oro y una comida en la mesa de la tentación. Que entienda el público más fácil de los dos (???)

-Revisar el regreso a Oz de ... para sonidos

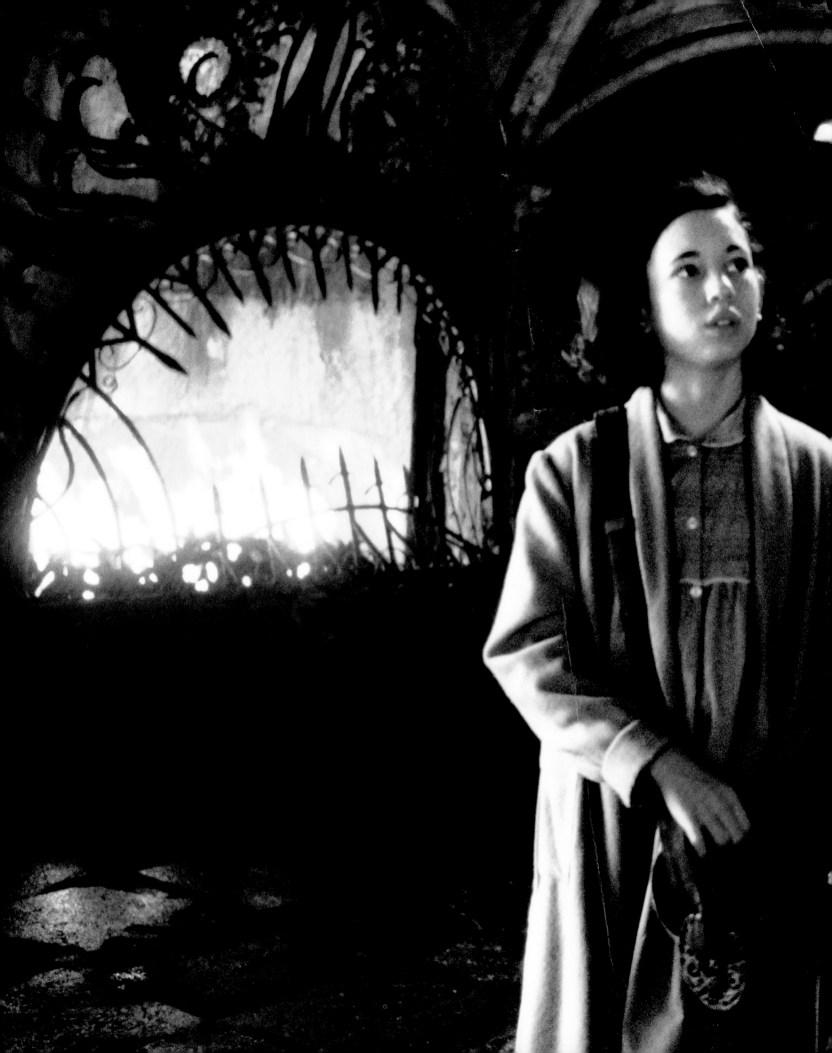

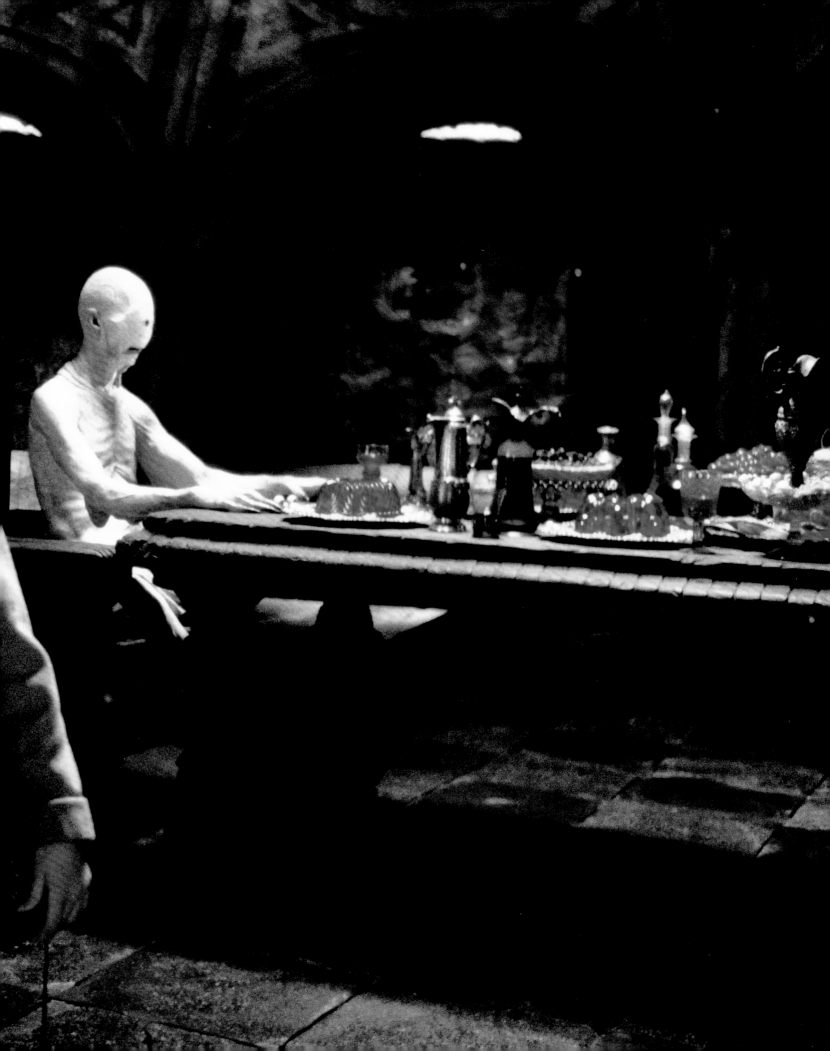

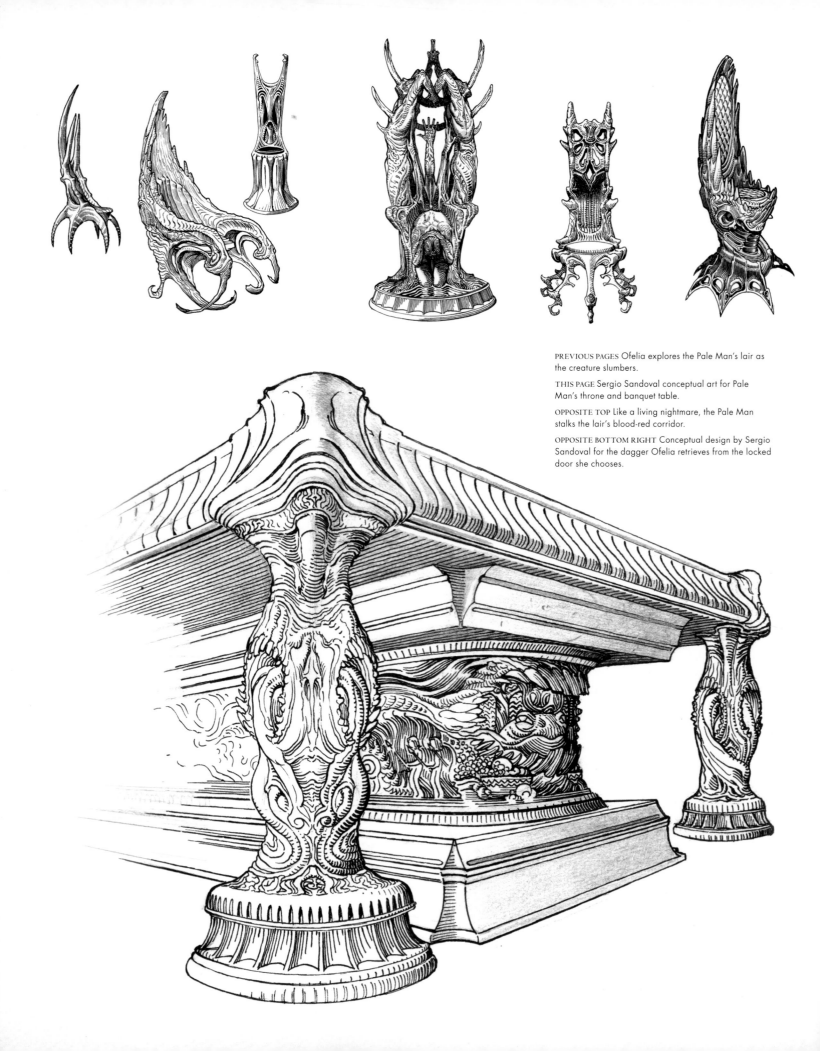

PREVIOUS PAGES Ofelia explores the Pale Man's lair as the creature slumbers.

THIS PAGE Sergio Sandoval conceptual art for Pale Man's throne and banquet table.

OPPOSITE TOP Like a living nightmare, the Pale Man stalks the lair's blood-red corridor.

OPPOSITE BOTTOM RIGHT Conceptual design by Sergio Sandoval for the dagger Ofelia retrieves from the locked door she chooses.

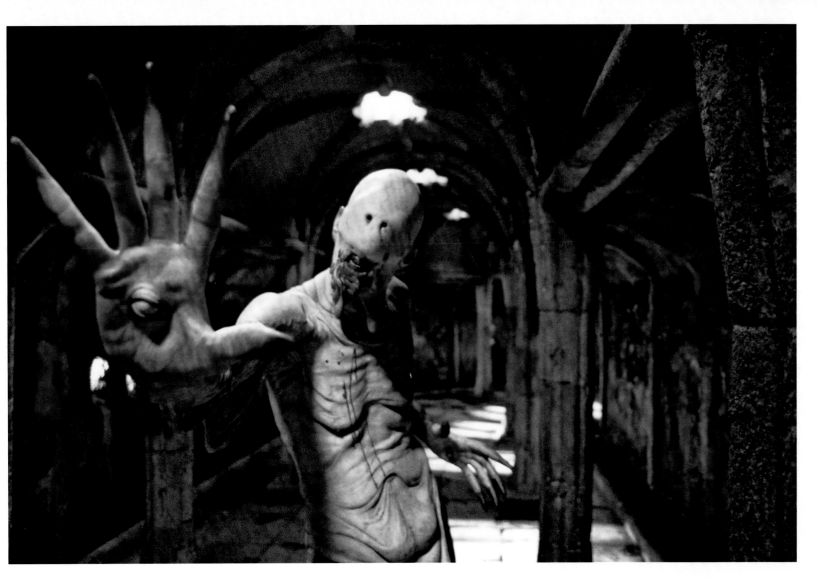

There is what we call the 'Doug Jones touch.' Even the way he moves his hands is very particular."

During her ordeal in the Pale Man's lair, and before the monster devours her fairy guides, Ofelia takes the key from her first task and turns to a wall and three little doors, imagined by del Toro as resembling a church tabernacle. The fairies buzz and gesture toward the middle one, but Ofelia ignores them and instead unlocks the left door, reaching in to pull out a golden dagger.

The three little doors in Ofelia's test were inspired by one of del Toro's first concepts for the monster. "Originally the Pale Man was going to be a wooden figure with drawers, a drawer for a mouth, a drawer on the chest, a drawer in the belly, and she needed to choose one," he explains. "But I thought the three doors were more interesting. The middle door is made of gold, the right one is silver, and the one made of humble wood is the door she chooses.

"In the movie, I used two symbols constantly—eyes and mouths," del Toro continues. "At the beginning, she puts an eye back on the sculpture and the fairy insect comes out of the mouth. And then I [visually] rhymed that with the mouth of the door the dagger comes out of. And if the key opens a door and she takes out a dagger, whatever the dagger is going to do cannot be good news: It's just fairy-tale logic—'choose the most humble option.' For

me, that's storytelling done visually. You see the progression of the tasks is a key that opens a door that gets a dagger—it's going to draw blood at some point. So the final test is, 'Will you use the dagger or not?'"

The avoidance of horror film clichés in the Pale Man sequence included Javier Navarrete's music as Ofelia succumbs to the temptation of tasting fruit from the lavish banquet. "We absolutely did not want the conventional way of scaring people, to make them jump out of their seats," Navarrete notes. "There is a 'hit,' as we call it, where the music evokes a scare and it does become horror music when the girl is chased by the creature. But the first part had to reflect the idea that she is not allowed to eat but is tempted by the food. So it is sensual, temptation music."

"And here is where we made the biggest editing faux pas in the movie," reveals del Toro. "In the last two days, my editor, Bernat Vilaplana, and I decided to remove a crucial line that explains why Ofelia is so hungry. Mercedes, right before this scene, tells her, 'You haven't eaten a thing' and then sings to her. We removed that line and—much as the grape works in fairy-tale lore—it removed the notion that Ofelia has not eaten since that morning."

The eyes the Pale Man inserts into his palms came from the iconography of Saint Lucy, a martyr and one of eight women commemorated with the Virgin Mary

109

in the canon of the Mass. Saint Lucy is also revered as a protector of eyesight and has been pictured holding a plate with two eyes on it—a disturbing image to "lapsed Catholic" del Toro.[2]

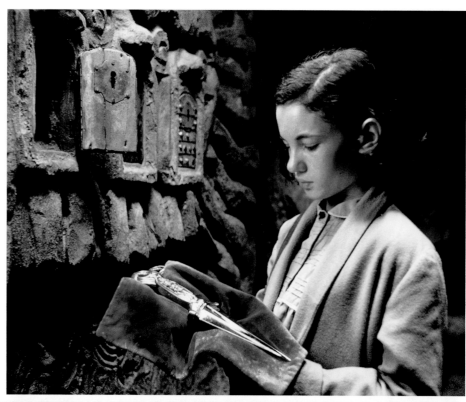

And what was Doug Jones thinking as he made the Pale Man come to life? "I didn't know where he came from—was he hatched, birthed?" the actor muses. "How long have I been asleep? We don't know. But all the saggy skin would denote that I've lost a lot of weight. But I've eaten a lot of children, as you can see in the pile of shoes. I've been sitting there a long time, kind of wasting away—until I get another child who comes in and does what Ofelia does. She takes a piece of food from the table, one little grape, but she was told not to. That's breaking the rules! And that's what disturbs my slumber. So that banquet table is a trap for children. I think what was running through my mind was, 'Wake up. I'm *hungry!*' And that child smelled really good, that was like bacon and eggs cooking."

Del Toro recalls a high point of making *Pan's Labyrinth* was screening the finished film for famed writer Stephen King and his son. During the Pale Man sequence, del Toro's favorite living writer, the acknowledged master of horror and suspense, visibly squirmed.

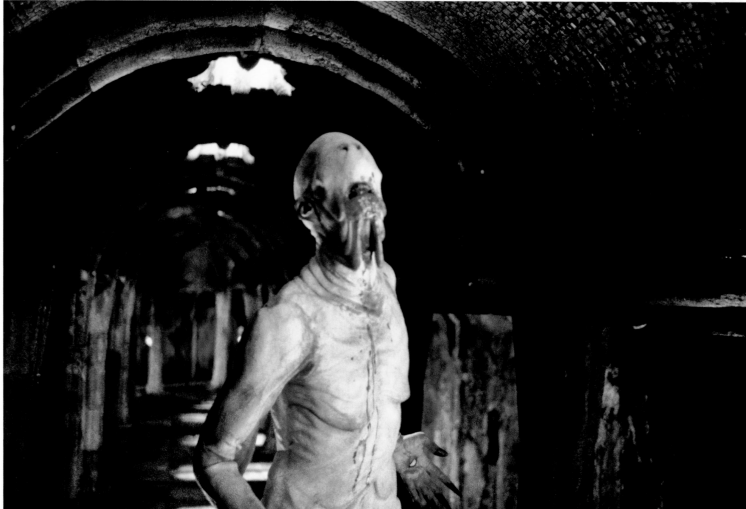

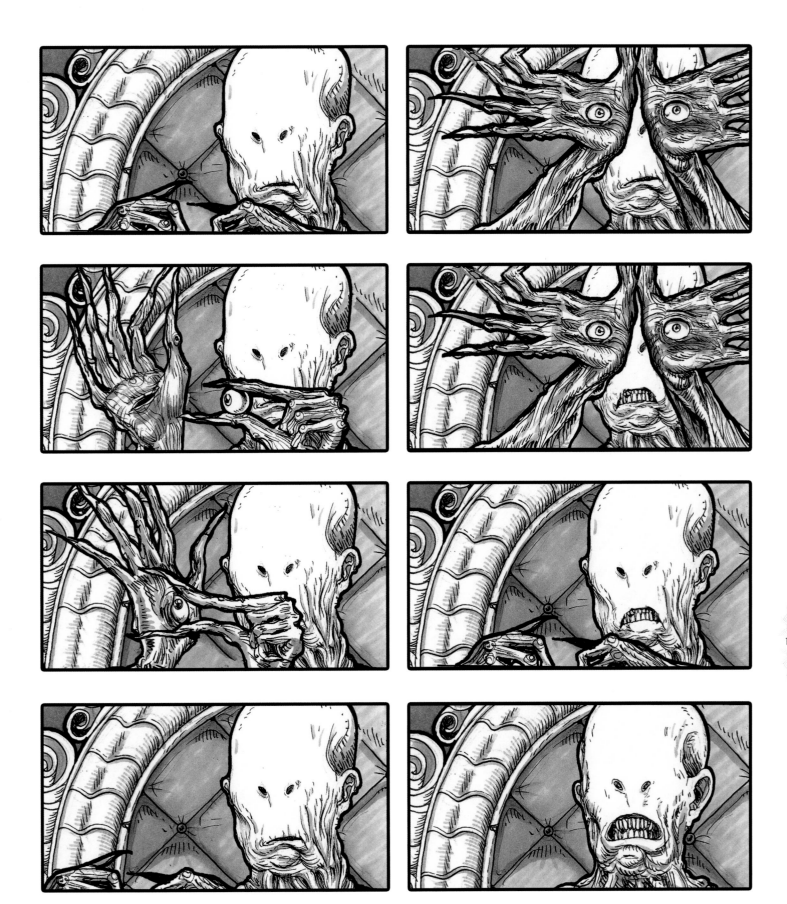

OPPOSITE TOP Ofelia gazes at the dagger, an object that will come to have vital significance in the film's final act.

OPPOSITE BOTTOM The Pale Man narrowly misses his prey.

ABOVE A Raúl Monge storyboard sequence depicts the Pale Man's awful awakening.

Guillermo had a huge film to make, with very little resources. I didn't know how he was going to do it. It was also a tough shoot because he was very clear that although his lead was a girl, this was a story about brutality and cruelty. Maybe it was at that dinner in London, when he first told me the story, but I remember talking to him about the cruelty. It is a fairy tale, but it's not for children. It would be irresponsible to shy away from the violence. I said, "You just have to trust that your heart is in the right place." So he decided not to shy from the violence because that would be against the purpose. —ALFONSO CUARÓN

THE HUMANOID-LOOKING MANDRAKE is another echo between worlds, a skewed reflection of Carmen's unborn child. But even as the mandrake hidden under the ailing mother's bed begins to heal her, Vidal discovers it and is disgusted by the thing. But it is Carmen, who has given up on magic and wants Ofelia to grow up and face the "real world," who kills it by throwing it into a fire.

CHAPTER 6
DARKNESS ASCENDANT

OPPOSITE The mythical mandrake has held a life-long fascination for del Toro. Here his notebook drawing and notes imagine the exposed roots as resembling human limbs and facial features.

ABOVE RIGHT A disgusted Vidal discovers the mandrake root that Ofelia has placed in a bowl of milk under her sick mother's bed.

Del Toro asked DDT to reproduce an old style of Spanish bowl for the mandrake to lay in. They sculpted it out of clay and made three plastic finals for use on set. Martí was showing them to del Toro, when the director explained that Vidal was to break the bowl when he discovers the mandrake, so he needed at least fifty to cover potential takes.

"You don't want the actor to be upset and you want to give the director what he needs—but you can't because of the money," Martí recalls. "But when Guillermo said he needed at least fifty bowls, I said, 'No way! With this one bowl you can shoot all the fucking takes you want!' And I took the bowl and I threw it up to the ceiling. The bowl was up in the air and I was already thinking, 'What the fuck are you doing, David?' That was a slow-motion kind of moment. And the bowl falls to the floor and goes *bong, bong, bong*. It didn't break; it just bounced. I took the bowl from the floor, put it on the table, and said, '*Here!* You have your damn fifty bowls.' Guillermo looked at me like, 'David, are you mad at me?'

"He understood we were under so much pressure. He was like, 'These guys are *burned*.' He has big eyes and he was starting to tear up. And, suddenly, he goes and hugs me super strong. He said, 'I'm very sorry. This is a lot of pressure, but we don't have to be mad at each other.' Another director would say, 'Fuck you, I want my fifty bowls.' After he hugged me we started to walk and it's like a scene out of *The Sopranos* because then he said, 'So, David, are you okay?' 'Yeah, I'm okay, much better.' And then Guillermo said, 'Now you have to know, this is the first time of the three that you can be mad at me. After the third time we are done.'

"So, I still have two left," Martí laughs.

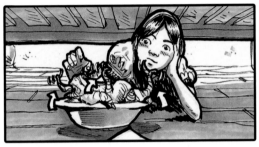

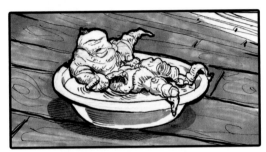
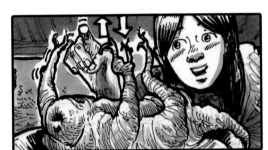
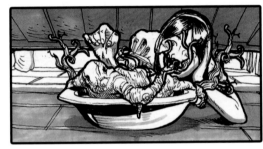

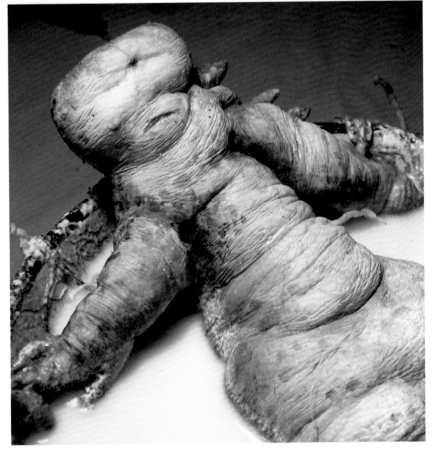

"No one was under more pressure than I was, but I honestly understood where he was coming from," del Toro adds. "For DDT this film was a huge growth from, say, *Devil's Backbone*, when it was one creature and a handful of effects."

The mandrake itself was a sore point, with del Toro asking DDT to create two animatronic versions of the creature, a version small enough to fit into a bowl and a version four times bigger, what Martí called the "fat mandrake," to be used in foreground shots so that they wouldn't lose sharpness (a technique del Toro went on to use in *Hellboy II*, *Pacific Rim*, and *Crimson Peak*). Although the small version was used for shots of the mandrake in the bowl and under the bed, the director ended up not using the bigger version. "I wanted David to create this oversize mandrake that was easier to manipulate and control," del Toro explains. "I've used oversize creatures and miniatures—or 'maxi-tures,' if you will. I thought we could do the same with the mandrake and give David more room to operate it, but I quite honestly didn't like the paint job. I approved every stage of the sculpting, but we were building the sets in preproduction and I couldn't approve the paint job. We ended up substituting the mandrake, almost all the time, for a CG mandrake."

TOP AND LEFT The mandrake takes form, from Raúl Monge storyboard art to physical prop.

114

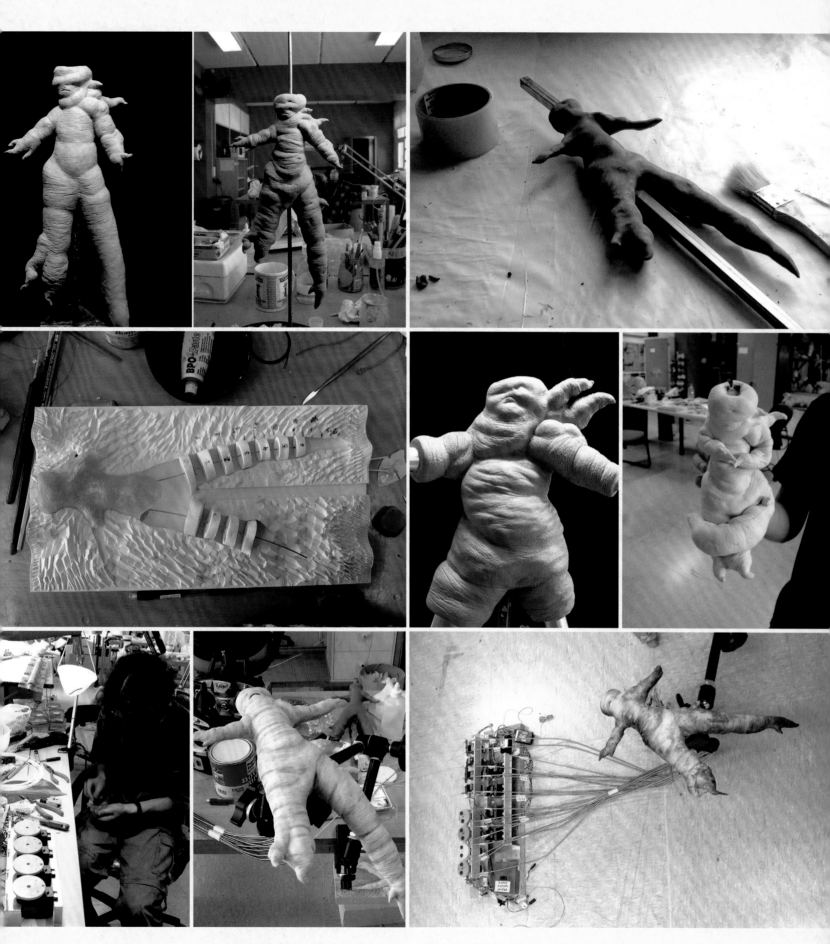

ABOVE DDT built two animatronic mandrakes, one small enough to fill a bowl, the other an oversized prop nicknamed the "fat mandrake."

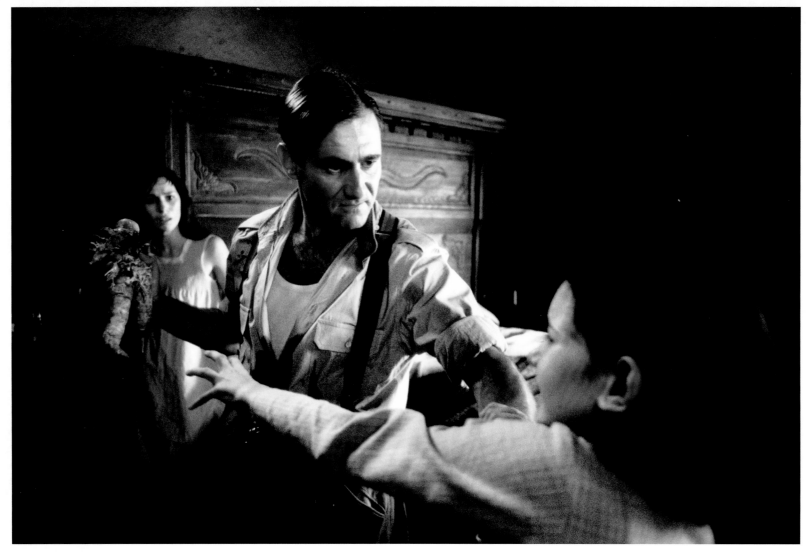

Del Toro notes the production stress had a particular impact on the makeup effects department, and David Martí confirms that two key members of DDT's crew left during the filming. "David and Montse were having a lot of dissonance among their ranks," del Toro says. "People quit on them and, at some point, I think David was ready to quit, too. But David and Montse are absolute soldiers. They will not leave until [the job is finished]. They were completely heroic about delivering."

The interrogation scene, featuring a stuttering guerrilla whom Vidal toys with, is another prime example of a potentially disastrous production problem and what del Toro calls his "negotiation with accidents."

In the film, the interrogation comes about as Ofelia endures her lowest, loneliest emotional point in both worlds. After the flames consume the mandrake, along with its healing powers, her mother dies, although Ofelia's baby brother is saved. Ofelia is now an orphan at the mercy of her evil stepfather. Her quest to return to the promised throne also seems over, because she disobeyed and ate from the Pale Man's table.

Vidal's forces are winning the real-world battle as well. The seemingly fading fortune of the resistance is epitomized by Vidal's sadistic interrogation of the captured guerrilla, one of the seminal scenes del

Toro imagined back in 1993. Even Dr. Ferreiro's support of the resistance is discovered and Vidal coldly shoots him in the back. The Captain will soon be out for Ofelia's blood, embodying del Toro's vision of the "fairy-tale essence" as he essentially becomes the big, bad wolf.

The interrogation was originally planned to take place in a chicken coop alongside the mill, but there was a problem with the set, one del Toro likens to the classic *Spinal Tap* scene in which that film's fictitious heavy metal band takes the stage with a prop of Stonehenge that, thanks to bad measurements, is not a towering icon but a scale miniature. "The exterior of the pigeon coop was okay, but, like the *Spinal Tap* Stonehenge, the measurements for the interior were structurally wrong," del Toro explains. "We couldn't fit in the cameras or the actors to shoot the interrogation! It was too small, and we didn't have time to make it ready."

It was then that del Toro and Eugenio Caballero decided to shift the interrogation scene to the set that was variously called the "pantry" or "warehouse," where food and medicine is kept under lock and key. Originally, that full exterior and interior set was planned for only two scenes, the first with Captain Vidal securing a padlock to the pantry door and telling Mercedes he was going to keep

TOP Although a furious Vidal discovers the mandrake, it is the mother who destroys it. With the mandrake's healing powers gone, Carmen succumbs to her illness, although her baby boy is saved.

OPPOSITE At her mother's funeral, the grieving Ofelia stands in the protective shadow of faithful Mercedes.

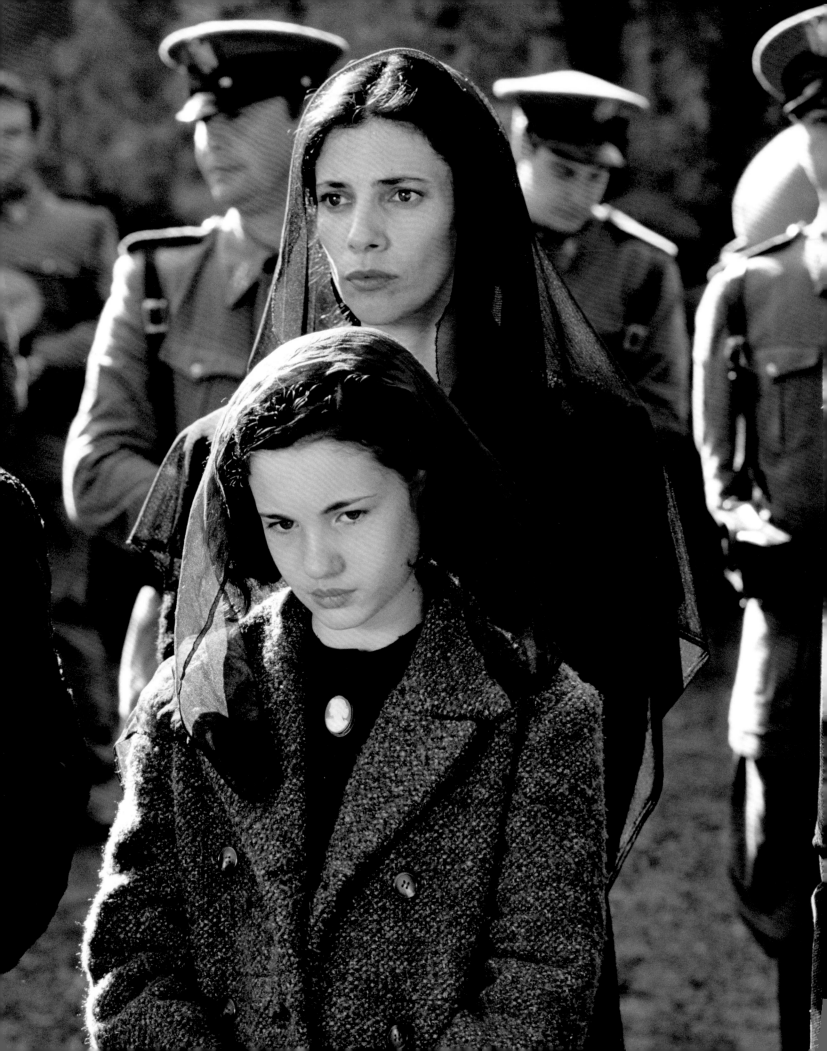

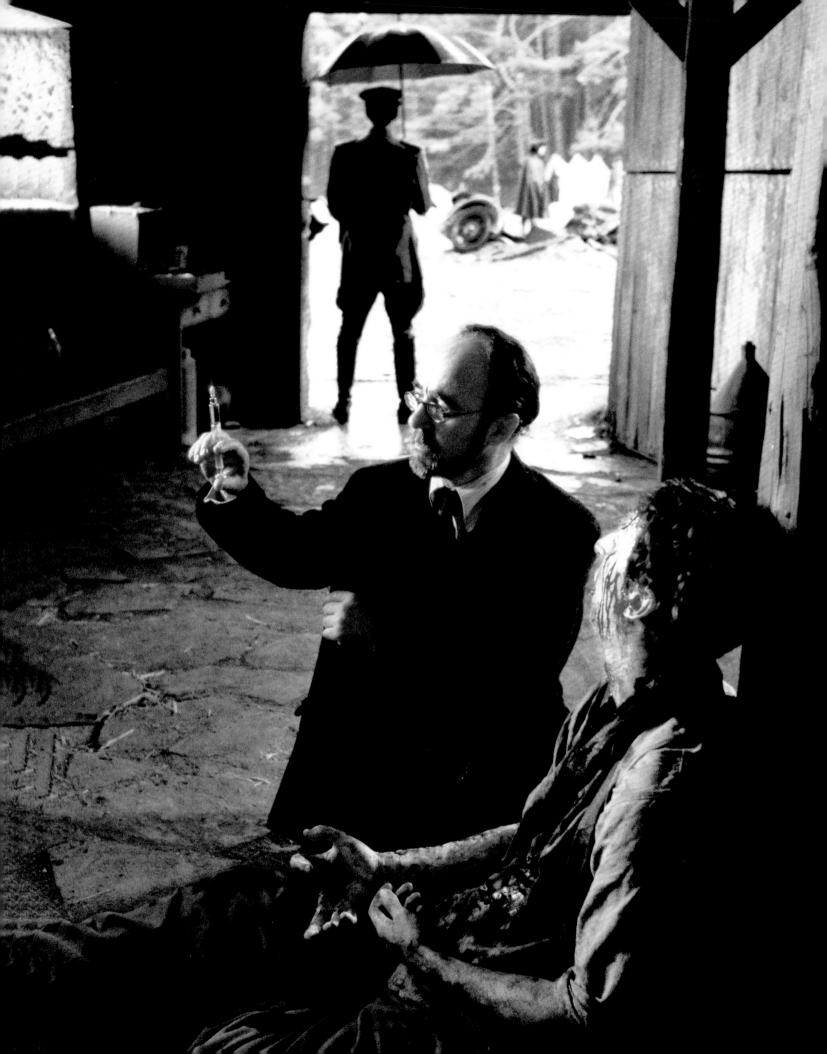

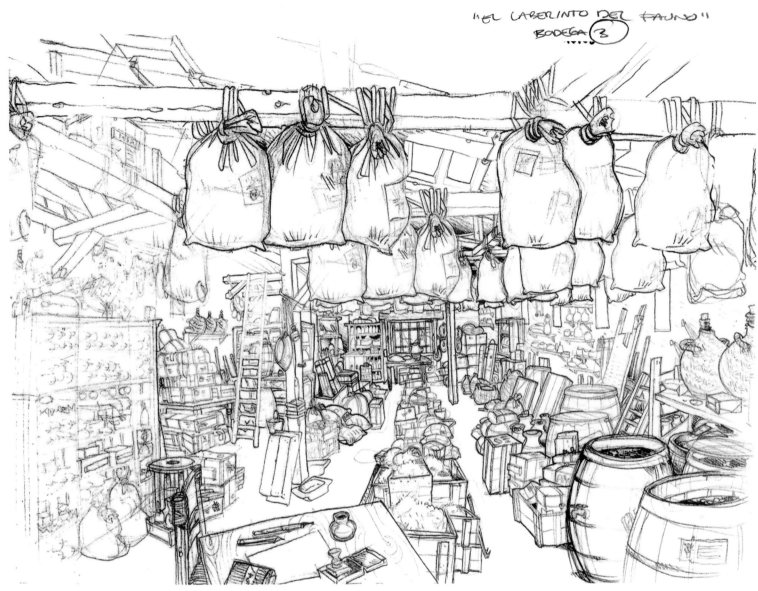

ABOVE A concept sketch by Raúl Monge of the "pantry" where the torture scene would eventually be staged.

OPPOSITE Doctor Ferreiro ministers to the tortured prisoner in the pantry. The new venue for the scene allowed del Toro to play with composition and contrast the incongruous warmth of what has become a torture chamber with the cold and wet weather outside.

the key, and then in the aftermath of the guerrilla raid, when Vidal discovers the lock has been opened.

"I said, very quickly, let's go to the warehouse and shoot the interrogation there, let's do a better job of dressing it and make it a hero set," del Toro says. "Honestly, it made for a better scene. Again, it was a huge failure that turned out to be good. It was better for the story, because that set had more straight lines that we were associating with the human world."

For the interrogation scene, del Toro's "negotiation with accidents" led him to not only use the fully built set to his advantage but also to create one of his favorite compositions for the film. Del Toro had the tortured stutterer sitting in the right foreground and being tended to by the doctor, with the frame of the open doorway looking directly out onto the rainy outdoors, with Vidal standing at a diagonal inside the left of the doorway frame and his two lieutenants standing with opened umbrellas outside to the right. "I love using a frame within the film frame," del Toro says. "That became a beautiful composition that was not planned beforehand."

The only problem with the new setting for the interrogation was the warm ambience inside, contrasted

with the view to the rainy outdoors, seemed to break one of the rules separating reality from fantasy. But, as cinematographer Navarro explains, they allowed themselves to stretch, even break, the rules: "The film is a unique piece that allowed us to have our own set of rules, and they weren't set in stone. For instance, [when the] military brings the prisoner to the pantry it's raining and very cold outside, but inside it is warm. Now, our definition for that military world was for it to be cold, with bold lines. But the distinction we made was that there was a human scale where the rebels and the women were, so inside that warehouse it's a warm environment. The continuation [of the rules] is underneath, in the narrative."

"Rules are like a good mold that allow you to shape a sculpture," adds del Toro. "You can pour ideas into that mold, but if they are too constricting, and damage the movie, you know they are not organic and they end up thrown to the wayside. On *Pan's Labyrinth* the movie kept changing. But the basic rules—the real world was cold and built in straight lines, the imaginary world was this sort of uterine red and amber and the shapes were very curvy—all that stayed."

119

The interrogation scene belies any sense of warmth or refuge from the cold world outside. Vidal sadistically puts fear into his prisoner as he reveals the pounding, stabbing, and cutting tools he will be applying to his victim's defenseless flesh. Cuarón observes that del Toro does not use "Hollywood violence," where the hero might get shot in the shoulder or suffer a perfectly composed cut that is artfully concealed behind a bandage. In *The Devil's Backbone*, for instance, the orphan boys prepare to take on Jacinto by sharpening staves into makeshift spears. The muscular Jacinto sneers at the scrawny kids—until he gets the sharp end of a spear buried in his armpit. "Guillermo can do *uncomfortable* violence," Cuarón says. "Guillermo can have characters hurt in 'ouch-y' ways."

Director James Cameron, whose action movies have had their share of violence, was concerned about the interrogation scene when he subsequently gave del Toro his feedback on the film. "In terms of technique, methodology, and directorial mind-set, Guillermo and I are very similar," he reflects. "He writes his films, I write my films. He designs, and I design. We both choreograph our action and are very actor-focused. But where we diverge is his love for horror, which is much deeper and broader than mine. My perspective is I don't need to invent horror—the world is full of horror as it is. One of the things I advised him was to cut out, or cut down, the torture scene. I said that when you do *Frankenstein* or any kind of mythic or metaphorical horror, there's a remove from the real world. But that type of torture probably took place in the Spanish Civil War and it felt too real

for me. But that's also what's important about it, because this is a film about dissociation, of escaping from horror into fantasy. Like any good artist he's going to do his own thing, but he's going to factor in what his friends and fellow artists tell him. I think he ultimately toned it down."

During his work on the score, composer Javier Navarrete was struck by the turbulence in Ofelia's mind as both worlds start unraveling. "Guillermo knows his story very well and what he wants of the music, but I realized some things as I was working on the score," Navarrete notes. "The path of the movie is like a maze. The strange side of her mind gets increasingly unsettled and, at the same time, the reality is also getting rougher because she has lost her mother and the Captain is getting uglier and uglier to her and everybody. There is growing tension in both worlds. As we're going through these increasingly demanding tests the girl doubts more and more, but she is also becoming more confidant of her fantasy world. It is like a circle that gets tighter and tighter and is spinning faster and faster and faster."

The production had to be ingenious in stretching a tight budget, but the adversities they were facing also included the aforementioned prohibition from the government's forest management agency that prevented them using normal pyrotechnics and even explosive "squibs"—used to simulate bullet hits—outdoors.

Jeff Barnes recalls that going into the production they weren't anticipating these restrictions at the forest location. But in another example of "invisible" effects—and the production's resourcefulness—CafeFX would fix

ABOVE Eugenio Caballero, Guillermo Navarro, and del Toro film another challenging outdoor scene.

OPPOSITE BOTTOM Vidal's carefully ordered world starts to fall apart as the rebels attack in these storyboards by Raúl Monge.

120

the problem in postproduction by adding muzzle flashes and blood bursts, with visual effects supervisor Everett Burrell heading the "Elements Unit." "If Guillermo was shooting a big dialogue scene, he would give me the second camera and crew, and me and the effects boys would set up a greenscreen in the corner of the stage," Burrell explains. "We'd shoot blood or smoke or gun muzzle flashes. On this film I learned a lot from Guillermo Navarro about how to light something and how *not* to light in terms of purposely keeping things in shadow. And Guillermo del Toro basically taught me how to direct. He said, 'When you say 'Action,' you yell it *loud* and with *power!*' When Guillermo says 'Action' you stand at attention. *We're making a movie!*"

The explosions seen in battle presented a whole other challenge that was solved using much less modern methods. "To create the illusion of an attack and explosions, I had to do it theatrically, with big lights," explains Guillermo Navarro. "It was not planned like that, of course. We had to react and come up with that solution. It was a set of gelled lights that you fade with a big switch—you create the moment of light and bring it down. It was very old-school theatrical. We had to pull off many, many things like that. We had to come up with clever ideas to fix things that in another situation would have had an easy solution."

"We also came up with the idea of using air cannons with mud for the explosions," del Toro adds. "But on the last day of shooting in the forest, we did blow up a truck because it was the last day and I said, 'Let's do it. What the fuck!'"

The blowing up of the truck was a rare "what the fuck" moment in a production that had to scrupulously adhere to all the requisite permits and shooting procedures. But adding to the pressures of the production, throughout principle photography del Toro and his team were being closely watched by a confederation of Spanish producers who wanted to see the production shut down, as del Toro recalls: "The way I interpret it is *Pan's Labyrinth* was seen as a Mexican group coming to make a movie in Spain, rather than using an existing Spanish-producing entity."

More ominous was del Toro's discovery that this organization had spies among the crew who each day were posting about mistakes or problems from the shoot on a blog and message board. "This message board was very unfriendly," del Toro recalls. "I have a director/producer friend who had access to this message board. I met with him a couple of times when he felt they were really going to threaten us. He kept telling me every couple of days, 'Be careful. They are coming for you. You better make sure all your paperwork is impeccable and up to date, because if they can, they will shut you down.' They were incredibly vigilant—in a negative way—about visas, shooting permits, the constraints placed on us because of the forest fires, everything. In many ways, this was worse [than battling with a studio]."

PART III
OUT OF THE
LABYRINTH

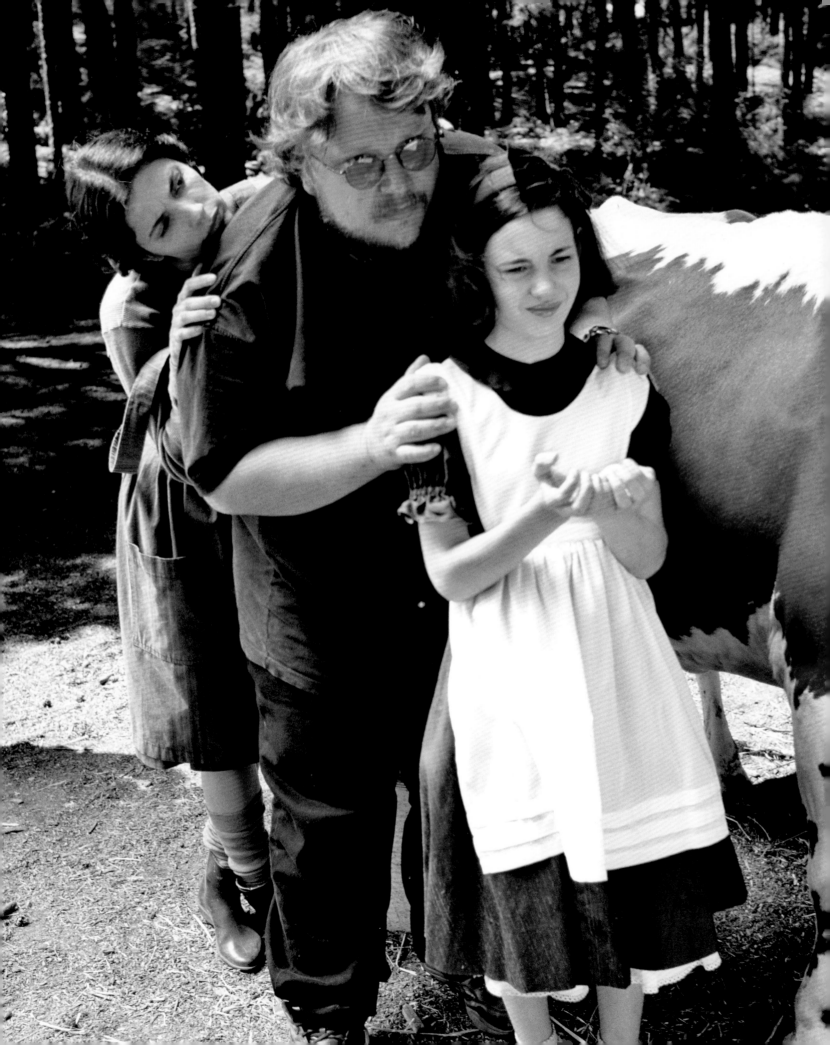

The idea is that no matter what she is told to do, Ofelia gets to disobey—to choose. As the movie was being developed a lot of people were saying, "Why is she so stubborn? She disobeys the Faun and she disobeys the fairies." And I said, "I really think that disobedience is actually the beginning of the will." You don't define who you are by obeying someone. I thought that it was important that she didn't obey the Faun, that she didn't obey the fairies—she followed her instincts. At the end of the movie the Faun tells her, "Give me the kid, we'll just take one drop of blood and we can go." That disobedience that accumulated through the film is what makes her say, "No. I renounce everything. I don't want to be a princess. I can't let you hurt my brother." And her refusal to draw blood is what allows her to pass the final test. —Guillermo del Toro

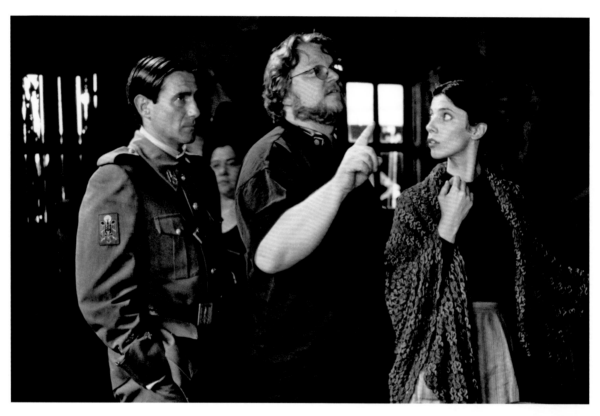

AFTER THE RELEASE of *Pan's Labyrinth*, the notion of a little girl at the center of a story steeped in violence and horror spiked some early controversy. But Ivana Baquero's fellow cast members note that she was never overwhelmed, either by the demands of her role or the terrors in the story. "Ivana was a little girl back then, but she was an authentic actress—she was more focused than the adults!" says Sergi López. "When she was acting with me we might be joking around or laughing before a scene, but when it came time to film it was like a switch"—he snaps his fingers—"and she'd be in character. It was beautiful to see. She is someone born to do this kind of thing. It was a lesson for the professionals, too. The whole thing was very simple. Guillermo is someone who doesn't leave a single loose thread. Ivana, Maribel, me, and all the characters, every angle and detail, he grabs hold of. Guillermo led, and Ivana was right behind him. The rest of us followed."

"When I first met her, there was a maturity, an old soul behind her eyes, that was so refreshing and different from any child actor I'd ever worked with before," says Doug Jones. "And when the camera rolled this utter magic came

out of her. She was so connected. A lot of us have worked with so many precocious kids or kids pushed forward by their parents. But for child actors in Europe, stardom is not revered as much as art. Ivana was a shining example of that. She had a respect for the art, of building a character from the inside out, so when the camera rolled, her heart and soul became Ofelia. You didn't see Ivana anymore."

The actress instinctively understood how to dance with the restless camera that was always searching, like a curious child. "You cannot do the elaborate shots we did with an actor who does not understand their position in the frame," Navarro notes. "That is a cinematographer's struggle. But she didn't show up to do her thing and leave—she was participating. She understood the limits of the frame, and that allows for incredible filmmaking."

"In fact, Ivana was incredibly precise," says del Toro. "There were two adult actors, however, that were irritatingly erratic and imprecise and who taxed Navarro's and my patience to its limit. But Ivana? Not once!"

Looking back a decade later, Baquero chalks it all up to experience: "Because I had been working on genre films since I was eight, I was quite used to the dynamics of a set. And when you're on a set shooting movies at that age you are constantly surrounded by crewmembers. It's certainly different to watch the final cut, once it's pieced together with the music, special effects, and everything. But I was

CHAPTER 7
WHO'S AFRAID OF THE BIG, BAD WOLF?

PREVIOUS PAGES Ofelia's first encounter with her stepfather is an awkward and upsetting one, as she fails to properly shake hands using the right hand that is gripping her precious fairytale books.

ABOVE RIGHT Sergi López and Maribel Verdú take direction from del Toro. "The character is the one who speaks for us, but I never forget that it's *me* interpreting the character," Verdú muses. "Some actresses submerge themselves so much in a character that they forget who they are. But that's not me."

OPPOSITE The director sets up a shot with Baquero as Maribel Verdú looks on.

125

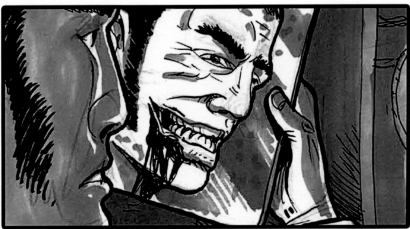

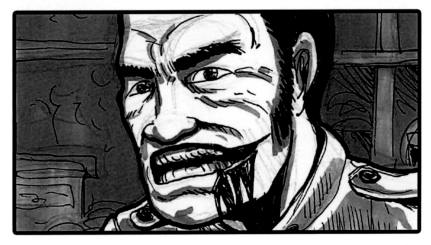

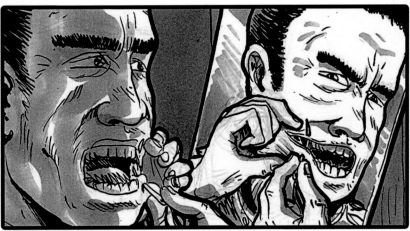

very aware of *Pan*'s dramatic content from the beginning, and I had taken it upon myself to learn about the Civil War and to watch Guillermo's past work. I guess it was a mix of my experience in the film industry and my parents' constant care and effort to keep me grounded that never allowed me to drown in the darkness of the film."

And there is much darkness to drown in, especially toward the end of *Pan's Labyrinth* when the impending defeat of Vidal and his men is no less brutal and uncomfortable to watch than the film's other horrors.

After a brazen attack on the mill, Vidal notices the pantry has been raided. But the door was not forced open; a key was used to unlock it—a key that only he is supposed to have. A tense scene follows in the Captain's quarters between Vidal and Mercedes, where the Captain challenges the housekeeper about the key. "I'm very proud of this sequence, because we decided on the spot to do it in a single shot," Navarro says. "It's a great example of that little crane, the Puchi. In another movie, the dynamics would have required all kinds of coverage, cuts, and close-ups. But here it flows naturally, in one cut, like choreography."

Fearing that Vidal suspects her complicity with the guerrillas, Mercedes awakens Ofelia and they flee into the forest, only to be captured by the Captain and his men. Because of a lack of technical resources, that scene—as well as 90 percent of the exterior location night scenes, Guillermo Navarro estimates—were shot in daytime using various techniques to simulate darkness, a technique known in the industry as "day for night." "The lack of resources forced us to be very ingenious, but doing that much 'day for night' is *ridiculously* complicated," Navarro explains. "I underexposed everything to incredible degrees, used filters. I had no choice, but I took huge chances in terms of the narrative of the movie. But ten minutes in, the movie already takes you into this magical realm so there are a lot of things you can accept."

Mercedes is now a prisoner, with her hands tied, and she finds herself alone in the pantry with Vidal and his implements of torture (Vidal doesn't need a guard, as she is "only a woman"). But when he turns his back, she uses the hidden kitchen blade she always secures in the fold of her apron to cut the rope binding her hands. She stabs Vidal in the back, slices open his mouth across the cheek, and escapes.

Vidal emerges with his hideous, gaping facial wound and orders some of his shocked men to bring Mercedes back. "I'm running and running with the horses chasing after me," Verdú recalls. "Of course it's a bit strange, an absurdity of cinema, to have a person outrun horses, so I don't know how many people know what that feels like, but it's incredible. The earth shakes. You think the world is going to end, that they're going to trample you. What if you make a misstep and trip on a rock? So that look of terror on my face is absolutely authentic. I'm thinking the same thing as Mercedes: 'They're going to catch me, they're going to catch me, they're going to catch me, I am going to die.' I did not need to interpret anything in that

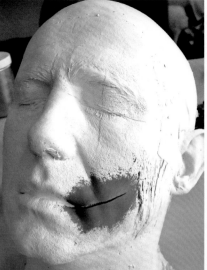
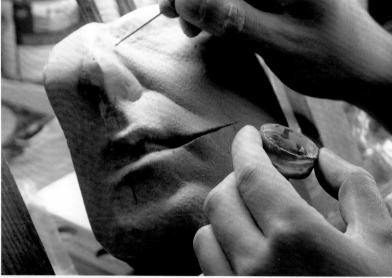
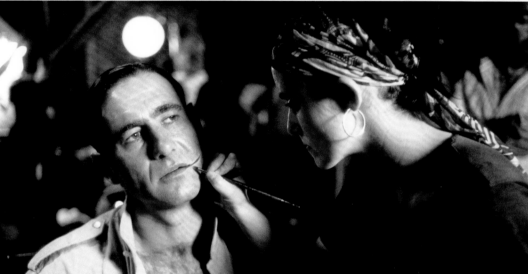
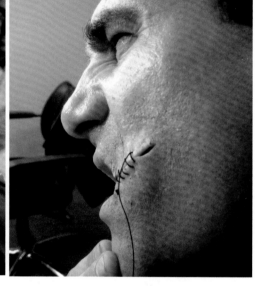

OPPOSITE At a turning point in the story, Mercedes cuts open Vidal's cheek. In this storyboard sequence by Raúl Monge, the stoic captain begins sewing up his gaping wound.

ABOVE The process of creating one of *Pan's Labyrinth's* most unsettling visual effects. Montse Ribé can be seen bottom left blending in a DDT facial prosthetic to give the illusion that López is sewing up his own sliced cheek.

scene. The danger, the fear, the feeling of being pursued and encircled, is real."

"That scene was shot with long lenses and highly trained horsemen, but horses are always erratic," says del Toro. "They respond to each rider differently. There were a couple of angles that were more risky, but we rehearsed very carefully."

But just when it seems Mercedes is about to be recaptured or killed, Mercedes's brother and the other guerrillas ambush the soldiers and save her. Mercedes's attack against Vidal and her successful escape is when "hopeless is now hopeful," del Toro notes. Meanwhile, Vidal retreats to his inner sanctum where "in one unflinching shot," as del Toro calls it, he stitches closed his own sliced cheek. He puts on a bandage and takes a shot of liquor that burns through his wound. This is the point, the director notes, when Vidal completely becomes "the big, bad wolf."

"Everything falls apart when Mercedes wounds Vidal," López adds. "She is in his confidence, and although she is not the mother of his child, she is his woman. And she betrays him and flees. That is something you can't live with. The thing about taking a swig of liquor and feeling

the sting is so utterly brutal. From that moment on, he is physically carrying the mark. His well-kept aesthetic, the clean-shaven and well-combed part of him, is torn open. He starts to transform. From that wound the monster starts coming out and expressing itself more openly."

"The two thousand frames of Sergi sewing his mouth up was an incredibly elaborate effect," Burrell explains. "DDT put on an appliance so that he could put in a dulled needle and push it through. He was sewing for real, but we had to add that whole chunk of flesh inside. I remember we laid some saran wrap on a flatbed scanner, put a piece of steak on it, and scanned the inside of the steak to get that natural fat inside the mouth."

"I always knew this effect—which was unique at the time—needed to be a set piece in itself," says del Toro. "No cuts, no inserts—just the action, with minimal camera motion. I wanted to show the audience that this guy was unflinching. Unstoppable. He could sew himself up and then take a swig of liquor—and when it [stung], he would pour himself another!"

While DDT and CafeFX collaborated on what would become postproduction aspects of the film, every day throughout principal photography, del Toro and his editor,

127

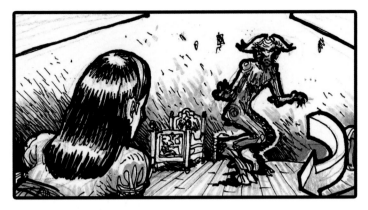

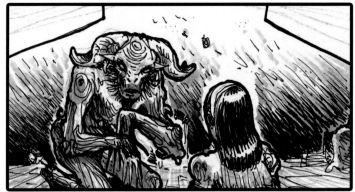

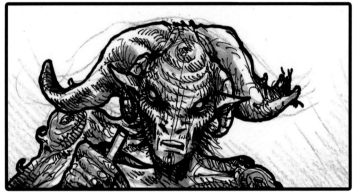

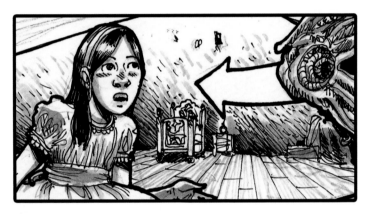

ABOVE The Faun gives Ofelia one last chance to prove herself in these storyboards by Raúl Monge.

OPPOSITE The un-posed portrait taken on Doug Jones's sixth day of shooting. Jones is sitting on his special bicycle seat and del Toro has pulled up a stool to the padded T-bar across which both men are leaning.

Bernat Vilaplana, had been pre-empting the final phase of production and assembling a working cut of the film. Del Toro always knew he would have a short postproduction period on *Pan's Labyrinth*, but cutting in tandem with filming has been his practice since *Mimic*. "On *Mimic* I edited every day, because I wanted to protect myself, and that became something I do on every movie," del Toro explains. "If you came to visit me on a Tuesday, I could show you the edited sequence up to Monday, you know? So, the day after we wrap the movie I have a first cut." In addition to del Toro's preproduction advice that Jones study the physicality of animals and apply it to the Faun, the only other notes the actor recalls was to reflect the backward-aging process in his performance. "They film out of sequence, of course, so it was up to me and the makeup folks to keep track of my backward-age progression," Jones explains. "I'm stiff and rickety at the beginning, but by the end I'm younger and my performance is more fluid."

The tempo of the editing helped realize del Toro's vision of the real and fantasy worlds ultimately merging. As the story builds to a climax, the forces of darkness represented by Vidal and his fascist plan of exterminating the Republican insurgents gives way to Ofelia's belief in hope, magic, and wonder—despite her disobedience, the increasingly youthful-looking Faun returns to forgive and give her the chance to complete her final task. "Each interaction with little Ofelia, and the more she believed and committed to passing these tests to get back to the underworld to claim her place as the princess, the more life was coming back into the portals and into the underworld," Doug Jones notes. "I am the gatekeeper to the underworld, so I was getting younger and more life was coming into me again."

Doug Jones recalls the happy day the director told him that he was successfully bringing the Faun to life, an intimate moment between actor and director captured in an often-reproduced photograph. "That's a very special photograph to me," Jones says. "We were on day six of filming and there's the picture of us in profile, looking at each other. I'm in the Pan makeup, of course, and we're almost nose-to-nose. I was sitting on my special bicycle seat and leaning forward on the padded T-bar, and he had pulled up a stool in front of me and was leaning on that padding. That photo of us was not posed. The photographer on set just took it while we were having this conversation. Guillermo patted my forearm and said, 'I know you have not heard much from me, my friend. But it is because you are getting it right.' He said that I was delivering what he asked for. That's his way. If you're delivering your own spices to the soup, and it's working and the soup tastes good, it's perfect the way it is. That's part of the shorthand. It's a brilliant director who can trust his actors like that."

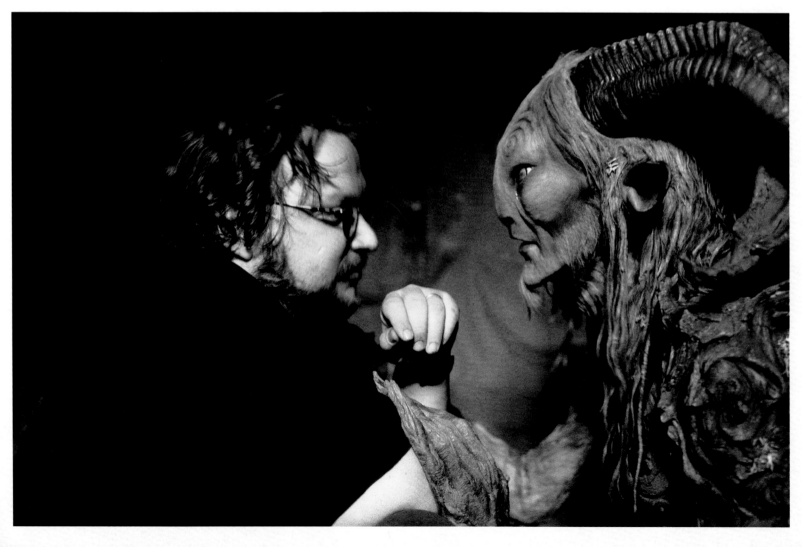

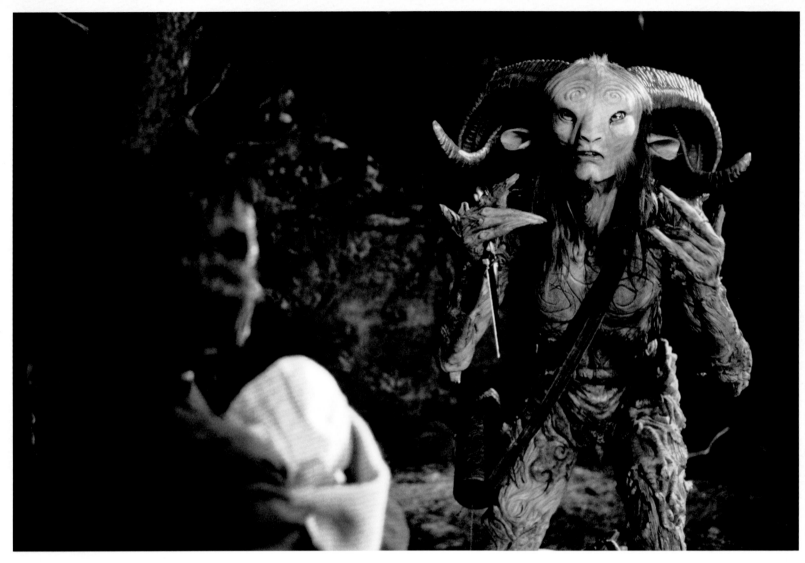

"In the final Faun scene," says del Toro, "when he looks his youngest—which was the first one we shot—I asked Doug to behave like a rock star and, depending on the shot, I would say, 'More Jagger' or 'More Bowie'!"

Ofelia's final task for the Faun is the most harrowing—she must kidnap her infant brother from the Captain's clutches and bring him to the labyrinth. Ofelia succeeds, but Vidal chases her even as explosions from the final attack rock the mill. With the separation of reality and fantasy completely blurred, even the real world's color palette now reflects the warm and golden palette of the fantasy realm. For the final guerrilla attack there were CG elements, as well as the use of practical effects, such as the air cannons and Guillermo Navarro's use of theatrical lighting.

Ofelia carries her infant brother down into the labyrinth's inner portal, where she finds the Faun in the full bloom of youth—if he had more money, del Toro would have made the Faun even younger, perhaps a juvenile, a concept explored in early production art for the character. The Faun is now in his most beautiful state—but also his most menacing, particularly given he is holding the shiny dagger that Ofelia obtained from the Pale Man's lair. The Faun explains that only an offering of innocent blood will open the portal. But Ofelia, holding her baby

brother tight, refuses, even as the Faun angrily demands, "Give me the boy!"

By refusing to hand over her brother, Ofelia passes the final test. Jones muses that the Faun is a performer whose air of menace would have bent a lesser child's will to do what was demanded, not what was right. "I have called the Pale Man a creation of the Faun," Jones says. "The Faun had to be a good actor—and a trickster—to put these tests before Ofelia."

"In the final shots, there's proof that the Pale Man was the Faun and it was all a test," reveals del Toro. "You see all the fairies come back and fly around; he didn't eat them. He was testing Ofelia!"

Ofelia's final triumph is cut short however in the film's most tragic scene: Vidal staggers into the portal, takes back the boy, and coldly shoots the girl. Despite being one of *Pan's Labyrinth*'s most emotionally devastating moments, the scene's filming was another example of the unfolding chaos del Toro had to manage—Sergi López had a prior commitment and was running out of time on the project. "I had this huge machine of hundreds of people, incredibly expensive rented lights, in a fake labyrinth in the middle of the forest and Sergi was under pressure to go to a theater in a province of Spain and perform to an audience of seventy people," del Toro says, with a

TOP Completing the final task, Ofelia brings her infant brother to the labyrinth but bravely refuses to hand him over when the Faun says he must take a drop of the infant's blood.

OPPOSITE Ofelia faces the darkness in *Pan's Labyrinth*. "In this film you walk in the shoes of this little girl who is pure, innocent, and sensitive," says Guillermo Navarro. "As she learns, you learn. Even though she's in the middle of all this horror, once you're in the mind of a child that has all this imagination and purity of heart anything can happen."

130

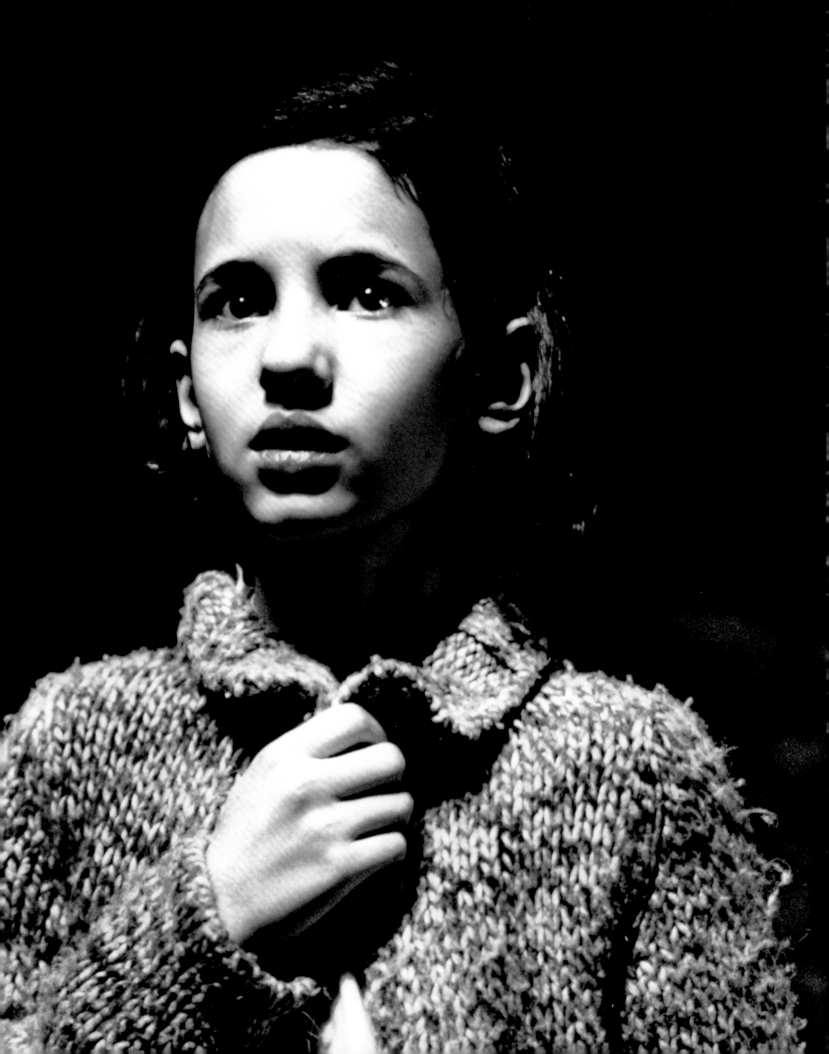

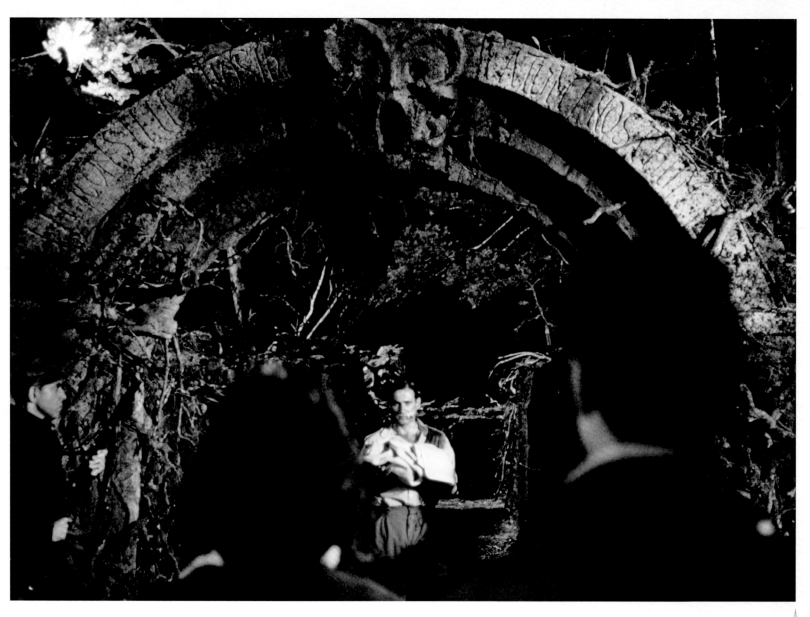

hearty laugh. "We knew he had to leave, so we shot in a different order; we needed to deal with it that night. We could not pay for an extra day, because under no conditions could we go over budget. In the entire time I went over fifteen minutes one night, and that was it. We had no leeway and the crew would not give us the extra time we wanted. So we were dealing with things like that all the time. But if you have really great people around you, Guillermo Navarro, Eugenio, Lala Huete on wardrobe, the DDT guys, [they will help you see it through]."

In story continuity, we see Vidal for the last time as he emerges from the labyrinth with his infant son in his arms—and is greeted by the sight of the mill in flames and the guerrillas silently facing him. In del Toro's world, there is empathy for the "bad guy," although they answer for their crimes. At the end of *The Devil's Backbone*, Jacinto is given a humanizing touch as he poignantly pores over a batch of old photographs from his past. Even Vidal is allowed a human moment as he hands over the infant to Mercedes, pulls the cracked watch out of his pocket one last time, and asks that his son be told what time his father died.

"No," Mercedes says. "He won't even know your name."

That first taste of oblivion hits the shocked Captain just before the bullet fired by Mercedes's brother.

Everett Burrell and the special effects department gave the actor a blast from an air gun to simulate the bullet's impact. "Sergi wasn't expecting how impactful it would be," Burrell recalls. "We had a thin metal rod that would force high-pressure air precisely onto his cheek. We got as close to his face as we could without being in frame. It gave the actor a little shock—you see his reaction as it causes a ripple as if a bullet was entering his face. We had a big squib on the back of his head to blow blood out, and we did the entrance wound in CG."

"It's curious, isn't it, that after he's killed a little girl, this murderer asks that his little boy be cared for?" López reflects. "For once, you see him as a father in love with something. It is perverse, though, this idea of protecting only what is yours. When we finished rolling on that scene, the whole production broke into cheers and clapping. Everybody was celebrating. It couldn't happen any other way. There was no escape. He had to die."

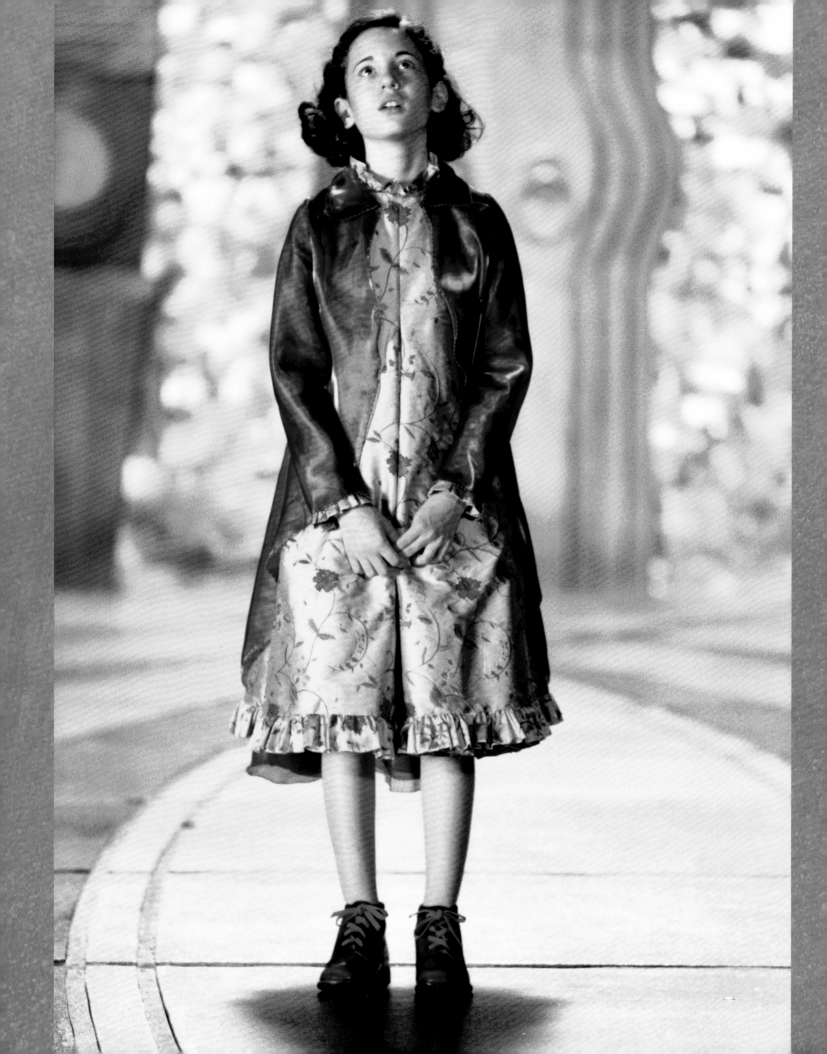

THE ENDING of *Pan's Labyrinth* confounded some viewers. Mercedes finds Ofelia dead in the labyrinth, but the girl wakes in the throne room of the underworld kingdom, with her parents alive and reigning as king and queen—had the young girl truly died? Was the fairy-tale kingdom real or the final illusion in the fading consciousness of a dying girl? For his part, del Toro believes that Ofelia becomes immortal, and he worked to make the scene of the underworld kingdom Ofelia's triumph.

CHAPTER 8
KINGDOM COME

"Lala Huete and I knew we needed to create a red dress for Ofelia at the end—I wanted red to mean life for Ofelia—that was sort of a variation of her wardrobe, and her shoes magically become these red shoes in reference to *The Wizard of Oz*," del Toro explains. "I wanted it to be like the trinity at the end, with three thrones. I wanted to show her complete with the mother she lost, the father she basically never knew, and the third throne, on the left, is reserved for her. It's her family the way she would love it to be: no captain, no war."

The throne room set was a partial build on a green-screen stage that included the floor and the three elevated thrones. CafeFX brought the cathedral-like look to life

ABOVE LEFT The well where the dying Ofelia falls, concept sketch by Raúl Monge.

ABOVE RIGHT Raúl Monge storyboard panels depict the girl's final moments—to enter the underworld requires innocent blood, but it is not that of the infant boy but Ofelia herself.

OPPOSITE A starry-eyed Ofelia awakens in the underworld kingdom, her triumphant return bringing a golden glow to the shadowy realm.

digitally, adding carved wooden structures and stands filled with celebrants. There was production concept art for the scene, but Jeff Barnes brought on Robert Stromberg, a noted matte painter who has since made a successful transition to directing, to help develop the visual effects–heavy sequence. "Basically, I wanted Robert's eye on the project, as a consultant," Barnes adds. "That was the 'Big Ask,' and he helped make it look fantastic."

From a musical perspective, there are several endings, Javier Navarette observes: "The movie slowly comes to an end, and all these characters have their own endings in the music, too. There is a slightly evocative, epic feeling for the Captain, but, of course, he dies and his story is finished. And we still have to finish with the girl and Mercedes. And we go into the girl dying, which

becomes this fantasy where she goes to the other world where she finds her father and mother. The kingdom is like the development of the lullaby, actually. We start with the lullaby and go in and add layers, and when we arrive there is a choir hitting the highest note [possible]. The music gets very high in the register, which brings a sense of relief, and then it finishes."

Del Toro was anxious for Navarette to start writing the music very early in the editing process—and, since the director was editing during filming, it was easy to turn over edited sequences to the composer earlier than usual.

"Normally, a composer starts writing when the movie is already assembled and, as they are cutting the movie, you keep adjusting and following the process," Navarette explains. "Guillermo is different in that sense. It was parceled out—the first sequence he had, he sent to me, and then the next sequence. One day came the continuation of something I had done fifteen days before. It was a lot of fun, because I felt like I was cutting the movie."

Navarrete recorded his score with the City of Prague Philharmonic Orchestra, led by conductor Mario Klemens, the same musical team he had worked with five

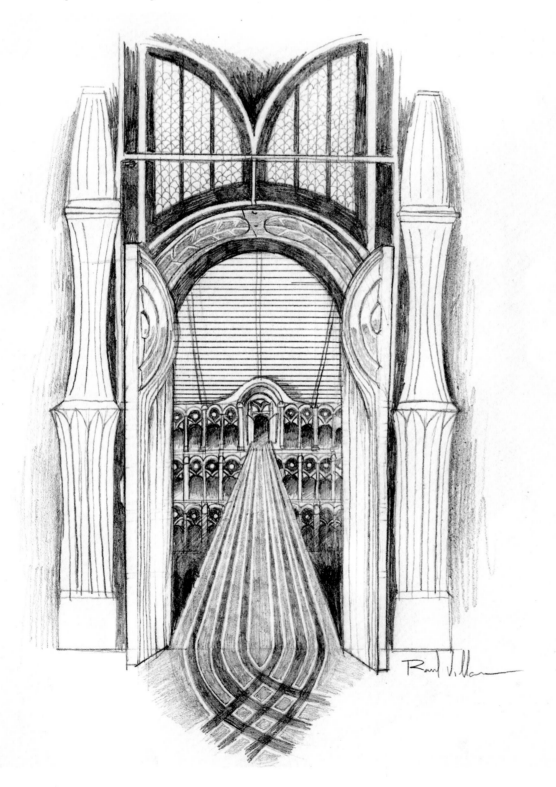

LEFT Throne room conceptual design by Raúl Villares.

OPPOSITE TOP Throne room conceptual design by Raúl Villares.

OPPOSITE CENTER Throne room window by Raúl Monge.

OPPOSITE BOTTOM LEFT The final throne room, with a shining stained glass window behind the three thrones, was largely a CG environment created by CafeFX.

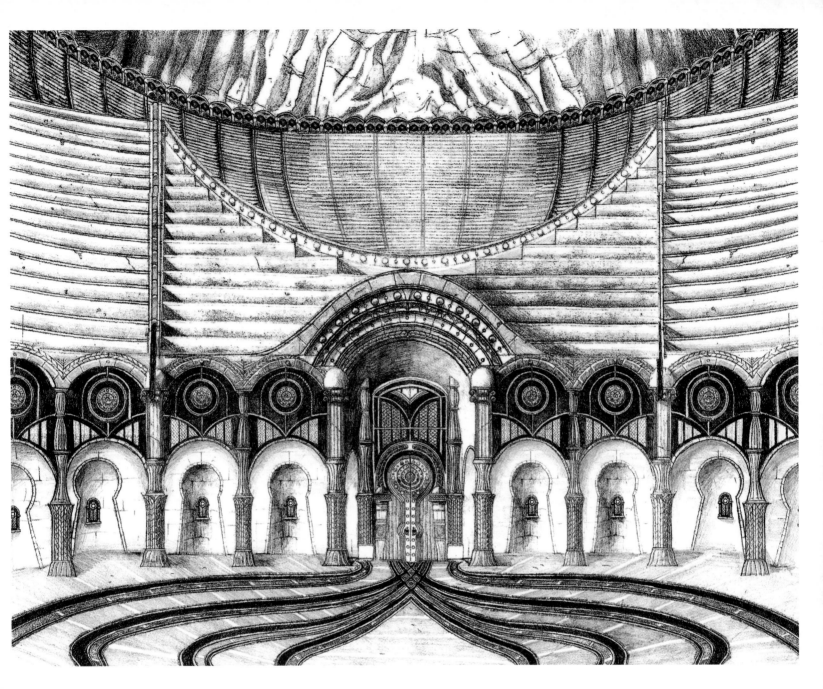

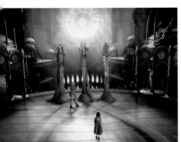

years before on *The Devil's Backbone*. He was familiar enough with them to request pianist Jaroslava Eliaasova, who had since retired. "I knew how good she was, but she didn't want to do it," the composer recalls. "I insisted and insisted and we finally got her to play."

Navarrete had special praise for Klemens ("very good, experienced, and skillful"), and also singles out the contributions of concertino Bohumil Kotmel, soloist Lua (who provided the haunting lullaby), and the recording and mixing by Marc Blanes. "It was not a big budget recording, a super blockbuster sound like in London or Los Angeles, but they had very good performances and we all could feel that," the composer says. "They played with spirit, which is what matters. Even the conductor was quite surprised at the sound of the orchestra. He often came into the control room to listen to

the cues when they were recorded, which is very unusual. The movie itself has a spirit that certainly went into the composition—everything I tried worked very well. It was easy, somehow. And the same thing in the performance; everything went well, somehow. I think the magic in the movie translates to every level of the work."

Despite the rigors of the long shoot, Everett Burrell recalls the indomitable director was in a positive mood as the work shifted to postproduction. The CafeFX visual effects supervisor recalls times in postproduction when they couldn't physically be with the director and had interactive cineSync sessions via computer to share and discuss work in progress. "It's a great tool, because it allows the director to look at the same image as we are and he can draw little images or circle things, frame by frame," Burrell explains.

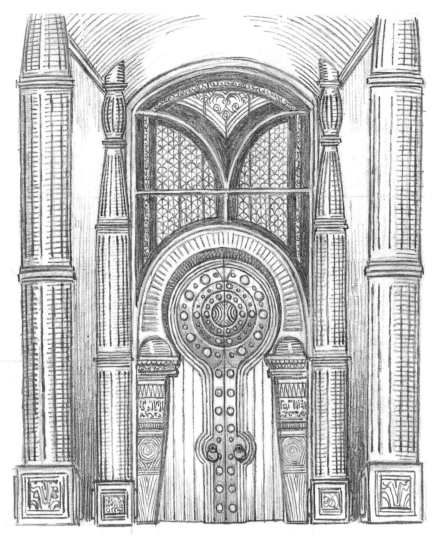

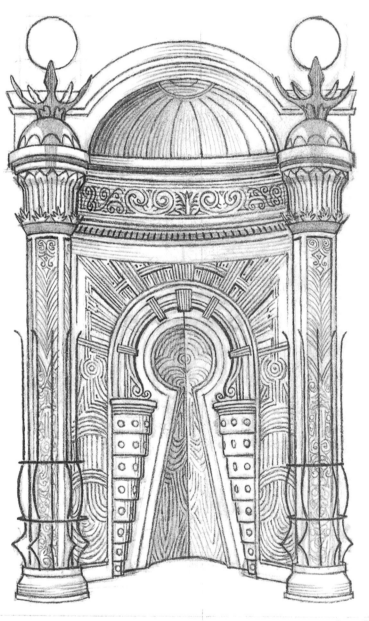

SANDOVAL 05

139

ABOVE Throne pillar designs by Eugenio Caballero and Raúl Monge.

LEFT AND RIGHT Throne pillar designs by Sergio Sandoval.

CENTER Throne room window by Eugenio Caballero and Raúl Monge.

OPPOSITE Throne room concepts by Sergio Sandoval.

TOP LEFT AND TOP RIGHT Throne room concept art by Sergio Sandoval.

FOLLOWING PAGES Throne room art by Raúl Monge.

Del Toro recalls the postproduction period as "crazy." The plan was that the sound design and final sound mix would be completed in Mexico City with sound designer and supervising sound editor Martín Hernández and main mixer Jaime Baksht, whom del Toro had known from his teenage days. Meanwhile, the director would be working with Guillermo Navarro on the color correction at the DeLuxe Lab in Toronto (one of the many worldwide postproduction facilities of the venerable company that was first formed as part of the Fox Film Corporation by producer William Fox in 1915). Del Toro's efforts would be further complicated by the fact that the director of photography had moved on to shoot *Night at the Museum* in New York. "Guillermo Navarro could only join me for a couple of weekends, but it took Chris Wallace, the color corrector, and myself many, many many weeks to get it done," del Toro says

The color correction work in Toronto was indeed an extensive and intensive affair. The digital process—known as the "digital intermediate," or "DI"—allows filmmakers to create "windows" that essentially roto-scope the desired area of a frame to manipulate the density and saturation of colors and increase contrasts and highlights. Since scenes are often shot out of order, the color schemes must match. And sometimes, the conditions under which certain scenes were shot needed to be corrected—for example, the moment when Mercedes milks a cow as she is talking to Ofelia. "The raw footage was shot at noon to two o'clock, which is the *worst* sun in which to shoot an exterior scene, so the color correction was done to the limit on that scene," says del Toro. "We created every single window that was available to us in the color suite. We were on a very tight schedule, but Chris is one of the best in the business."

The Toronto–Mexico City commute made postproduction particularly tough—"I was simply unprepared for the mileage," del Toro says. "And it was one of those grueling mixes. In Mexico it is rare to have a movie with as many tracks as we had for sound and sound effects, the music, the final mix. I think the last session we had went forty hours."

Del Toro's constant back and forth between Toronto and Mexico City resulted in another crisis—the "travel" hard drive that contained the color correction for the entire movie was stolen from del Toro's checked luggage. "It was a big expensive drive, a few terabytes, and somebody saw it as good loot," del Toro recalls. "It was a movie nobody knew anything about, so they probably erased it and put their entire iTunes catalog on there, I don't know. We ended up having to generate a second one—that was not a good phone call to make."

All the while, the production had been looking toward a potential premiere screening at the Cannes Film Festival, in May 2006. The production had sent an early edit that included rough composites of the visual effects work to Cannes, and the production heard back around February to March—the film was accepted! But

that left precious little time to make all the pieces fit together into a finished film. "When that news came back, we then needed to go very, very fast," del Toro recalls. "I remember the last night before we closed the editing room. Alejandro Gonzáles Iñárritu came over, we ordered Chinese food for everyone, and we edited all night. We took out about seven or eight minutes of the film that night, and that is the cut that you see."

Cannes was the first opportunity for the filmmakers to see the film with an audience. Guillermo Navarro arrived feeling pleased with the final result. "Always with a movie there is something you missed, something you loved that is out of the movie, some sacrifice—but it was everything we wanted," he says. "I was crying when watching it. It is a parallel reality, going through that Cannes world. It was unbelievable, the reception for the film, the nonstop standing ovation. We had to get out of there because the next screening was coming up and it was delayed because the audience would not stop! And we go out later, and we're a little bit drunk with all this. People in the streets would stop you and thank you for the movie, that it really touched their hearts."

Producer Thomas Tull watched *Pan's Labyrinth* with del Toro in a screening room at Warner Bros. before its theatrical release. "When I saw the film I thought, 'This is something very, very special and different,'" he recalls. "Generally, when that happens, a film will find its footing with an audience. It has this unique blend of beautiful, picturesque filmmaking—every frame looks like a painting—and a dark and twisted fairy tale where there's foreboding and a threat of violence. The bottle scene hit me like a freight train—it gets me to this day."

"The spectacle and creature designs were all fine, but for me it was the raw emotion," recalls *Hellboy* creator Mike Mignola, a frequent collaborator with del Toro. "At the end, the girl has died but she goes to this fairyland, and you cut back to the woman crying her eyes out. It was such a strong, powerful emotion."

"I would love to believe that at the end the girl really does go to that magical kingdom and that such things do exist," says James Cameron. "If nothing else, we've journeyed in her shoes and seen how her imagination insulated her from the horror around her. You think of all the kids who have been through traumatic experiences that go on to live normal lives because of that mechanism."

Before being drowned by a tidal wave of critical praise, there was the early backlash regarding the violence. Both Bertha and Guillermo Navarro also recall some resentment in Spain about outsiders making a movie about their history. "I loved the movie, but there were all these concerns about violence, about mixing a fairy tale and a little girl with grown-up themes," says Cuarón. "Let me put it this way—it was not a by-the-book film."

"The movie was weird, in a way," David Martí reflects. "We thought, 'Who is going to like a movie about fantasy, this little girl, and the Civil War?' This is a very crazy idea. We thought it would work in Spain and

ABOVE Sergi López, Guillermo del Toro, Ivana Baquero, and Ariadna Gil at Cannes in 2006.

OPPOSITE The finished film was released to international acclaim, with poster art tailored to each country. The original Spanish title, *El Laberinto Del Fauno*, was changed to *Pan's Labyrinth* for the English language release.

INSERT An early concept for the *Pan's Labyrinth* theatrical poster by Raúl Monge used to drive sales of the film at the Cannes Film Festival in 2005.

142

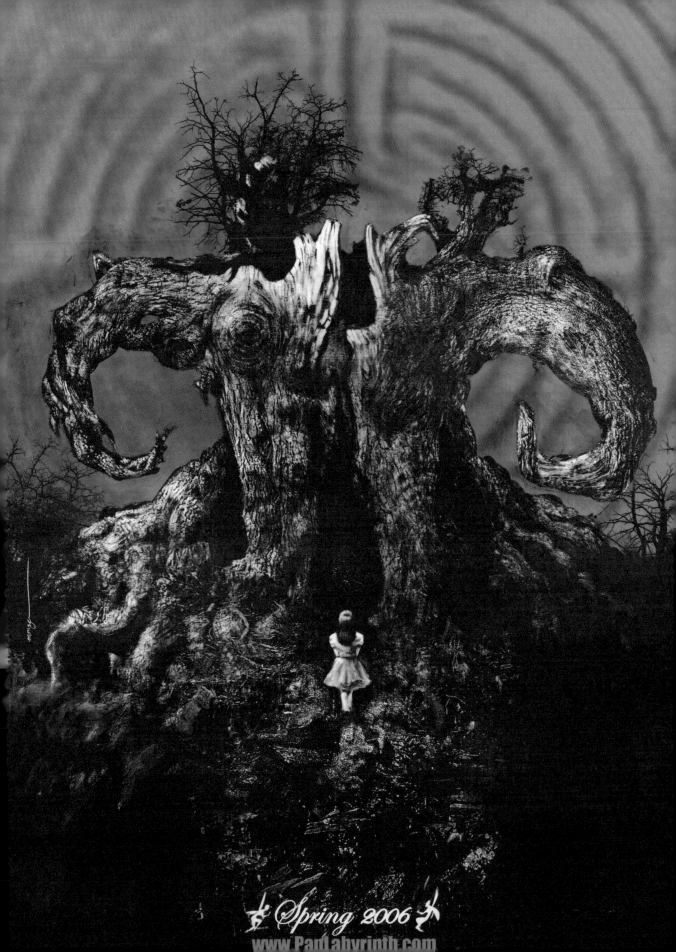

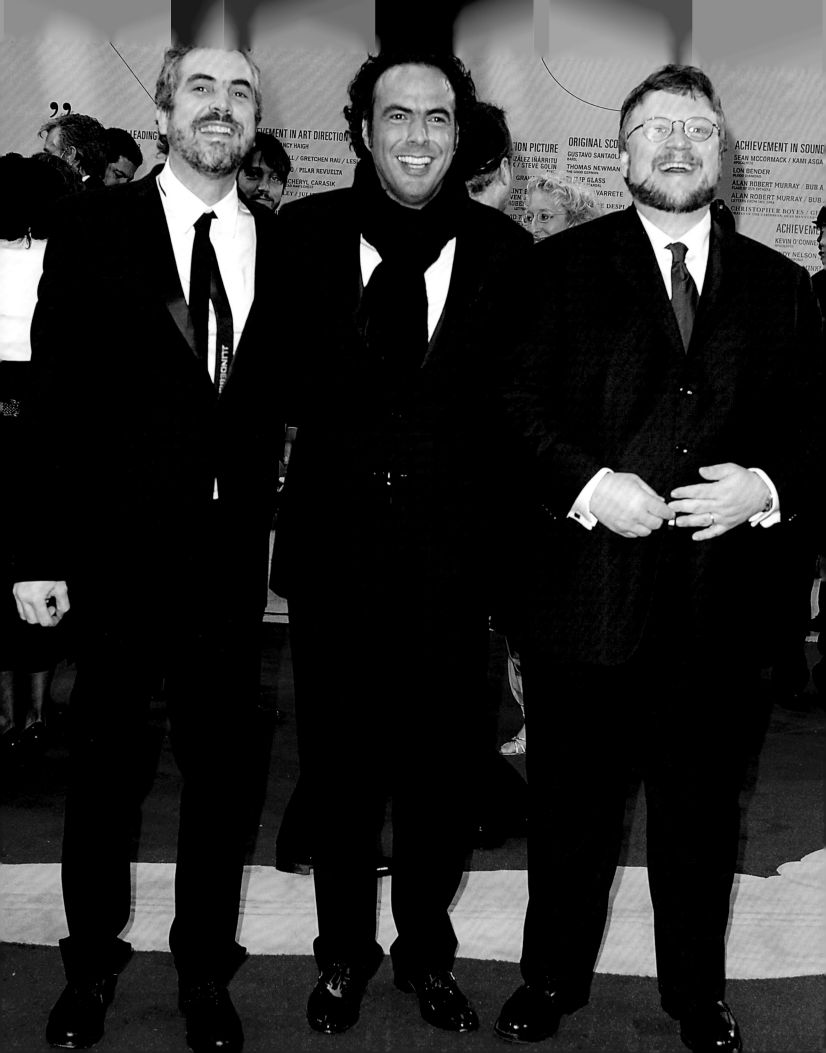

OPPOSITE Friends and collaborators Alfonso Cuarón, Alejandro Gonzáles Iñárritu, and Guillermo del Toro made a huge collective impact at the 2007 Academy Awards.

ABOVE Set decorator Pilar Revuelta and production designer Eugenio Caballero share an Oscar moment.

BOTTOM RIGHT Doug Jones is among the cast and crew who look back on *Pan's Labyrinth* as a career milestone.

that's it. It was completely the opposite. In Spain it did well, but not as good as it did outside, and in the States."

"All the movies I do—no matter how big—have a bit of an 'outsider' element to them: something that doesn't conform to expectations at first viewing—something undomesticated," says del Toro. "They are cagey and those that love them—often upon second viewing—love them as much as I do."

The filmmakers point to the reception at Cannes as the first indication that they had created something memorable. "With that standing ovation at the end, we all thought, 'This is a sign—special things are coming!'" Ivana Baquero remembers. "After that it was just a roll—the Goyas in Spain, the Golden Globes, the Oscars."

"When Ivana won the Goya for best new actress I was outside of Spain, far away, and I had just learned that I was going to be a mother," casting director Sara Bilbatúa recalls. "That left an imprint on my heart. Two girls. Learning about that award for one girl and, at the same time, learning that another girl was on the way."

Mexico's Ariel Awards honored the film, including awards for best director, a best supporting actor award for Álex Angulo, and best actress for Maribel Verdú. "When you work on a film, you don't expect recognition and critical acclaim," Verdú reflects. "It happened to me with *Y Tu Mamá También* and it happened to me with *Pan's Labyrinth*. I think it surprised everyone and it found us all in a wonderful place. For an actress who isn't Mexican to win an Ariel is incredible."

The 2007 Academy Awards ceremony was a mutual triumph for the triumvirate of Guillermo del Toro, Alfonso Cuarón, and Alejandro González Iñárritu (who has a thank-you credit at the end of *Pan's Labyrinth*), with their three films earning a collective sixteen nominations. *Pan's Labyrinth* was the official Mexican entry for best foreign language film, with nominations for cinematography, original screenplay, makeup, art direction, and original

score. Cuarón's *Children of Men* won nominations for cinematography, adapted screenplay, and film editing. Iñárritu's *Babel* was nominated for best picture, director, original screenplay, film editing, and original score, and garnered two nominations in the supporting actress category.

As the only *Pan's Labyrinth* cast member from the United States, Doug Jones became the American media's go-to interview, after del Toro. "When you find yourself on the red carpet at the Oscars and you are being interviewed by Joan Rivers, your life has completely changed," Jones says. "And what a proud night that was. Hollywood royalty surrounds you. Every famous person you've ever seen is there. Every time *Pan's Labyrinth* was mentioned, a cheer went up from the crowd. *Pan's Labyrinth* was a darling that year, a favorite. I was screaming from the audience."

Eugenio Caballero was nominated for production design, along with set decorator Pilar Revuelta. Caballero had already won the Art Directors Guild Award for Excellence in Production Design and that, along with "the crazy buzz" of pre-Oscar night chatter, meant a win was possible. When Caballero arrived, he learned that production design was the first award of the evening. A friend and colleague gave helpful advice to get grounded by making sure he knew where he was sitting in relation to his film's director and producers so it would be easier to spot and thank them, and then said, "Good luck!"

"I had a notion of space, I'm a production designer," Caballero says. "I was trying to keep calm, which was not easy. I'm used to being behind the camera, so the idea of making a speech was challenging for me. But I knew very clearly whom it was that I wanted to thank. And then, suddenly, you have an Oscar in your hands. I was very

clear that night that we were the tentacles of this creative monster, Guillermo."

Pilar Revuelta echoes the on-rushing sensation of an Oscar win. "I didn't understand that they'd called my name," she says. "Everyone was so euphoric. I saw that Eugenio had stood up and walked out front and I had such a super long dress on that I could hardly catch up. He looked back at me and put out his arm for me to join him. It's hard to explain, but there are so many lights, so many people, you get a bit lost. I was there, but I was somewhere else. It was surrealistic. But wonderful."

David Martí and Montse Ribé were nominated for best makeup, an honor Martí recalls as "really weird" for a small special effects company from Spain. "I'm a film geek and I've loved and watched the Oscars every year of my life," he says. "But I *never* thought that one day I'd be there. You are just not part of that system."

But then came the moment when the envelope was opened and the best makeup Oscar went to *Pan's Labyrinth*. "And then it was, 'What the hell! *This is happening!*'" Martí remembers. "We went up there and you see all those faces in front of you—Helen Mirren, Jack Nicholson, Leonardo DiCaprio, Steven Spielberg, Clint Eastwood. I was thinking, 'What the hell am I doing here?' Montse was giving thanks to everyone and this and that and I wanted to thank Guillermo, and I could not see him, because my eyes were wet and the lights were on in front. I said, 'Okay, Guillermo, where are you?' And when I found him in the audience, I said, 'Okay, this is for you, Guillermo. Because what you see in the movie is one hundred percent Guillermo. We are like the tools of his brain, let us say.'"

Cinematography nominee Guillermo Navarro says the Oscars was a particularly proud night, given the sixteen nominations for Mexican filmmakers. His own work had been honored in 2006 with the top award at Camerimage, a prestigious film festival devoted to cinematography, and he won a Goya. "In the middle of all that came the Oscar nominations and it was this fantasy world. Really? For this little movie in Spanish? How did it get there?

"At the Oscars I felt completely out of body," Navarro continues. "And then comes the cinematography award. It was a level of nervousness where you almost don't want your name to be heard. And then—*buenos noches*—you get distracted and you turn and a wave hits you, like when you're in the ocean. . . . And then you're up there and [Oscar presenter] Gwyneth Paltrow is walking toward you. She gives me a kiss and in perfect Spanish, with a Castellan accent, she congratulates me! For some reason, I didn't know she could speak Spanish, so that completely destroyed my brain. I see all the faces and I hear myself talking, a completely out of body experience."

The Oscar preview issue of *Entertainment Weekly* had a prescient take on the race for best foreign language film: "Box office hit *Pan's Labyrinth* is definitely the front-runner, but Germany's *The Lives of Others* could pull an upset if older voters are put off by *Pan's* fantasy elements."[1]

"The voting system for foreign film was, for decades, almost entirely limited to a couple hundred older voters—a fact that Pedro Almodóvar protested many times—and it was very predictable," says del Toro. "I knew this so I kind of knew the outcome would not favor fantasy."

Whatever the reason, the award did indeed go to the German entry, a look back at the Communist surveillance state in East Berlin that was a deserving winner and, like *Pan's Labyrinth*, critically acclaimed and commercially successful. It had been a triumph for *Pan's Labyrinth*, with three wins out of six nominations, but hopes had been high that the night would be crowned with recognition for del Toro and the film itself. James Cameron remembers he had his "fingers crossed" but was resigned to the outcome: "I think the film should have won in its category, but I think the Academy will only go so far when it comes to fantasy, horror, and science fiction. They'll honor the artistry, but that's just not the film they're going to vote for. We saw that happen with Sigourney Weaver's nomination for *Aliens*—it was great to be nominated, but you know you're not going to win. It was great to be nominated for *Avatar*, but it's an uphill fight for a science fiction film to win. I was hopeful that *Pan's Labyrinth* would be an exception because of Guillermo's stature as an artist, but I was certainly prepared for the outcome."[2]

For his part, del Toro was philosophical about not winning for foreign film and original screenplay. For him, the final film was its own reward. "The way I see my craft, and the way I see the stories I tell, has completely changed as a result of this movie," he said in an interview prior to the film's theatrical release. "Shooting *Pan's Labyrinth* was very painful, but it also became a war about me not compromising. . . . It's the first time in the six movies I've directed where I've said: I'm doing this one my way, no matter what. . . . I'm very happy with the result. And for me, nothing will be the same again."[3]

Although it didn't take the main prize, *Pan's Labyrinth* broke records by becoming the first Spanish-language film to win three Academy Awards. The win not only announced the rise of del Toro but also his Mexican counterparts Alfonso Cuarón and Alejandro González Iñárritu. "That year, with the three of us and the three Oscars—the rule of three—announced the Mexican Oscar tidal wave to come!" says del Toro.

David Martí, who vividly remembers the difficulties and challenges of the low-budget production, calls the Oscar win for makeup a kind of "karmic justice," a little something back for their troubles.

Ten years later, DDT is still creating makeup for big movies. The Oscar for *Pan's Labyrinth* resides at their Barcelona shop—although not always in a conspicuous place of honor. "Sometimes we hide it inside a cabinet, because it is a little bit disturbing," Martí explains. "With the Oscar you always think of all the moments you had at the Academy Awards, all the super excitement. So we'll go, 'Okay, it's time to hide it for a while.' This guy takes attention, let's say."

ABOVE Guillermo Navarro collects his Oscar, later describing the moment as an "out of body" experience.

OPPOSITE Academy award winners David Martí and Montse Ribé. Ten years later, they still call *Pan's Labyrinth* the toughest project of their careers, but they were all smiles that eventful Oscar night.

In my experience, a crisis always ends up being fruitful. People think directing is an exercise in control, but it's an exercise in controlling chaos. Whether it's the sun setting, rainy conditions you didn't expect, or an actor gets sick, you have to extract the best out of a terrible situation. —GUILLERMO DEL TORO

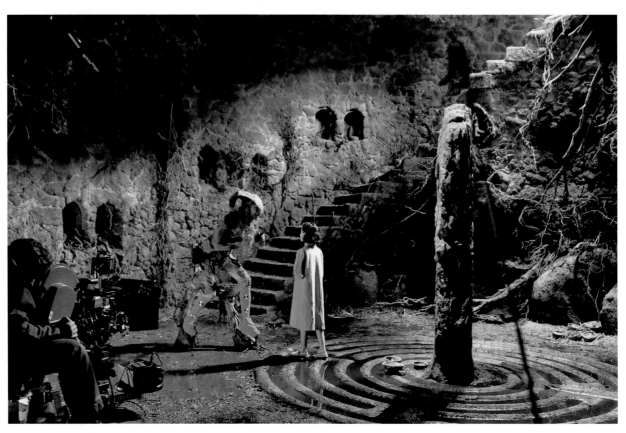

TEN YEARS AFTER its release, *Pan's Labyrinth* stands as a fantasy classic and a personal and collective achievement for the filmmakers. For many, the movie marked a crossroads that helped set the course of their lives and careers.

CHAPTER 9
MASTERING CHAOS

Legendary horror author Stephen King called it "the best fantasy film since *The Wizard of Oz*,"[1] while review aggregating website Metacritic lists it as the highest rated film of the first decade of the century. It continues to appear year after year on top ten lists for fantasy and foreign movies.

"Shooting *Pan's Labyrinth* was like going to acting school," says Ivana Baquero. "Guillermo was my mentor, carefully guiding me through the entire process and helping me give life to Ofelia. He always stood by me as a rock. I remember how he would always sit with me for a few minutes before shooting a scene, patiently briefing me about Ofelia's feelings and giving me tips and advice. I still laugh when I remember my little self at eleven trying to massage Guillermo's back—apparently, I was having a little masseuse phase—and he would always say, 'Ivanita, don't bother! Your little hands feel like ants on my back!'"

"It was a dream," Maribel Verdú recalls. "We were living together in the same hotel, sharing meals together. I didn't know Sergi, but we are great friends to this day from doing that film together. When we did the film Ivana was the same age I was when I started to work in cinema. I

worked with her again a few years back and she's got a boyfriend! She is not a little girl anymore. And the ambience Guillermo creates on a production is so brilliant. One other thing—Guillermo del Toro brings the best catering of anybody! I don't think I've ever worked on a film with better catering than *Pan's Labyrinth*."

Doug Jones, who between films works the fandom sci-fi/comic book convention circuit, recalls that of all his films, *Pan's Labyrinth* is the one fans talk about the most. "That's the film that gets the tears and goose bumps, that reaction, 'Oh, it changed my life!'" he recalls. "It breathed life into the artists who watched it. People said that after seeing it they could paint or sculpt again. I heard that many times over the years. I've even had people say they were suicidal and they saw this movie and it gave them a reason to keep breathing. When a movie has that kind of power, then it becomes the favorite movie you've ever been in!"

Before *Pan's Labyrinth*, performers like Jones, who specialize in characters requiring makeup or elaborate costumes, had become oddities in Hollywood. Jones recalls being labeled in the media as everything from "suit performer" to "movement specialist"—everything but *actor*. "We had lost a reverence for actors doing crazy makeups," Jones concludes. "Lon Chaney, Boris Karloff, Bela Lugosi—they were movie stars and respected as actors. *Pan's Labyrinth* was a movie where I was being referred to as an actor, as a movie star. The *LA Times* Lifestyle section called me today's Lon Chaney. To have my name equated with such an iconic film personality was tearjerk-y for me.

OPPOSITE *Pan's Labyrinth* poster art by Drew Struzan. Del Toro now owns the original, which he keeps at Bleak House. ABOVE Jones and Baquero at work on the soundstage labyrinth set. Ten years later, the production remains a vivid memory for all who worked on it.

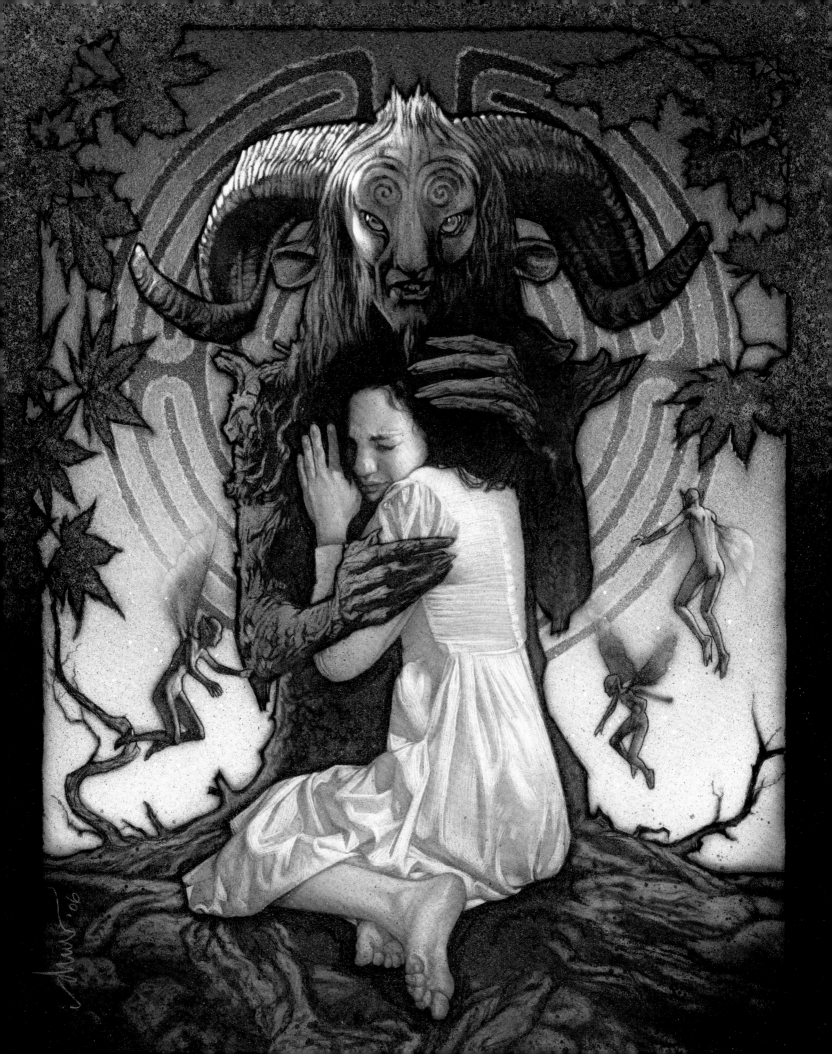

It was, basically, reeducating the entire system. Casting agents never quite knew what to do with me. But I have *Pan's Labyrinth* and Guillermo del Toro to thank for them finally getting it. That film changed my life."

Alfonso Cuarón feels that *Pan's Labyrinth* marked a turning point not only for del Toro but also for Alejandro Iñárritu with *Babel*, and himself with *Children of Men*: "*Pan's Labyrinth* was like the before and after. It's fair to say that from that point on, in terms of careers, we got a more secure footing." Cuarón also recalls it as a time when visual effects began to change dramatically "I remember, when I was doing my *Harry Potter*, we had a shot count for the CG that I had to do. When they were doing the next *Harry Potter*, I was talking to the director, and he said, 'No, we don't count the CG shots anymore.' It's an industry that grew up so fast. People forget how difficult and expensive it was to achieve CG shots."

In the past decade, the globalization of movie making, competition from overseas visual effects studios, costs of technology and R&D, and other factors have indeed changed the US visual effects industry. As with many visual effects studios, CafeFX didn't survive, and after a seventeen-year run, it closed in 2010. But for the effects artists themselves, *Pan's Labyrinth* remains a highpoint.

"You couldn't really pay for the publicity that surrounded the film, so what we didn't optimize in terms of the visual effects budget we got back in PR value," Jeff Barnes recalls of the post-*Pan's Labyrinth* boost. "Because the project has such creative integrity, it validated us as not just another visual effects facility but a higher-end creative option for clients. In the months that followed, we had all sorts of people calling us, wanting to visit and talk. The studios all reached out. People like Frank Darabont came to us because of *Pan's Labyrinth*, and we worked on *The Mist* with Frank. It was pretty unbelievable, actually. Over the years, our company worked on more than ninety feature film releases and *Pan's* is, for me, my shining star. It's the project I'm most proud of."

Eugenio Caballero recalls that the fame of the film, and his Oscar-winning work, opened a lot of doors. For a few years after the Oscars, every script he received was a fantasy or genre film. He decided to not be labeled and has worked on diverse films, often in Mexico and with Latin American filmmakers. But he continues to apply the lessons learned in the labyrinth. "*Pan's Labyrinth* basically showed me that you really can think outside the box and then achieve it," Caballero concludes. "It also showed me that my craft is way more complex than I imagined and that I needed to learn a lot of things that

BELOW Del Toro setting up a shot in the Pale Man's lair with Baquero and Doug Jones.

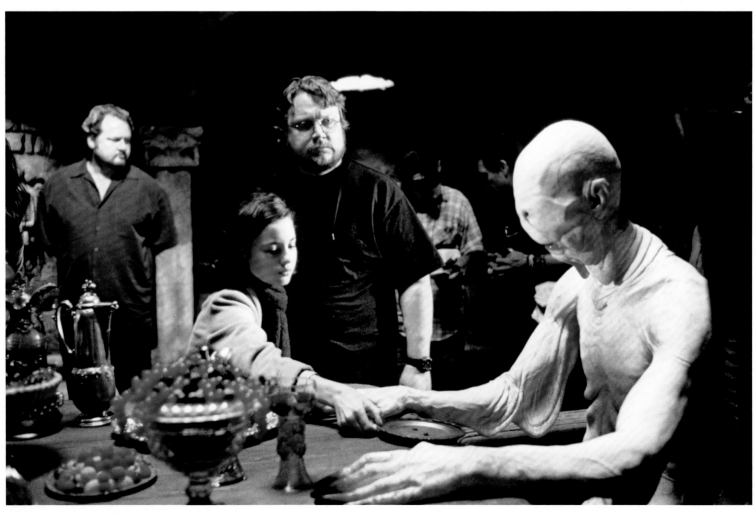

I've been doing since then. Also, Guillermo del Toro as a creator challenged me. The platform to go on to bigger projects, and solve all those puzzles in a successful way, completely comes from that film."

"I like all my films, I love them like my children, but *Pan's Labyrinth* was like winning all the prizes in my life!" says producer Bertha Navarro. She is particularly proud of the growth of the Mexican film industry, with the film-makers of del Toro's generation leading the way. "The Mexican film industry is more open to fantasy films, it has more funds. And it's very important that Guillermo, Alfonso, and Alejandro have been able to do international things and be successful. . . . Something happened in that generation, I don't know what, but they are inspiring a new generation. I'm very grateful to be a part of it."

At *Pan*'s tenth-anniversary mark, Guillermo Navarro is looking to move into directing, with epi-sodes of the *Hannibal* TV series on his résumé for starters. "Anniversaries are sort of annoying," he says. "I don't feel ten years older—I feel that the experience is right next to me. So when I see my Oscar I think, 'Wow! That hap-pened ten years ago?!' Ridiculous. But it's one of the best movies I've done. It's rare to find a movie where the cine-matography, the film language, has such a great role."

Following *Pan's Labyrinth*, Guillermo del Toro has enjoyed several high-profile projects, including *Hellboy II: The Golden Army*, his next film after *Pan's* and one of his favorites. Producer Thomas Tull was so impressed by *Pan's Labyrinth* that he pursued the filmmaker with offers to make movies at Legendary, a collaboration that has already resulted in *Pacific Rim* and *Crimson Peak*.

But there have been disappointments, including a very long preproduction sojourn in New Zealand to direct *The Hobbit* that fell apart, with Peter Jackson directing the eventual, and hugely successful, trilogy. When del Toro returned to the United States, James Cameron had an intriguing proposal that breathed new life into del Toro's long-gestating dream film project, an adaptation of H. P. Lovecraft's novella *At the Mountains of Madness*: "I sat down with Guillermo and said, 'Let's get a movie going and let me throw my weight as a producer behind it, let's get you back in the saddle without all of that preproduction devel-opment hell.' He wanted to do *Mountains of Madness* and had a script ready to go. We'd just pitch it to Universal and get a deal going. It seemed like a great idea at the time.

"Cut to six months later," Cameron continues. "Guillermo has designed every character and setting, polished the script to a fine degree that's ready for cam-era, he's got every frame of the movie in his mind. But Universal basically said, 'We really don't want to make this movie, sorry, our bad.' It was the same script and designs, everything we discussed. It boiled down to Guillermo wanting to do an R-rated horror film that hit you in the face. They decided that was not a good business decision, and where is the honor in that? We came in as a pretty powerhouse team and, I think, in their twisted way of looking at it they thought, 'We don't want to mess up this

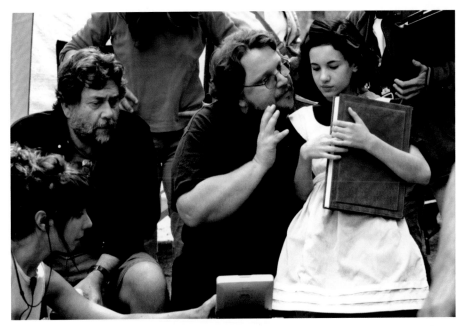

ABOVE Del Toro prepares Ivana Baquero for a scene. Del Toro tailored his direction to the unique personality and talent of each actor.

relationship. Let's get into the deal and figure out some way downstream to get out of this gracefully.' But it kind of went off a cliff. So, ironically, it was his next preproduc-tion development hell. The worst part was Guillermo was taken off the market again on another project he loves."

Bertha Navarro, a link to del Toro's beginnings as a pioneering makeup artist on the Mexican film scene, says that *At the Mountains of Madness* is a project that has been in del Toro's mind since before *Cronos*. "I think [disap-pointment] either leaves you hurt or helps you grow," she reflects. "*Mountains of Madness* is a film he should do. It is the kind of film that will live forever, because he wants so badly to do it. And I think it will be his *best* film, because if Guillermo is there, his heart is there."

"**MY CHILDHOOD WAS,** spiritually, full of fear. My grandmother put the fear of God in me, literally. She would tell me about Hell and Purgatory. I had this sense of doom as a child. I have an overwhelming sense of mel-ancholy and loss that lives with me every day of my life." Guillermo del Toro is reflecting on his beginnings but it is hard to square the sense of melancholy with the com-passionate, honor-bound, and mirthful man described by his friends and colleagues.

The year 2016 not only marks the tenth anniversary of *Pan's Labyrinth* but also of del Toro's Bleak House, his cel-ebrated L.A. area "man-cave" that aptly recalls the title of the Charles Dickens's novel. As Dickens's famous book was crammed with characters, intrigues, and subplots, so too is del Toro's house crammed with curiosities, artifacts, and obsessions. More than a shrine or museum, it's a creative place with room to study, create, collaborate—all the won-ders within its walls are meant to stoke one's imagination.

"In 2006, I was trying to decide whether I was going to invest money in a portfolio, the stock market, or another such adult decision," del Toro recalls. "Or was I

going to indulge my mental ten-year-old self and buy a house and fill it with monsters? And I chose that.

"In a way, Bleak House is the most satisfying thing I've ever created because, unlike a movie, I can actually live in it! I make the movies I make because I want to live in those environments briefly, you know? I could have lived the rest of my life in *Crimson Peak*. But I know they're going to go away, I know we're going to tear them down. But if you toured Bleak House you would see all the movies I've done, or that I could ever make, on the shelves, the tables, everywhere. It is literally an exploded view of my brain and my soul. It's the house I dreamt of when I was ten years old. I know absolute happiness when I'm here."

As if reflecting the filmmaker's growing ambitions, Bleak House was expanded after *Pacific Rim*, with del Toro buying the house next door, making two adjacent homes connected through a back garden. In a strange way the expanded Bleak House recalls his grandmother's home in Mexico, which had been two houses connected by a passageway. It was in a bedroom of the second house, where his great-grandmother and great-aunt dwelled, that the nightmarish goat man of his boyhood dreams made his nocturnal visitations.

Although del Toro recalls a childhood of fear, in particular the emotional impact of his fanatically devout grandmother's visions of Hell and its lost souls, he has some pleasant memories. "I remember always telling my grandmother how we could build secret passages in her house if she gave me a little bit of money," he says with a chuckle. "I'd say, 'We could create a false door.' We could do this and that. And I would draw it for her. And she, of course, never agreed. But *this* house has secret passages and secret doors."

On the occasion of the film's tenth anniversary, del Toro's thoughts are chasing the ghost of *Pan's Labyrinth*. It remains a crossroads experience, the sum total of everything he learned before the cameras rolled that summer in Spain in 2005. His previous three studio pictures—*Mimic, Blade II, Hellboy*—served as a kind of R&D lab.

"People see both sides of me as being separate," says del Toro. "They are not really. I am yet to make a film I didn't profoundly care for—even a misfire like *Mimic* started off like that. But each of the big movies gives me more and more tools. Other directors make commercials and practice there. I can't stand the idea of it, and every meeting I've had in that field confirms this to me: I don't want to do commercials.

152

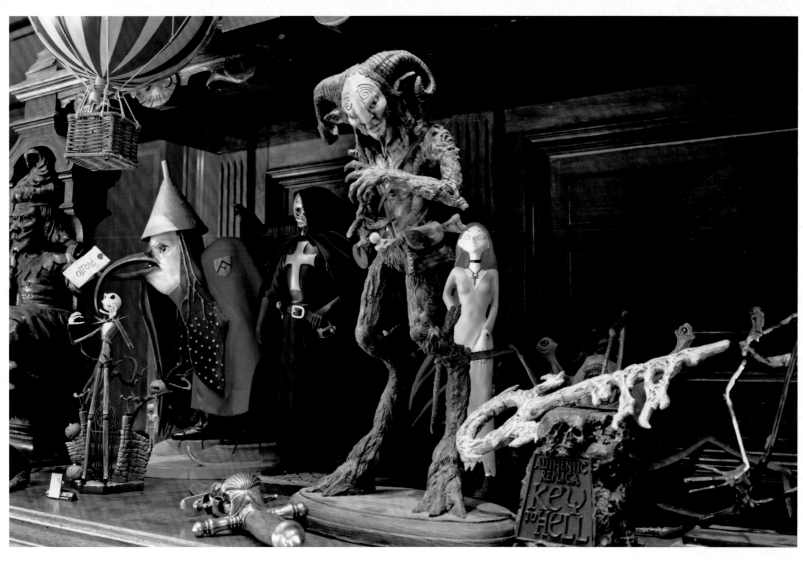

OPPOSITE TOP RIGHT
The monument prop from *Pan's Labyrinth* at Bleak House.

OPPOSITE BOTTOM
Guillermo del Toro with the monument prop in 2016.

OPPOSITE TOP LEFT *Pan's Labyrinth* won a "Rondo," an annual award for the best of horror in various media that was inspired by B-movie villain Rondo Hatton, whose startling features were shaped by the pituitary gland disease known as acromegaly.

TOP A Bleak House shelf crowded with icons ranging from a figurine of the bird-like creature out of Hieronymus Bosch's "The Temptation of Saint Anthony" to Jack Skellington of *The Nightmare Before Christmas* fame and del Toro's own Faun.

"In reality, I couldn't have done *Pan's Labyrinth* if I had not learned what I learned on *Hellboy*, *Blade II*, or *Mimic*," continues del Toro. "If I hadn't done the DI on *Hellboy*, I wouldn't have been able to try to push digital color correction as I did on *Pan's Labyrinth*. If I hadn't done the visual effects on *Blade II* and *Hellboy*, I could not have designed or directed the complicated visual effects / makeup interface on *Pan's Labyrinth*. It was a very complicated movie and looks more expensive than the nineteen million dollars it cost to make. If I had not done those films I wouldn't have been that useful to Eugenio, guiding him into what was essentially his first big movie. I tortured him, yes. I admit it. But I also think he grew a lot and he won the Oscar on his first go.

"I know I'm a bit of an alien. I don't quite belong in a genre and I don't quite belong in an industry. I think that's the main reason I do one and one—a big studio movie and then a little movie. When I feel alienated in one, I go to the other. And I start seeing the positives and the negatives on the big movies and the little movies. It keeps me happy and perpetually unsatisfied at the same time. I do what I do, and there's a bit of me in every film I make—for those who know where to look."

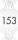

Del Toro reveals he has recently decided to complete his Spanish Civil War trilogy: "I do want to finish it in the next few years. When? I do not know. A career is—to paraphrase Lennon—what happens while you're making other plans. It will be set in Spain in 1939, the same year as *Devil's Backbone*. It will be about past and present. In my opinion, Spain has never quite dealt with the Civil War. There have been many movies made about it, many books have been written. But for some reason, as a society, it still seems to be a sore point, a topic not to be put to rest, you know? That is basically what the movie is about.

"The third movie is important for me because I have it conceived in my head as a circular movie. It's called *3993* because the movie opens and closes as a perfect circle, you know? And I think *Devil's Backbone*, *Pan's Labyrinth*, *Crimson Peak*, and this third movie are all circles. *Devil's Backbone* opens with a speech, and by the end of the movie that same speech has a different meaning—the last line is, '. . . a ghost, that's what I am.' It sends a chill down my spine, even talking about it."

Del Toro is open to shooting that final chapter in his Civil War trilogy in Spain, although he has some trepidation. In fact, when he embarked on making *Pan's*

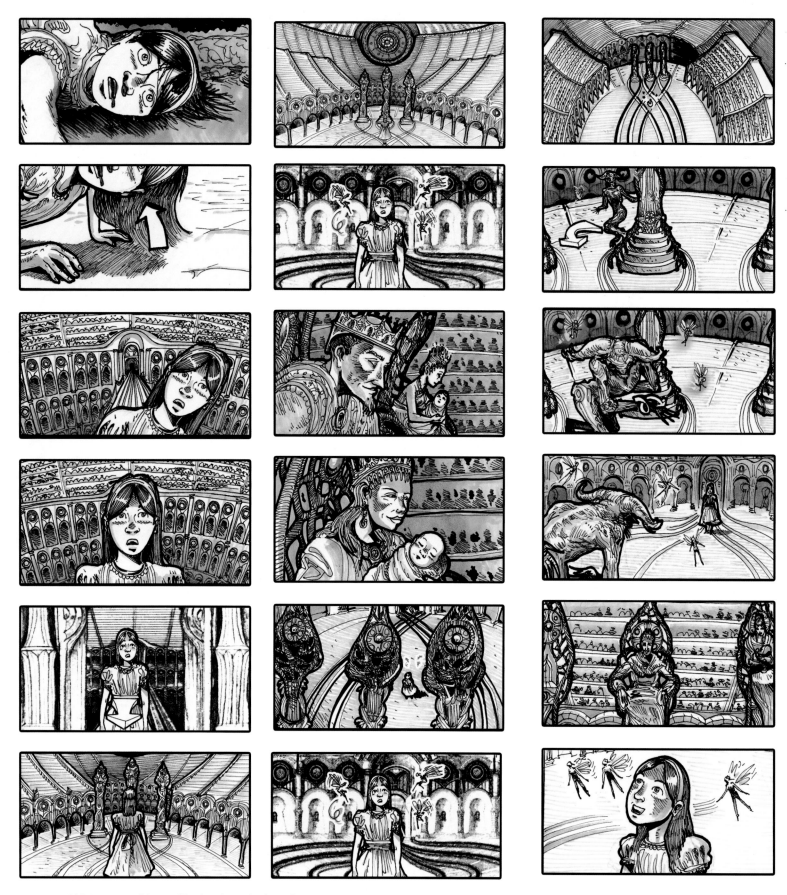

ABOVE Ofelia's reunion with her royal family is depicted in this Raúl Monge storyboard sequence.

OPPOSITE *Pan's Labyrinth* poster art by Jock, commissioned in 2014 by pop culture company Mondo.

Labyrinth, del Toro had planned to permanently relocate to Spain, plans he soon scuttled—the daunting ghosts of *Pan's Labyrinth* still haunt him.

"I have gratitude toward the people [in Spain] who supported me in making *Pan's Labyrinth*, the amazing people at Moya Construction and José Luis Moya, the head of the company; Carlos Giménez, DDT, Pilar Revuelta, Lala Huete, and the few in the crew that did not see it as a folly. Some of them became family. It was a time of huge love and huge adversity. And even though I'd very much want to film [*3933* in Spain], but I'm still incredibly anxious whenever I'm in Madrid. It's involuntary, these anxiety episodes, I feel it at a physical level. It was a tough movie to make. I feel like Baryshnikov at the opening of *White Nights*."

"But it's a movie that changed my life and it did exorcise a huge level of sadness—in fact, for me, *Devil's Backbone*, *Pan's Labyrinth*, and *Crimson Peak* represent huge purges of sadness. The difference is that shooting *Devil's Backbone* and *Crimson Peak* were really fun—*Pan's Labyrinth* was not. I cannot be autobiographical in a straight way; I cannot make a movie about my childhood in Guadalajara. I cannot do an *Avalon*, I cannot do an *Amarcord*, I cannot do that type of chronological biography. But these three movies are very much biographical; they are taken from emotions and situations that I have felt at an existential level in my life, so they are incredibly important to me."

"But *Pan's Labyrinth* is one of the movies I love the most and it's one of my most personal movies. It's a movie that makes sense of the movies that came before and has allowed me to make the movies that have come after. It's a touchstone, the key, to all the movies I have done and will make. It is the movie that is the most painfully heartfelt for me."

That *Pan's Labyrinth* remains a classic is testament to the ingenuity and resourcefulness it took to make it. Something sublime, unique, and wonderful came out of the chaos of its creation. But such is the aim of any filmmaker—to dream dreams, conjure worlds, bring order out of chaos.

Del Toro's work reflects his visions and his life in an interlocking circle of images and meanings, some as wistful as the fleeting memory of a dream. There is a circle in *Pan's Labyrinth*, and it closes with a narrator's fairy-tale coda:

"And it is said that the princess returned to her father's kingdom. That she reigned there with justice and a kind heart for many centuries. That she was loved by her people. And that she left behind small traces of her time on Earth, visible only to those who know where to look."

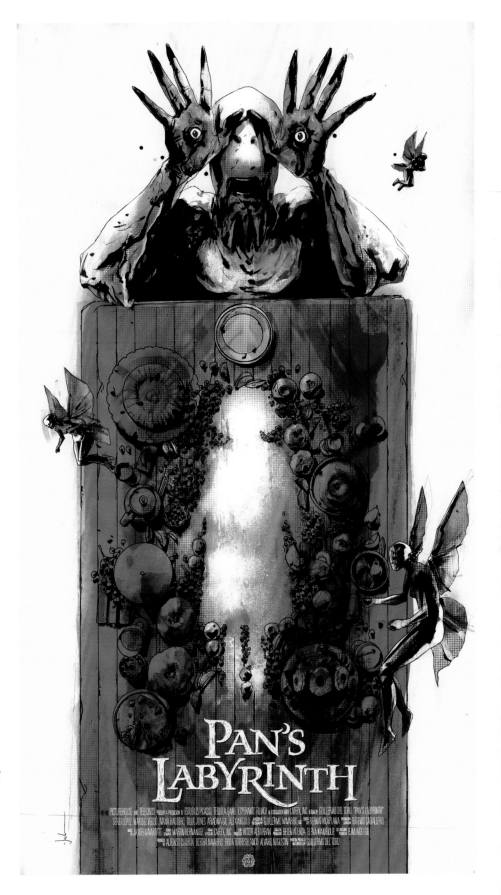

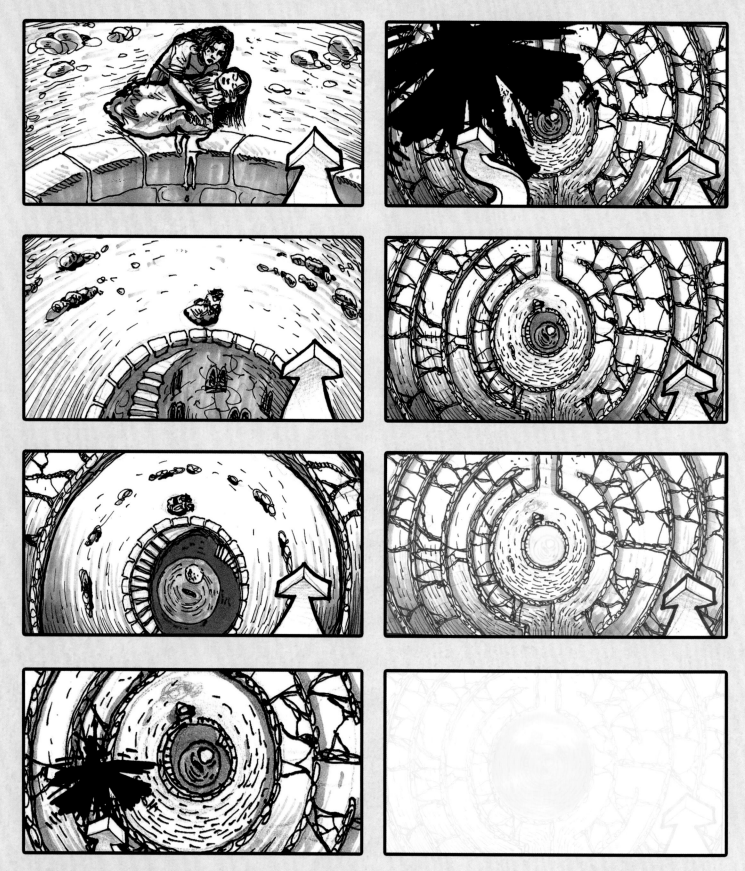

THESE PAGES Storyboard art by Raúl Monge.

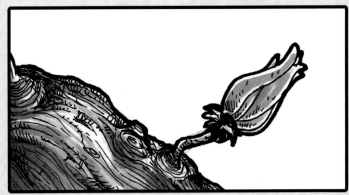

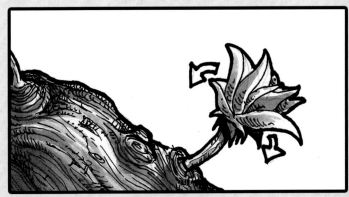

NOTES

INTRODUCTION: THE STORYTELLER

1. Guillermo del Toro and Marc Scott Zicree, *Guillermo del Toro: Cabinet of Curiosities: My Notebooks, Collections, and Other Obsessions* (San Rafael, CA: Insight Editions, 2013), 14–15.

CHAPTER 1: THE PATHWAY

1. Del Toro and Zicree, *Cabinet of Curiosities*, 87–88.

2. Mark Kermode, "Pain Should Not Be Sought—But It Should Never Be Avoided," *The Guardian*, November 5, 2006, http://www.theguardian.com/film/2006/nov/05/features.review1.

3. Erich Boehm, "Tequila Gang to Pour Pix," *Variety*, September 4, 1998, http://variety.com/1998/film/news/tequila-gang-to-pour-pix-1117480135/.

CHAPTER 2: THE SPANISH CONNECTION

1. Jean Cooke, *History's Timeline: 40,000 Year Chronology of Civilization* (New York: Crescent Books, 1981), 207; Paul Preston, *The Spanish Holocaust: Inquisition and Extermination in Twentieth-Century Spain* (New York: W. W. Norton & Company, 2012), 471.

2. Cuarón was directing the 2004 release, *Harry Potter and the Prisoner of Azkaban*.

3. Del Toro had seen the period film *Balarrasa*, in which fascists are heroes and one, convinced he is about to die, cracks his watch to mark the time of his passing. "And I thought that was a really arrogant gesture, and I took it for the captain's father," del Toro says. Del Toro and Zicree, *Cabinet of Curiosities*, 183.

CHAPTER 4: THE TOAD IN THE TREE

1. English subtitles from the Spanish, *Pan's Labyrinth* Blu-ray.

2. Del Toro and Zicree, *Cabinet of Curiosities*, 177.

3. Joe Fordham, "Into the Labyrinth," *Cinefex* 109, April 2007, 37–38.

CHAPTER 5: THE MONSTER'S BANQUET

1. Michael Guillen, "*Pan's Labyrinth*—Interview with Guillermo del Toro," *Twitch*, December 17, 2006, http://twitchfilm.com/2006/12/pans-labyrinthinterview-with-guillermo-del-toro.html.

2. Background on Saint Lucy, or Lucia of Syracuse (ad 283–304), Wikipedia, https://en.wikipedia.org/wiki/Saint_Lucy.

CHAPTER 8: KINGDOM COME

1. "Oscar 2007: How the Votes Will Go," *Entertainment Weekly*, February 23, 2007, 57.

2. Weaver was nominated for best actress in Cameron's 1986 film. *Avatar* had an incredible nine Oscar nominations, including best picture, but won only three at the 2010 ceremony—cinematography, visual effects, and art direction.

3. Kermode, "Pain Should Not Be Sought."

CHAPTER 9: MASTERING CHAOS

1. "Stephen King's Top Movie Picks for 2006," *Entertainment Weekly*, February 1, 2007, http://www.ew.com/article/2007/02/01/stephen-kings-top-movie-picks-2006.

ABOVE AND RIGHT Dagger handles by Sergio Sandoval.

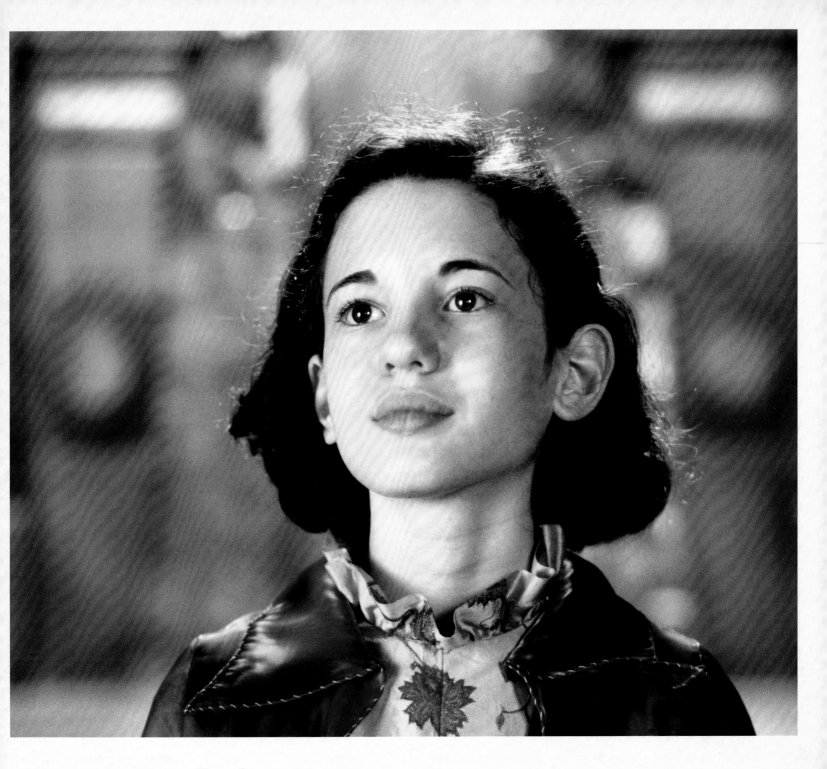

The Interviews

Guillermo del Toro's Pan's Labyrinth
Copyright © 2016 Guillermo del Toro

HarperCollins books may be purchased for educational, business, or sales promotional use. For information please e-mail the Special Markets Department at SPsales@harpercollins.com.

First published in 2016 by
Harper Design,
An Imprint of HarperCollinsPublishers
195 Broadway
New York, NY 10007
Tel: (212) 207-7000
Fax: 855-746-6023
harperdesign@harpercollins.com
www.hc.com

This edition distributed throughout the world by:
HarperCollinsPublishers
195 Broadway
New York, NY 10007

Library of Congress Control Number: [TK]

ISBN: 978-0-06-243389-3

First Printing, 2016

Printed and bound in China

Acknowledgments

Special thanks to Insight Editions senior editor Chris Prince for helming this project and to editor Greg Solano for his invaluable assistance. A salute to *Pan's Labyrinth* gaffer David Lee; to Alice Scandellari Burr, assistant to Alfonso Cuarón; and to Paula Comesaña Pose at DDT. As always, a deep bow and a tip of the hat to John Silbersack at Trident Media Group and to his stellar assistant, Hannah Ferguson.

—Mark Cotta Vaz

INSIGHT EDITIONS would like to thank Guillermo del Toro, Gary Ungar, James Cameron, Alfonso Cuarón, David Martí, Montse Ribé, Sergio Sandoval, Eugenio Caballero, William Stout, Guy Davis, Esther Gili, Raúl Monge, Ana Isabel Izquierdo, Ethan Boehme, Drew Struzan, Jock, and all the cast and crew members who gave their time to be interviewed for this book.

About the Authors

Mark Cotta Vaz is a *New York Times* best-selling author of more than thirty-five books. His works include the award-winning *The Invisible Art: The Legends of Movie Matte Painting* (co-authored with Oscar-winning filmmaker and Academy Governor Craig Barron) and the critically acclaimed biography *Living Dangerously: The Adventures of Merian C. Cooper, Creator of King Kong.*

Nick Nunziata was one of the pioneering voices on the Internet as the creator of the film website CHUD.com in the mid 1990s. His career continued to evolve as he contributed to dozens of print publications and became the on-air film critic for *CNN Headline News.* Now he is a composer, producer, and writer in the film industry, with credits ranging from *Grizzly Park* to Guillermo del Toro's *Don't Be Afraid of the Dark*, as well as the co-writer of *Grim Reaper: End of Days* with best-selling author Steve Alten. He lives in the Atlanta area with his family and is currently working on a feature with filmmaker Joseph Kahn.

Page 12 Cannes photo courtesy of EdStock/istockphoto.com. Photo by Peter Kramer.
Page 20 Image of Guillermo del Toro and James Cameron courtesy of Featureflash Photo Agency/Shutterstock.com.
Page 144 Image of Alfonso Cuarón, Alejandro Gonzáles Iñárritu, and Guillermo del Toro courtesy of Everett Collection/Shutterstock.com.
Page 145 Image of Pilar Revuelta and Eugenio Caballero courtesy of Margaret Herrick Library, Academy of Motion Picture Arts and Sciences. Copyright © Academy of Motion Picture Arts and Sciences.
Page 145 Image of Doug Jones courtesy of s_bukley/Shutterstock.com.
Page 146 Image of Guillermo Navarro courtesy of Margaret Herrick Library, Academy of Motion Picture Arts and Sciences. Copyright © Academy of Motion Picture Arts and Sciences.
Page 147 Image of David Martí and Montse Ribé courtesy of Margaret Herrick Library, Academy of Motion Picture Arts and Sciences. Copyright © Academy of Motion Picture Arts and Sciences.

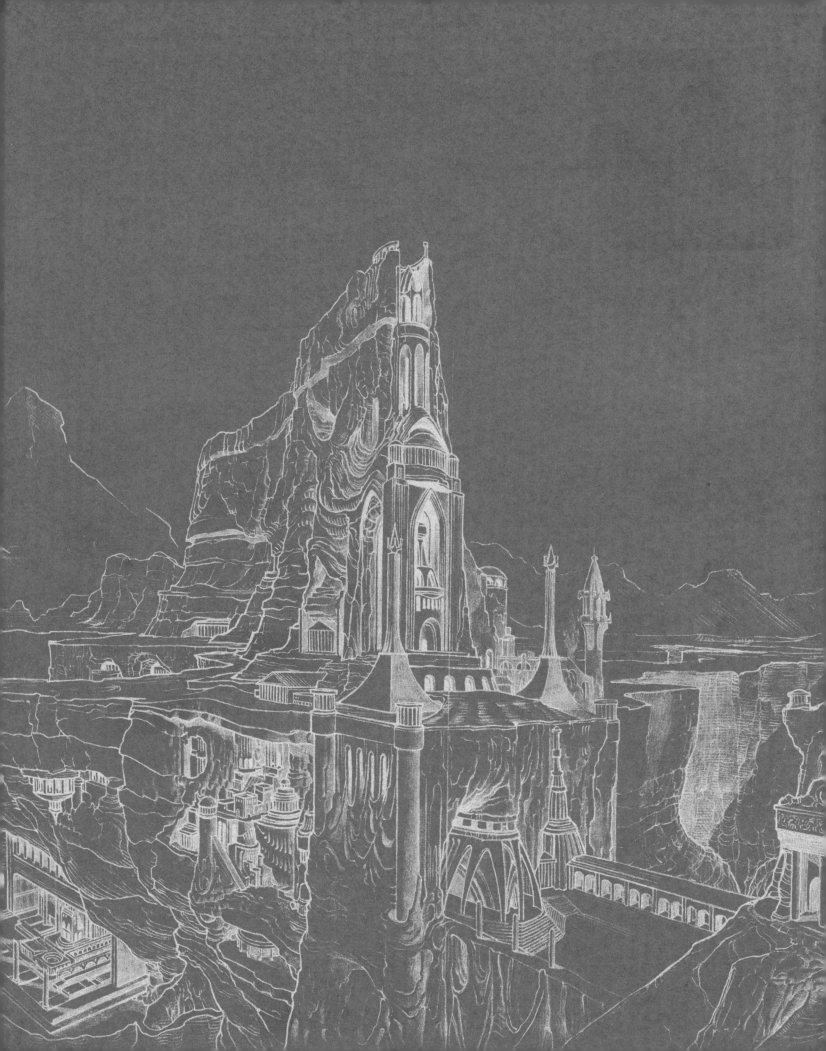